D1600836

TradeWorks
publishing

IT BEGAN WITH THE KENNEDY ASSASSINATION

TRIP IN THE DARK©

Trip in the Dark is a work of fiction. Apart from the well-known actual people, events and locales that figure in the narrative, all names, characters, places and incidents are the products of the author's imagination or are used fictitiously. Any resemblance to current events or locales or to living persons companies or institutions is entirely coincidental.

*For Andy—the real Mr. Nielsen—my best friend,
poker consultant and true love.*

For Sunjay and Mila

And for bankruptcy lawyers everywhere

Acknowledgements

Like most authors I have many people to thank. First and foremost my husband, Andy Nielsen. The hero of this book is named for the two of us, Andy and me (Thomas Nielsen) for a reason. Andy was my editor in chief. He has read the book in all its versions dozens of times and cried at the sad parts each time. He is also my poker expert. He and I spent many hours constructing the Texas hold'em hands in the book. I don't play poker myself so that part of the story could only have happened through Andy.

I owe a great debt of gratitude to the "real" Jake McCarty—Honorable John B. Connally, Jr. Most people will realize Jake is a reincarnation of "Big John." I did not use his real name because I wanted to emphasize that this story does not represent what happened. Despite the suspicions of my friends and family, I have no knowledge of any tapes or any conspiracy. Still, I hope I've been able to capture a lot of Connally's persona in the book. Connally and I were both at Vinson & Elkins law firm in Houston from 1981 until his bankruptcy in 1986 and I had the privilege to work with him. He was brilliant and funny, never condescending, always helpful, a big tall Texan who lived through incredible personal success and failure and accepted both with dignity, good humor and serenity. One of the last things we did together was a bankruptcy conference at University of Texas School of Law. After Connally filed for bankruptcy, I invited him to come and speak at the conference. He charged no fee. He asked if his bankruptcy judge would be there and I said he probably would. Connally said, "Then Hell, yes! I have a few things I want to tell that man." And so he did, brilliantly, to a standing ovation.

I do use the name of Connally's ranch, the Picosa Ranch, with the consent of his grandchildren, Bubba and Charlie Ammann who now run the place as a luxury resort. Please visit them at www.picosaranch.com. They still have lots of Connally's memorabilia there, and it's a great, unique, fun place to stay. And they did not ask me to put in this plug.

I was not born a writer. I took lessons, lots of lessons, at Gotham Writers Workshop, an online school that's terrific. Thanks to all the professors and students who reviewed and critiqued parts of the book over the years, especially Russell Rowland, a great writer of Western stories in his own right.

Finally, many thanks to Shane Cashion at TradeWorks Publishing. Shane was more of a midwife, patiently listening to my screams of agony as I labored to bring this story into the world. He has been creative, responsive and gentle, all one could ask of a publisher.

PREFACE

November 22, 1963, 11:38 a.m.:

This is a national news bulletin. Dallas, Texas.
Three shots were fired at President Kennedy's motorcade in downtown Dallas. The first reports indicate that President Kennedy has been seriously wounded by this shooting.

November 22, 1963, *12:38 p.m.:*

It has been one hour since that electrifying flash came over the wires that bullet shots had been heard to ring out in the Kennedy motorcade. President Kennedy arrived in Dallas airport from Fort Worth Texas. It was the third stop on his swing of Texas that began yesterday. A swing that up to then had been wildly greeted by thousands of Texans and given a warm Texas welcome. He arrived at the airport and with Mrs. Kennedy and Governor McCarty

of Texas climbed into an open limousine to drive through streets crowded with cheering Texans.

About two thirds of the way to the downtown hotel where he was scheduled to make a speech, as his car approached a railroad underpass; three shots were heard to ring out. Mrs. Kennedy was heard by reporters nearby to scream "Oh, No." The President, blood gushing from a wound in the head, slumped into her lap. Governor McCarty slumped onto the floor of the limousine. It was later determined that he had wounds in the chest. At any rate, after that shooting incident, of course, pandemonium broke out. Secret service men immediately began fanning out into the crowd looking for the assassin. A report has it that the man has been arrested; that he was operating from a second floor window oddly enough cattycornered from the county jail, fired from that window almost down into the limousine like, it is said shooting fish in a barrel. The limousine speeded up then and was used under police escort of course to rush the President to a nearby hospital, Parkland hospital. He and Governor McCarty were taken into the emergency room of the hospital. Shortly afterwards Governor McCarty was removed from that room and taken to the emergency—to the operating room of the hospital. The President was left in the emergency room because aides said that the facilities there were quite adequate. The President's own physician rushed into the room shortly after that. He was on the tour with the President. Pints of blood have been rushed into the room for transfusion purposes and two priests were called to the room. There is the report in Dallas that the President is dead but that has not been confirmed by any other source and as late as 15 minutes ago it was reported by aides outside in the corridor that he was still alive.

We have just learned however that Father Hubert, one of the two priests called into the room has administered the last sacrament of the church to President Kennedy.

Bill Stinson—an assistant to Governor McCarty says he talked to the Governor in the hospital operating room. He says the Governor was shot just below the shoulder blade in the back. Stinson said he asked McCarty how it happened and he said "I don't know. I guess from the back; they got the President too." Stinson said he asked McCarty if there is anything he could do and McCarty replied "Just take care of Belle for me." Belle is Governor McCarty's wife.

November 22, 1963, 1:10 p.m.:

Further information here, the catholic priest who helped perform the last rites, Father Hubert, Dallas, said that he does not believe that the president was dead at that time. The priest left the emergency operating room at Parkland Hospital and walked out of the hospital.

It is believed that a gap in the motorcade perhaps saved Vice President Johnson from being a target of the assassin today. Apparently, a gap had opened up in the motorcade just before the assassin's bullets rang out.

November 22, 1963, 2:38 p.m.:

From Dallas, Texas the flash, apparently official, President Kennedy died at 1 pm Central Standard Time. That's two o'clock Eastern Standard Time. Some 38 minutes ago. Vice President Lyndon Johnson has left the hospital in Dallas but we do not know to where he has proceeded. Presumably he will be taking the oath of office shortly and become the 36th president of the United States.

Prologue: Deep in the Heart of Texas

I drove to our country house alone this time. When I told Beth about my trip, she sighed, "Jake," as she had so many times in the past, in a way that was both question and answer. The mere mention of his name conjured up his ghost to stand confidently in the space between us as he had for so many years during his life. Beth nodded to the briefcase in my hand as confirmation. Jake had somehow reached from beyond the grave and caused me to do his bidding once again. I mumbled something in a way that was both acknowledgement and resignation.

Her eyes met mine, looking for a sign. Was this some long-postponed obligation or a nostalgia attack, or something less comprehensible, more threatening? "Call when you're on your way back," she said finally, looking away.

"I will. I have to stop by the law school tomorrow so I won't be home 'till tomorrow afternoon. Love you." I felt her smile.

After the long hot drive from Houston, Austin's gentle hills welcome me with a spectacular sunset. Dinner can wait. The back porch calls. I delay my task, choosing to sit for a few minutes in the bentwood rocker and take in the evening, the delicate smells of bluebonnets blanketing the fields that stretch from the back porch to the line of cottonwoods by the river. Bluebonnets shrivel up in the hot afternoons and hide their tender smells. But they come alive in the evening. Sundown brings a magical moment. A breeze wafts over the blue carpet towards the porch and envelops me with their scent. It's delicate, not sweet like roses or strong like hay. It reveals itself to those who know it's there. Others will tell you bluebonnets have no smell. I know better. I have known for years—it's fragile and haunting, like innocence.

Trip In The Dark by Kaaran Thomas

Now the little blue dots shimmer with the light of a spring moon just risen over the hill. I'm alone with my conscience and my task. I return to the house, fry my hamburger and sit at the kitchen table with my old-fashioned tape recorder and the twenty boxes of recordings, the reason for my trip, stacked neatly in front of me. The contrast still disconcerts me – the boxes sit among the remains of a simple meal in a little house in the Texas hill country, a strange way station on their bizarre journey, begun almost half a century ago in the Oval Office in Washington. More surprising are the secrets they contain—secrets of such enormous import that their appearance on my very ordinary table would be unthinkable to anyone but Jake and me. And Jake is dead.

The boxes look harmless enough to the casual observer: twenty uniform containers, yellowed with age, their frayed edges indicating the stress of their journey. Only two distinguishing features would inspire closer examination. On the edge of each box is a date range. The dates are of immediate interest to anyone of my generation. They begin November 23, 1963, the day after President Kennedy was assassinated. The second feature, to one who understands the meaning of the dates, would compel a look inside: on the cover of each box is the Seal of the President of the United States.

The tapes coil like vipers inside their nests, ready to inject a venomous reality into those who can't resist the temptation to listen. I close the kitchen window and the whispers of conspiracy replace the evening breeze as the thin brown ribbon winds through my old machine; through my ears to my brain to my heart and lungs. I feel the constriction, the chill, and remember how evil has a tangible physical manifestation.

Though I'm looking for just one conversation, I give in to a morbid fascination with the unfolding story—told through hundreds of conversations with dozens of people—of how and why

President Kennedy was killed and how the killing was covered up. There's a congratulatory call to newly elevated President Johnson from one of his Texas buddies who was in on the plot—the first step in restoring Texas to her rightful dominance of the world's oil markets. In a later call, Johnson cautions a co-conspirator they aren't out of the woods yet. Things need to settle down before Johnson can use the reins of power to correct the damage done by his predecessor.

The callers are put through by Johnson's secretary so their names are matters of record. Back then in the sixties many of them were young, aggressive, ambitious and amoral. And the guy was dead, after all. Covering up the crime was probably a service to the country—help avoid a political crisis and keep things nice and stable and so forth. Later the callers became senators, governors, officials in the justice department, wealthy businessmen, presidents—perfect candidates for extortion and blackmail.

Some voices need no introduction. J. Edgar Hoover tries to defend his decision to release an FBI whitewash report—"Oswald acted alone"—just days after the assassination, raising well-founded public suspicions that the assassination might have been a conspiracy and that Hoover might have been involved. The report feeds growing rumors that Johnson, Hoover's old friend, was behind the killing. Things are slipping out of control. Johnson tells Hoover it's time to plant some false leads tying Kennedy to the Mafia, blaming the shooting on a hit man to throw the press off his trail.

Johnson later complains to someone how Hoover's foolish reaction has forced him to appoint an independent commission to back up the FBI report. Johnson tells Hoover he had to pull a hell of a lot of strings to get the FBI appointed as the primary investigator for the Warren Commission. He assures Hoover that although Warren is a straight arrow, Johnson has stacked the Com-

mission with others who can be bought. In another conversation Johnson reports to a contact in Pakistan, a Mr. Abedi, that Gerald Ford, a young congressman, will serve on the Warren Commission. Abedi asks why Ford was selected and Johnson reveals that Ford's original name was Leslie Lynch King, Jr. The FBI will revive the discarded identity and document it so their friends can use it to funnel money to Ford. Abedi's Saudi contact, a Mr. Baijan, outlines the process for laundering the funds through his family's bank in Saudi Arabia. The transfers will be untraceable once they reach his bank.

As the disembodied voices continue, I fight the instinct to get up, check my surroundings for unknown presences, unseen threats. People have fought for possession of these tapes—silent, desperate, undisclosed struggles like shark attacks, unseen. The losers have disappeared beneath the waters of history. The victors have caused dramatic changes in American politics, changes the public finds difficult to understand. President Ford's pardon of Nixon, for example. People have no idea that Ford's involvement in the cover-up was discovered and used against him. So many other events have an obvious cause when you know what really happened. Even now, after almost fifty years, the tapes are dynamite. I should have given them up long ago, but I could not. Until now.

Now, before we part company, I need to listen to them alone in this quiet retreat and look for answers. Maybe they're not here, in these tapes. But maybe they are. I find the one conversation I think might help me; it occurred late in December of 1963. The caller is my Jake—Jake McCarty, Governor of Texas just released from the hospital where he was treated for the wounds inflicted by Lee Harvey Oswald. Tonight I want to hear how Jake sounded back when the all-powerful heir to Lyndon Johnson's throne as head of the Democratic Party first realized he was a

mere human, vulnerable to betrayal by LBJ, the man he believed was his closest friend and mentor and faced with the reality of his own eventual death from the scars left by Oswald's bullet as it tore through his lungs. I'll listen to the conversation carefully for this one final time, then I'll erase it and Jake's voice will vanish like the wisps of smoke from his famous cigars. Maybe then I'll understand how he got from there to the person he ultimately became. And maybe then I'll understand how I got to be what I am, and how Jake really felt about me. And if not, maybe I can at least put Jake to rest, exorcise him from my life, and return home to Beth without his shadow following me.

Tomorrow, I'll complete a mission I started more than twenty years ago; I'll deliver my burden to the University of Texas and be done with everything. And on a certain date the public will learn about the tapes. But they won't hear Jake's call to the president. They won't learn of his part in the cover-up. They'll only remember the hero, their Gov, the smooth, polished image he left behind. And that's who I'll remember as well.

I could re-record the edited tapes onto a new set, I suppose, and remove these few minutes of silence that once captured Jake's voice, but I prefer to leave them in their current form, in their incriminating box, so future listeners will understand the source of the information. Besides, these tapes have many intriguing gaps. Others before me have deleted things, unknowable things. Apparently the Oval Office recording system was programmed to capture every call automatically when the president picked up the phone. It may have become so unobtrusive that the presidents forgot they were recording. That might explain why the tapes exist at all. As to why they've been preserved, edited, copied, reedited, hidden, that's another story. Powerful men have claimed them, used them, re-recorded them and passed them on. Why do the mighty do such things? Are they convinced

there will be no consequences—that they're masters of their destiny? Of course, those delusions of grandeur merely tempt Fate. Fate takes such strange twists, turning secrets into weapons.

Nixon, for example. He discovered the tapes in the middle of the Watergate investigation. He was fascinated with them; took them and edited them into the twenty reels that sit on my table. It's his seal on the boxes. He believed he could use them to threaten the Democrats into stopping the impeachment proceedings, but he never did. He told Jake about them. Jake, his closest confidant, convinced him to keep them secret, then stole them out from under the President's nose while he was giving his resignation speech.

Before all that, while his wounds were still fresh, Jake's voice comes through the recorder. It's hoarse. He coughs repeatedly, gasping for breath. Johnson's voice is unnaturally high, his greeting ends in a nervous squeak.

"Jake—how the hell areya? I heard you got out of the hospital this week. I was going to call ya."

"How do you think I am? Neal Wallace came to see me. I suspected that you might be behind this, of course, especially after that suspicious gap in the motorcade. So I confronted Neal. He told me everything."

"Everything about what?"

"Don't fuck with me, Lyndon. You know very well what. Neil told me how you were afraid Kennedy would use the bribes to Abdul Kassem to impeach you. How you plotted with him and our other Texas friends to eliminate Kennedy before he could put his plan in motion."

There are a few moments of silence. Then, "I told Neal we should let you in on the whole thing. It was his idea. He said we should keep the information on a need to know basis."

"So I didn't need to know? The Governor of Texas? The person riding in the car in the path of the bullet?"

"We didn't think you'd get hit, Jake. We never thought that."

"Damn right, you never thought about it. You never cared."

Another pause.

"Jake, we didn't even think you'd even be in the parade. That seat was reserved for Mr. Yarborough. You changed your plans after it was too late to stop everything. There are some things we can't prevent . . ."

"No, Lyndon. There are some things we don't want to prevent. I worked for you, slaved for you for thirty goddamn years. They called me Lyndon's boy. Hell, they still do. I loved you like a father and you put my life at risk. No . . . no what you really did was kill me. I'll just die slow instead of having my brains blown out. I hope you enjoy the Presidency, Lyndon, but I have a feeling it'll turn to dust. All that power and glory, it'll all come to nothing. If there is a God."

"Hold on now, Jake. Don't do something stupid. You're the governor of Texas and now you're a national hero. Wounded with the president. You can be governor for life. And think of what I can do for you, for our friends, for the State of Texas—our state, Jake."

"What do you think I'm gonna do, Lyndon? Tell somebody? You want to do things for me so I'll keep quiet? Neal said the same thing. He and the rest of our Texas friends are gonna take care of me. You damn bet they're gonna take care of me. And so are you, Lyndon. You won't lose your precious presidency on my account, for what it's worth. But you'll regret this for the rest of your life. And you lost me. Maybe I wasn't worth anything to you in the first place."

Trip In The Dark by Kaaran Thomas

The line goes dead. There were no goodbyes. There would never be any goodbyes between them, ever again, until Jake spoke at Lyndon's funeral. He paid tribute to his former mentor only because President Nixon demanded it and his long time friend, Ladybird Johnson, requested it.

Jake never did report the crime. That's the other reason why I erase this call. Because Jake doesn't deserve to be implicated in the cover-up, not after all that's happened. History should record him as a victim, not as a conspirator. That's what he was, after all: one of the grandest victims of all time. He suffered near-fatal wounds from two great conspiracies. The first involved the Kennedy assassination. The second led to the destruction of all the trinkets and baubles, all the power and control the assassins held so dear. That one was conceived by a higher power.

Fate succeeded brilliantly where the authorities failed miserably. She lured the criminals to their doom with a siren's song of great wealth and power—the very things they most desired. Unfortunately, Jake coveted those things as well. He joined that second motorcade to disaster quite willingly.

All the perpetrators were punished. Johnson never helped Texas regain control over the world's oil supply. The new world power, OPEC, flexed its muscles in the 1973 Arab oil embargo and America finally woke up to what it had lost. LBJ's presidency turned to ashes. The war in Vietnam, Kennedy's parting gift, overwhelmed all the accomplishments of Johnson's Great Society and all the dreams of world dominance his Texas friends expected him to fulfill.

No human conspiracy can compete with the machinations of Fate. Humans, for all their wiles, can use only man-made devices to accomplish their ends. Fate has at her disposal human nature—its greed and selfishness, its generosity and fearlessness; its pride and envy and its innocence and decency. And its secrets.

Trip In The Dark by Kaaran Thomas

Over the course of my life, I've come to believe that secrets are the fickle traveling companions of Fate, and perhaps her greatest weapon.

I press the delete and rewind buttons. Jake vanishes. Such power, such power I have to change the course of history. I turn off the machine and go back out on the porch. The moon is up high now and the bluebonnets have come to life in the dark. I sit quietly, rocking, taking clean air into my lungs in great healing gulps, like someone surfacing from deep waters. What truth did I discover? Did I find an answer to the only unanswered questions I've cared about for so much of my life? What was the meaning of our time together—Jake's and mine? Was Jake my friend or did Fate bring us together to help accomplish her ends? Did he want to leave me something of himself, something to remember him by, or was he just leaving me holding the bag? Or perhaps he wasn't thinking clearly, perhaps Fate had taken control. Why do I have these tapes?

I have the rest of the night to think about the answer.

Chapter 1: Trip in the Dark

On my twenty-first birthday, my family threw an enormous party for me. All my relatives and friends attended to celebrate my majority. After the presents and the cake came the champagne; I toasted my father, thanking him for his help and encouragement along the road from boyhood to manhood. Dad shook his head. "You don't become a man by having birthdays, Tom," he said. "You become a man by having experiences. You are not a man yet."

I was embarrassed by the implication. Of course I was a man. I was well on the way to supporting myself; I was old enough to drink and drive and vote. I was an adult in the eyes of the authorities. But not in my father's estimation. He hadn't meant to hurt my feelings, especially on such an important day. When he saw my shocked face he tried to lessen the impact of his judgment:

"And when you've had too many experiences, son, that's when you become an old man."

Many years passed before I understood what was necessary to become a man. I remember the moment clearly. I was sitting in my car in a field of bluebonnets, not far from where I sit now—in the middle of the Texas hill country in the middle of the night. On the passenger seat beside me sat a packing box filled

1

with the tapes that are scattered across my table tonight. That's why I've chosen to come here; that's why I've waited until dark to perform my task. This is the hour, the place where my trip began, in March of 1987.

Journeys take many forms. Some are physical, like the midnight drive from Houston to Austin that changed my life. Some are psychological pilgrimages from one mental state to another. That night I traveled two roads: through the Texas hill country and from childhood to maturity.

My journeys to the dark field were as incredible in their way as the journey that brought the tapes to my table.

Chapter 2: The Legend

The man who sent me on my way was a legend. Only someone as powerful, as commanding as Jake McCarty could have bent me to his will. The Kennedy assassination made him a national figure, but Jake had been a famous Texas politician for years. He had been a popular Governor of Texas. During the 1950's, he had become LBJ's golden boy, managing Johnson's congressional campaigns. Jake grew into a master politician with an actor's face, an orator's voice, a brilliant mind, and an oversize personality.

I learned a lot about Jake as the two of us traveled the Texas back roads winding through the hills between Houston and Austin. Most folks would fly on business trips. Not the Gov. He loved driving, top down, silver hair disheveled in the wind, raising clouds of dust, ignoring the speed limit with aplomb. He had plenty of time to recount the stories of his campaigns for governor and, earlier, for LBJ.

"Over t 'other side of that hill (stab) is Creekwood Ranch, the old Lewis place. They were big supporters of Lyndon and me — they used to have fundraisers in their kitchen and invite the neighbors and Cheryl would bake chocolate chip cookies. Man,

3

you could smell them cookies for miles. Folks would come for the cookies and stay for the speechifying. Then later, when Lyndon was elected and got electricity for their ranch, they had another baby and they named him Lyndon. He was the first baby named after Lyndon, I do believe. Bill still lives there, but Cheryl passed a few years ago."

Jake's cigar, fat and authoritative, drooped pensively.

For most men, cigars were something to smoke. For Jake, they were like mood rings. When he was happy or excited they stuck up and waved like banners. When he was angry or demanding they pointed at you like a pistol. When he was pensive or distracted they drooped like naughty puppy dog tails.

"How many kids're named Jake?" I asked. The craggy sunburned face crinkled into a grin and the cigar waved triumphantly

"Not so many Jakes but lots of Jacquelines. Even a Jackarinda I'm told! What a name! As it turned out, there were mostly girls born in these parts while I was Governor. So folks had to get creative to pay tribute to me."

He assumed people's tribute had sprung with him from his mother's loins at his birth. Even after he retired as Governor and abandoned the Texas Democrats, Texans considered him their hero. After he retired from politics he was courted like a king by every big oil company and law firm in the state. He finally decided to join my law firm, Wainwright & Snow. They agreed to pay him a fortune, waived every conflict that might come up between his business deals and the interests of their established clients and catered to his every whim.

Jake was a natural fit for Wainwright & Snow. Wainwright lawyers were, and still are, the nobility of Texas' legal community.

I arrived at the firm at almost the same time as Jake, but under far different circumstances. Jake's entry into Wainwright

was triumphant, mine was unenthusiastic. That would be an understatement.

Until February, 1981, I was a solo practitioner, as almost all bankruptcy lawyers were back then. I was destined for a very ordinary legal career until the day, in 1981, when I got a call from Harry Reedwell. Everyone in Houston knew he was head of Wainwright & Snow.

"Don't tell me you're calling me to discuss your financial problems," I said, trying to be funny. I had never met the man and this was my first lesson in the perils of being flippant to Harry.

"Of course not," he huffed over the phone. "We wanted to see if you were interested in coming to work for us. But perhaps we're talking to the wrong person."

"No sir! Look, I'm really very sorry if I offended you." Apparently I struck just the right tone of slobbering obsequiousness because Harry invited me to his office for a "very preliminary interview." Harry's parting words left no doubt about how preliminary the interview was to be: "And one more thing, Mr. Nielsen. You are not to discuss this with anyone. Anyone. Do you understand?"

"Yes, sir!" Which meant I couldn't brag about my good fortune to my fellow bankruptcy attorneys who were slaving away in their little insignificant offices. Back then bankruptcy was considered an untouchable practice by all the important firms. Bankrupts were criminals. Texas nobility didn't practice criminal law. Period.

I had the credentials necessary to be Wainwright material. I graduated from University of Texas law school magna cum laude. But I had fallen in love with bankruptcy law. My friends told me I was crazy. Even my bankruptcy professor said so. "Nielsen, you're ruining your chance for a career at a big firm. You're giving up millions of dollars of income. Bankruptcy lawyers are like un-

5

dertakers. Lots of people need them but nobody wants to socialize with them. You'll be an outcast."

Who knew, ten years later bankruptcy lawyers would be among the most preeminent, highest-paid attorneys in the profession? But fame and fortune were far in the future. All I knew was my desire to understand how the economy really worked, and for me the answer was to study why businesses failed. Leonardo Da Vinci learned human anatomy by dissecting corpses; so I would study the workings of the economy by dissecting dead business corpses. And I was fascinated by the fact that the world's most famous democracy, founded on the "social contract" had created the world's most sophisticated system for getting away with breaking contracts. That's what bankruptcy is, I would try to explain. People said I was too intellectual.

Despite what everyone had told me, I didn't believe the big firms would turn me away. Didn't they realize bankruptcy was critical to our economy? Congress had just passed the "Bankruptcy Code"—legislation that would make the bankruptcy courts the key players in business restructuring. But nobody in the big Texas firms knew or cared back then. My interviews all took the same turn:

"We don't use the courts to restructure our businesses here in Texas, Mr. Nielsen. Maybe those New Yorkers do things like that but we don't, it's not considered good manners. Maybe you should go work in New York."

Houston had eleven major law firms when I was in law school. After the seventh rejection I gave up. It was too depressing. I had interviewed with Wainwright & Snow. In fact, Harry had the report of my initial interview in front of him when I came to his office.

"I see you have interviewed with the firm before, when you were in law school."

"Yes, sir."

"The interviewing partner noted you were very bright, but determined to pursue an unacceptable practice area. Is that correct?"

"No, sir."

"It's not?"

"I don't consider bankruptcy an unacceptable practice area."

"Oh, I see. Well, that gets me to my next point. Hiring someone who has been in private practice is a first for us. All our other associates came to us right out of law school. We bring them up the Wainwright way. Makes for a peaceful and happy working environment. Everyone has the same sort of appreciation for our customs, if you know what I mean. Once you join our firm you will technically have the same rights as any other associate. Which means you can technically leave your bankruptcy work and go into our banking or real estate practice groups. Needless to say they are a lot more prestigious and rewarding than your, er, your practice area. I want your gentleman's agreement that you will not exercise that right."

"You mean, I would never try to leave my bankruptcy practice and join your banking or real estate groups once I'm hired—if I'm hired?"

"Exactly. I must say we are getting a lot of resistance to the idea of hiring you. This is something we have never done before. You would be an outsider. And your practice area is something of an embarrassment to some of our partners. Frankly, they don't believe this little economic hiccup is going to cause any major repercussions for Texas. But they're willing to buy a little insurance against being wrong, if you know what I mean."

"So I'm the insurance?"

"Yes."

7

"And you want to have a handshake deal with me that I won't butt in on any of your partners' existing practices if I join the firm? Not upset the firm traditions, and so forth?"

"Precisely."

"But you don't want to put the agreement in writing?"

"Correct. People might get the wrong impression. It might just send a bad message to other attorneys who we might invite to join the firm in the future."

"I see."

"So before this interview process goes any further I want your gentleman's agreement, as I said."

"I can see you're already thinking like a bankruptcy lawyer." I was keen to indoctrinate him into the wonders of my profession.

Reedwell reacted like he'd been shot. "What do you mean by that?"

"You already realize a fundamental lesson about bankruptcy. The reason people live up to their agreements is because of their nature—their conscience. Not because of a written contract. Bankruptcy lets you tear up the written contracts. From then on, it's what people want to do either because it's their code of honor or because there's something in it for them. So if we come to terms I will honor our agreement, Mr. Reedwell—first because I am a gentleman and second because I do not want to be, nor will I ever be, anything but a bankruptcy lawyer."

I could see Harry was a little bewildered by my high-minded pronouncement, but he definitely got the part about my honoring the deal.

"Wonderful, wonderful. So now we can get down to business," he said, his face relaxing into what he apparently believed was a congenial smile. "Please, Tom, call me Harry."

Of course, I accepted Reedwell's offer. The temptation to be the first bankruptcy attorney hired by the most prominent law firm in Texas was too great. So was the salary. An associate at Wainwright made twice what I scraped together as a solo practitioner. Not to mention all the benefits of working for a firm of over two hundred lawyers that represented First City National Bank, the largest bank in Texas, and most of the richest Texans in the state.

My biggest problem was my former clients. I assumed I would be bringing them with me to Wainwright. But when I gave my client list to Reedwell, he held it like it was garbage.

"You need to get rid of these . . . people, Mr. Nielsen."

"You mean my clients?"

"Yes."

"All of them?"

"Absolutely. Just turn them over to one of the other bankruptcy attorneys you know."

"Some of them might object. I tend to get involved in their lives, their problems. We have a close personal relationship . . ."

Harry tipped back his chair and studied the ceiling for a minute or so.

"Here's what we'll do. We'll give them all season tickets to the Houston Oilers. They'll forget all about you."

That should have been a warning to me right there. Reedwell measured my value in terms of Oiler season tickets. Bum Phillips and his football team weren't having a particularly good season. I calculated the cost of good seats for all of my clients. The total wasn't encouraging.

"I'll see what I can do, Harry."

"Get rid of them by October 1. We're going to need you to consult on a big new case we just got in." Harry picked up his

phone—a sign our meeting was over. As I got up to leave he crumpled my client list and threw it in the wastebasket.

Chapter 3: Flushed

I thought I would grab some local headlines by joining Wainwright & Snow. I was looking forward to being a celebrity in the legal community. I was wrong. The employment of one unknown bankruptcy lawyer was lost in the publicity surrounding the association of an important new partner—a real celebrity—Jake McCarty. Jake was a graduate of my law school, University of Texas, and he was a brilliant lawyer and a tough, skilled negotiator with incredible personal contacts. And a national hero, of course.

I soon learned the reason Reedwell wanted me to join October first had nothing to do with a big case. It had to do with burying my big news in all the press about McCarty. There was no important case for me to work on. In fact there were no cases at all. I had a nice office with a desk and a chair, a phone and a bookcase and absolutely nothing to do. I showed up at 8:30 every morning and greeted everyone on the Wainwright elevator bank and they looked at me like they didn't know me, which they didn't. I got to my office, read the morning paper and looked out the window for four hours until lunch. I went to my favorite hangout to meet up with my fellow bankruptcy colleagues to talk about what was going on. I made up great stories about all the

cases I was consulting on. I listened to all the details of their cases—real cases.

"When are we going to see you back in court, Tom?"

"I'm pretty much working behind the scenes."

"Wow—there must be a lot going on behind the scenes! What're the banks going to do? Oil has dropped to thirty-two bucks a barrel. The bankers based their loans on a barrel of Texas sweet crude reaching a hundred dollars by 1988. Their loans must all be in trouble. Can you give us a heads up? We're starting to get calls from some pretty important folks in the oil business asking about bankruptcy. When's it all going to come to a head?"

"You know that's confidential information," I would say. Like I had any inkling what our banking clients were going to do. Because nobody told me. Nobody included me in the meetings, if meetings were going on. I didn't even know who to ask about whether any meetings were going on. Wainwright occupied ten floors in the First City National Bank building. Ten floors is a lot of ground to cover to find out if a meeting is going on. After lunch I went back to my office and stared out the window until five.

Two completely boring months passed before I decided to talk to Reedwell. My path to his office door was blocked by Linda, his supercilious secretary.

"You have to make an appointment to see Mr. Reedwell."

"I work here."

"So do I. We all need appointments to see Mr. Reedwell. He is a very busy man.

"OK, who do I talk to about an appointment?"

"Me."

"Do you need to make an appointment with him to talk about making an appointment for me?" I couldn't resist.

"Yes. Mr. Reedwell and I have a standing appointment every Monday at 8:30 to discuss his appointments for the week."

"You mean I won't be able to see him until next week?" My conversation was taking place on a Monday at 10:30 a.m.

"I'll put you down on my appointment list for wanting an appointment next week. It may not be next week. Next week is a very busy week for Mr. Reedwell."

"So he has already made appointments for next week even though you haven't had your appointment meeting for next week?"

"Believe it or not Mr. . . . er . . . Nelson, Mr. Reedwell has many weeks' worth of appointments on his calendar. He is a very very busy man."

"The name is Nielsen, not Nelson. Be sure to get the name right so Mr. Nelson doesn't slip in ahead of me."

"Oh boy" she muttered to herself as I walked away.

In due course I was summoned to his Presence. I was told to arrive promptly. I had been allotted five minutes. As I approached the door, Linda said, "You can't go in there. Mr. McCarty is meeting with Mr. Reedwell."

"He's cutting into my time."

A frigid stare. "Please sit in that chair"—motioning to a straight-backed wooden chair in the hall across from his Presence's door—"until they are finished."

Twenty minutes later McCarty emerged chomping on a cigar, his hand across Reedwell's back. Both were laughing. I was incensed. If people were going to cut into my five minutes it should be for something serious—not to tell jokes. I stood up. They ignored me.

"See you at dinner tonight, then?" Reedwell said.

"Looking forward to it," McCarty replied.

Reedwell headed off down the hall, calling back to his secretary, "I'm late for the partners' meeting."

"But I had an appointment!" I yelled, running down the hall after him.

"We don't run down the hall screaming at each other in this firm, Mr. Nelson. That is not the Wainwright way."

"It's Nielsen. Sorry, look, I've been waiting for two weeks to talk to you. Today was my appointment."

"What was it about?" He hadn't stopped walking. I was relieved when he turned into the men's room where I could corner him.

"It's about what am I supposed to be doing here, sir."

"Helping on bankruptcy things. Isn't that what we agreed?"

"Right, but what bankruptcy things? I've been here for months and nobody has even spoken to me."

"I guess that means we don't have any bankruptcy things, doesn't it, Mr. Nelson?"

"First, it's Nielsen. Second, you have lots of bankruptcy things, you just don't know it."

"Of course we know it—when somebody files bankruptcy we have a bankruptcy thing."

Reedwell and I were in the men's room by then, sharing the intimacy of neighboring urinals.

"You're sure none of the people who borrow money from First City National Bank, for example, have filed bankruptcy? None of them have even threatened to file bankruptcy?"

"How the hell would I know?"

"Well, if you don't know shouldn't you find out? Frankly, according to my colleagues in the bankruptcy bar, lots of First City customers are in trouble, and they're thinking of filing. Their loans are in default. The bank is threatening to foreclose. Shouldn't we be doing something about that?"

"Like what?"

"Like auditing the bank's files to make sure their loan doc-uments are all in order before they start trying to foreclose; like seeing if there's a way for the bank to work out the loans with the borrowers; like shoring up the loans—getting guarantees, more collateral . . . monitoring the bank's collateral to be sure it's not being hidden away or sold out from under them; like"

"Hold on, there, son. You said a mouthful. Are you talking to your friends about the bank's clients? Are you discussing whether they're hiding the bank's collateral?"

"No, that's not what I'm saying."

"Good, because some of the bank's clients are also clients of this firm. Valued clients. And friends. And I don't want you throwing around careless remarks about their integrity. Are we clear?"

The last remark was punctuated by an emphatic shake of his Presence's Organ and a flush, which applied to both his bodily eliminations and me. He left me without another word and head-ed for the elevator.

Chapter 4: Party

I was in a foul mood when we received a large engraved invitation to the Wainwright & Snow Christmas Party. It was a formal event ("Black Tie") held at the Houston Fine Art Museum.

"How exciting!" Beth had opened the invitation and was already planning her attire by the time I got home. Beneath her cool professional exterior lurks the soul of a glamour queen.

"This definitely justifies a new evening dress."

"I didn't know you had any old evening dresses."

"Don't be smart, Tom. You know what I mean. I can get something really spectacular. Are you going to get a tux?"

"I can rent a tux, Beth." I didn't feel confident enough to invest in something I might get to wear to only one Wainwright Christmas Party.

"I could get a vintage dress. That's so much more glamorous than the styles they're turning out now. And I'll have to get matching shoes, and make a hair appointment"

I let her go on. I didn't want to spoil the excitement. The Christmas party might be the highlight of my Wainwright career. Might as well enjoy it.

The party was held on a perfect evening, chilly but dry. In a city where rain was the norm, it was a lucky break. Hundreds of teased hairdos would be safe from destruction wrought by the

combination of torrential downpours and blustering wind that was a Houston trademark. Beth pirouetted in front of me in her new old vintage gown.

"Isn't it exciting, Tom? I feel like Ginger Rogers."

"You look like Audrey Hepburn."

"Really?"

She was fishing for compliments. I obliged gladly. Beth looked gorgeous. Her un-teased auburn hair fell to her ears in a shiny simple bob. It swung around her face as she performed her dance steps. The dress was lovely; totally Beth. It was straight and creamy and shiny.

"Satin." She explained. "You look like Fred Astaire."

She intended that as a complement.

"What do you say to a dance, Ginger?"

"Delighted, Fred."

I held out my arms and executed a clumsy twirl around the living room. We loved the old Hollywood musicals and this was our first chance to dress up and mingle with high society. I drowned my worries in Beth's happiness.

It was six o'clock. The invitation said Cocktails at 6. Dinner at 7:30. Dancing ???

"Shall we go?" I said, offering my arm.

We arrived at the museum at six fifteen and were surprised at how easy it was to find a parking place. Once we entered the museum we realized why—we were among the first to arrive. A few people I recalled seeing before were gathered into groups around the vast gallery. The emptiness made it easy to see the looks on their faces change from welcome to puzzlement to dismissal. I smiled and returned their stares with a noncommittal wave. They returned to their conversations. We decided to inspect the arrangements. In the middle of the room at double rows of serving tables, the staff was busily laying out the buffet.

Trip In The Dark by Kaaran Thomas

We saw bars set up at each end of the room and went over to get drinks. Several people were lined up in front of the bartender.

"Hi, I'm Tom Nielsen. I just joined the firm. This is my wife, Beth."

My self-introduction earned brief introductions in return.

"It appears we're a bit early," I commented, trying to keep the dialogue alive.

"No one comes until seven. We're on our way to another party. Just stopped by for a drink."

"Of course. Lots of parties going on tonight."

"I suppose so."

"What section do you work in?"

"Corporate. I'm a partner."

"I'm a bankruptcy specialist."

"I've heard."

"The economy is really showing signs of distress. You must be picking up some signals from your clients?"

"Not really, no."

He picked up his drink and hurried away.

"Maybe we should leave and come back closer to seven thirty?" Beth looked longingly at the exit.

"I know, why don't we hide in the bathrooms 'till then? Then we can pop out and surprise people." That produced a giggle.

"Do you really want to leave, sweetheart?"

"Just for a while. I hate being the first people here."

So we got into our car and made a tour of the Christmas decorations in River Oaks, then returned to the museum.

"This is better. All the parking places are full."

"Including the one we had."

"That's all right. We'll find one. We'll be part of the mob." Beth was smiling again.

18

She was right. This time we had to wait to get into the museum. People were crowded around the entrance, chatting. Inside we faced a wall of noise. Hundreds of people were gathered in groups, talking at the top of their voices. The museum was not built with acoustics in mind. Everyone had to shout to be heard. The result was bedlam. I looked for familiar faces in the crowd and picked out several attorneys who officed on my floor. I moved towards them with Beth clinging to my arm so we wouldn't get separated. My floor mates were bellowing at each other. We stood at the edge of their circle waiting to be acknowledged. After a few minutes of being ignored we moved on. After the non-reception repeated itself three or four times, we gave up.

"Do you see anybody you work with?" Beth yelled.

"No" I screamed back, grateful the noise level prevented me from explaining I really didn't work with anyone.

"They've opened the buffet. Let's get something to eat," she shouted. I just nodded.

The food was fantastic. We heaped our plates with salads, roast beef from a huge carving station and shrimp, crab and lobster tails from a seafood table decorated with an impressive ice carving of a fish leaping from a frozen sea. We were among the first to serve ourselves. I saw that at least we'd be able to get seats at one of the tables set around the room. We headed for the nearest one and sat down at an empty table seating ten, looking forward to at least meeting the lawyers who would eat at our table. Others were getting in line, filling their plates, finding seats. No one came to our table. It wasn't obvious at first, but as table after table filled and ours remained vacant we got embarrassed.

"Let's get up and get dessert and move to a table that has people at it," Beth suggested.

We headed for one of the dessert stations. The display was overwhelming. It took us several minutes to pick three from

among the twenty arranged in tiers on the white linen tablecloth. We headed for a semi full table with our plates.

"Is someone sitting here?" I asked as we started to take our seats.

"Actually, there is. We're saving these. Sorry."

We received the same reception at the next table. At the third table Beth replied, "We won't be long. We're just having dessert. We'll leave when your friends show up," and took a seat.

"Hi, I'm Beth Nielsen, Tom's wife. And you are?"

Our involuntary companions were saved from responding by the entry of Mr. and Mrs. Reedwell, accompanied by Mr. and Mrs. McCarty. I was fascinated. Somehow, within seconds news of their arrival had flashed through the crowded gallery. People surged towards them, then made a path like the Red Sea parting for Moses. The four celebrities moved through the crowd shaking hands, patting shoulders, engaging the fortunate few in conversation. Their dinner table had been reserved. They sat down and were served pre-filled plates by the caterer staff. Their wine glasses were filled with their choice of red or white and they settled into their meals as the dance music began. Once again Beth and I found ourselves alone at our table. The others had made their way towards Reedwell and McCarty, hoping to get a shake or pat or nod. We finished our dessert and looked at each other.

"Want to dance?" I asked.

"I don't think so, thanks."

I was surprised. Beth dragged me onto every dance floor we encountered. She loved to dance. But tonight, dressed in her Ginger Rogers gown, sitting in a glamorous venue with a live orchestra, she had declined the invitation.

"Are you OK?"

"Yes. Why?"

"Because here I am in my Fred Astaire outfit and here's great dance music and you're in your gorgeous vintage gown and I ask you to dance and you turn me down. It's never happened before."

She laughed softly. "I don't think we belong here. That's all."

"Why? Aren't we glamorous enough?"

"You know what I mean."

I thought about the evening of slights. I knew exactly what she meant, but I wasn't about to let it spoil our party.

"Just wait till they see our fabulous footwork. They'll be lining up for our autographs."

Grudging laughter. "You hate to dance. You don't even know how, really."

"Just watch me."

I stood up, did a twirl and almost crashed into someone with a full plate of dessert.

"Why don't you watch what you're doing!"

Beth hooted, attracting more irritated stares.

"I'd better take charge of you before you run somebody over," she said, taking my arm and leading me to the still-empty dance floor.

"There's nobody around so we're safe."

The band was playing a slow number: Endless Love. Something my speed. I put my arms around Beth and rocked her back and forth in time to the music. That was my version of dancing. The floor filled with other couples and soon we were part of the crowd. We held each other and looked into each other's eyes and didn't have to talk to or look at anyone else. After two or three more slow numbers the orchestra broke into Celebration, the latest hit from Kool and the Gang. The fast beat made me look like a monkey.

Trip In The Dark by Kaaran Thomas

"Time to go," I led Beth from the floor.

"Good night. Good night all." She added a royal wave to all the couples we passed on the way out. A few responded, most just looked at us in puzzlement.

"What a strange bunch," she said, half to herself, on the way home.

"They just don't know us yet."

"They don't even want to know us. It's almost like they're afraid to get to know us."

The following night we were invited to a party for the University of Houston Law School Professors. Beth was a popular faculty member. The crowd of corduroy-panted, pipe-smoking eccentrics and their long-haired caftan-wearing wives greeted us warmly. I was teased by our friends about becoming a newly-minted member of the establishment.

"Where's the ice sculpture, Lou?" Beth teased Lou Muller, a new faculty member who was hosting the party, after I regaled them with descriptions of the Wainwright extravaganza over cheese dip, crackers and beer.

"Sorry, no ice trout in this house," Lou retorted. "It's not chilly enough."

"Ice trout. That's what they all are, the Wainwright people. Ice trout." Beth imitated the fish forever frozen in its dramatic leap. Everyone laughed.

'Not you, of course, Tom. " Lou said.

"You're right," Beth said. Then, because she loved playing with words, she said, "Tom's the fish out of water."

Chapter 5: The Protégé

January's misty cold had never bothered me before. In 1982, though, it wrapped around my bones. My career was in freefall—I was trapped in a gilded prison while all of Texas sank deeper into recession and other bankruptcy lawyers were raking in the great cases. If I stayed at Wainwright I would be emasculated. If I left after less than a year, people would assume the reason lay within me—that I had been fired because of some personal failure. Either way, my professional reputation was in jeopardy.

Then Jake entered my life. Actually, he entered my office. January 12, 1982. I still have my desk calendar from that month with the date circled in red. I was staring out the window, as usual, when he walked in unannounced.

"Howdy, Tom."

"Howdy." That was not what I had meant to say, really. A dozen more scintillating greetings occurred to me seconds after I had opened my mouth.

"I'm Jake McCarty."

"I know."

He laughed—a huge sound that warmed the room to its edges. He pulled up a chair to my desk and sat down, patted in his Armani jacket pocket until he felt a cigar, pulled it out with a

big smile, bit off the end and spit it on my floor and stuck the remainder in his mouth. All the while he looked at me and grinned.

During my years as a solo practitioner I had learned to evaluate potential clients very quickly. A sort of sixth sense, honed by too many unpleasant experiences with dishonest types that hang around the practice of bankruptcy, protected me from getting involved with the wrong sort of people. Lots of unsavory people thought they could use bankruptcy to hide assets or to get away with something. They assumed a one-man shop might be desperate enough for their business to facilitate or ignore their misdeeds. I was generally right, detecting and getting rid of the wrong sort looking to take advantage of me, or those who didn't respect me. It was something in the eyes, in the way they looked at you. I looked into Jake's eyes that January morning and liked what I saw. The image of those bright blue eyes of a Texas legend looking square into mine stayed with me for the rest of my life.

"You're the bankruptcy lawyer."

"I'm trying."

"You're not happy."

I hesitated. The eyes demanded a straight answer.

"Nope."

"I like you, Tom. A man of few words."

"What can I do for you, Mr. McCarty?"

"Call me Jake. I need a bankruptcy lawyer, Tom."

"My calendar is free at the moment, Jake, so how can I help you?"

He laughed again. This time it was intimate, conspiratorial. "You're the Wainwright bankruptcy insurance policy, Tom. People don't look at their insurance policy 'till they need it. Trouble is they might not know they need it."

"So is this meeting about Wainwright or about you?"

"My brother John and I invested in a ranch down in Del Rio with Sam Crutchfield. Now Sam's gone belly up. Reedwell designated you as the lawyer who can help me. This is a favor to the firm, and to me, by the way. There's no big fee in it for you."

"I'm happy to have anything to do. I'm tired of looking out the window all day. So what do you want from Crutchfield?"

"Sam wants to keep his interest in the ranch. John and I want him out. Instead of just agreeing to be bought out, Sam's claiming we tried to cheat him—making up some bullshit lawsuit against John and me. I need to stop him. Get him out. Get the property back."

"I can do that." In my eagerness to get his approval I had assumed I would be able to carry out the assignment.

After a quick look at Crutchfield's bankruptcy papers I knew I was right. Crutchfield's lawyer, Ira King, wasn't particularly bright or hard working. He was required to disclose how much he had been paid to handle the case. The amount was too small to underwrite much of a fight. That meant Crutchfield was one of his "pump and dump" clients—take their money, promise them the moon and then drop them in the dirt. He probably assumed the case would be short-lived. After all, the opponent would be Jake McCarty represented by Wainwright & Snow. We were a tank. He was a toy truck.

I was ecstatic. Aside from the chance to finally do some bankruptcy work, I had a celebrity client. In my years as a solo practitioner I represented mostly people with financial problems, not creditors. None of my former clients had been important or particularly bright. Certainly they were not prominent citizens. From the day I filed pleadings as Jake McCarty's lawyer my reputation took off like a rocket.

"You represent the Governor?" My awestruck friends tried to pump me for information about him.

"What's he like? Does he ever talk about—you know— what happened in Dallas? Will he come to court, do you think? Could you introduce me?"

My walk developed a definite swagger.

"I hope this case will settle," I mused out loud to my friends. "Jake doesn't have a lot of time to waste on it. He's a busy guy, you know"

A few weeks into the case, Crutchfield's lawyer served Jake with a notice to take his deposition.

"They want to depose you in their offices, Gov. There's no need for that. We'll make them come to us."

Jake smiled: "Why should we do that, Tom? Let's go visit them."

"Of course, if you want to, but . . . "

" But what?"

"Well, I just thought it was a little presumptuous for them to demand you go over there."

"I like to get out of the office, Tom."

"I don't want you to be at a disadvantage in this case, Gov."

"I am never at a disadvantage, Tom. Never. Let's play by their rules and see what happens."

King's office was ten blocks away in another large new building. Jake said he wanted to walk over there since it was a nice day.

On the way I tried to assure myself that Jake was prepared for his deposition. "Did you review the pleadings and documents, sir? Do you have any questions about your examination, about procedures and so forth?"

"No, Tom. "

"No, what?"

"No, I didn't review anything and I don't have any questions."

I got nervous. I had represented too many overconfident clients who went into a deposition unprepared and came out on the losing end of a lawsuit. I didn't want my famous client to end up like that.

"If you didn't have time to read everything maybe we can stall them for a day or so. I'm happy to go over everything with you and discuss deposition strategy. Remember, you only have to answer the questions 'yes' 'no' and 'I don't know'. Don't elaborate or try to remember things. If you don't remember just say so."

"Don't worry, Tom. Everything will be fine."

I worried anyway.

The fun started when we got to King's office. It had a large lobby and a security desk for visitors to check in. It was the start of the business day and the lobby was full of people going to work. By the time we got to the security desk we had attracted a crowd.

"Hey, Gov!"

"How the hail areya?"

"Great to have you here in Houston!"

"Who are you going to visit?"

"Can I have an autograph?"

Jake was holding court, signing autographs, telling tall tales with obvious enjoyment. The security guard left his post to walk us to the elevator bank. He offered to ride up with us. Jake declined and shook the guard's proffered hand. A group of six or seven fans accompanied us to the law firm's floor.

We told the receptionist we were there for the deposition. Jake smiled at her and she dropped her pen.

Trip In The Dark by Kaaran Thomas

"Could I have an autograph, Governor? My son is such a fan of yours. Me too, of course."

Jake picked up her pen and signed her memo pad with a flourish.

King came out to shake hands and take us to the deposition room. The deposition was delayed because the entire office wanted to be introduced to Jake. When it finally got underway, I realized I had nothing to worry about. Jake's memory was perfect and he anticipated every trick question. He was polite, responsive and completely devastating to their case. The deposition was over in an hour.

Since King had spent so little time in the deposition he still had some of Crutchfield's money. So he prepared to take the case to trial. Trials happen very quickly in bankruptcy cases. Ours was set for April 27. We were the only case on the docket for the whole day.

In the interim, Jake made a big fuss over me. He spread the word around Wainwright that I was a "hell of a fine attorney." People began greeting me in the elevator.

On the day of the trial I picked up Jake at his office to walk to the courthouse. Reedwell was there.

"Excuse me, Harry," Jake said jovially. "I have to go to court with a real lawyer." Reedwell looked nonplussed.

The scene at the federal building was a repeat of the deposition. We attracted a crowd before we entered the building.

"Give'em hell, Gov!" someone shouted.

"Damn straight!" Jake yelled back and the crowd cheered.

Jake had to go through the security check at the courthouse like everyone else. He removed his special belt buckle, his Rolex watch, his wallet and silver money clip and stepped through the security screen. It beeped loudly. The guard sent him back and he checked his pockets and found several silver dollars, which

he put on the security tray. Another trip through the screen set off the same beep. He took off his boots—by now the audience was laughing at every move and Jake was hamming it up. Back through the screen with the same result. Finally he patted himself down, paused, and with a big smile extracted a silver cigar holder from his inner pocket. The audience cheered as he emerged beep-free.

We had time before the hearing and Jake said he wanted us to pay a visit to an old friend. The "old friend" turned out to be the chief federal judge in Houston, a person many lawyers would have paid good money to meet. He and Jake had been law school classmates. We passed twenty minutes discussing pleasantries in his office, then ambled up to the bankruptcy court.

Crutchfield and King were already seated at their table, nervously fiddling with their papers. As we took our seats, Crutchfield walked over and gave Jake a note: "Let's settle." Jake looked up at his opponent and said, "Let's not."

The judge, Judge Clark, had read all of the pleadings and evidence before the trial. That was rare—he was famous for his lack of preparedness. He took the bench and immediately announced that in his opinion Mr. Crutchfield did not have a case. Mr. Crutchfield was welcome to waste everyone's time but the Court hoped this would not be necessary. King immediately rose and, without consulting his client, announced he would regretfully accept the Court's judgment. Crutchfield's eyes flew open and his lips, formed wordless "O"s, like a fish out of water. King ignored him, packed up his papers and turned to leave.

"Are you coming?" he asked his client.

Crutchfield staggered out after his attorney.

After the losers left the courtroom, the judge's clerk asked if we could come back to chambers. There, over coffee and cookies, Judge Clark spent twenty minutes discussing how he would

like to be considered to fill the vacancy on the federal district court bench that would open up in the fall when the senior judge retired. He wasn't suited to be a bankruptcy judge, Clark complained. He needed a lifetime appointment and bankruptcy judges' terms were only seven years. Jake nodded sympathetically and said we must be getting back to the office.

"I've never seen Judge Clark come out and rule against someone without even taking evidence," I commented on the way back.

"You did a great job with the papers, Tom. And Crutchfield clearly had no case. And besides, Clark wants me to recommend him for the next opening on the federal bench."

I loved the first parts of Jake's analysis. The last part about Clark troubled me. It inferred that Clark had made his ruling in exchange for an expected favor. That was clearly illegal. My concerns were buried when we reached Jake's office and he announced my great victory to the lawyers in our lobby. He omitted the part about Clark's federal ambitions.

In the space of four months, my work with Jake had brought a huge improvement in my position in the firm. I was no longer a tolerated intruder. I was Jake's lawyer. But the payoff got much better.

During our drives to Austin to meet with Jake's brother on the Crutchfield case, I had tried to educate Jake about my chosen profession.

"Tom, you sure as hell like to talk about bankruptcy," Jake laughed.

"I guess I do ramble on," I apologized. Jake would just nod. But he never told me to stop.

By the time the Crutchfield trial ended I had shed my stigma in the firm and had gotten involved in several other matters. My new status was partly attributable to the compliments Jake

had so generously paid me, but it was also true that the economy had reached a point where Wainwright had to acknowledge my existence. Several partners had come by my office with questions that led to my involvement in their clients' financially troubled businesses. The Houston business community was awakening to the possibility that the recession was not just a blip, it might have lasting effects. They wanted advice on how to protect themselves and I was the only Wainwright lawyer able to provide it.

I hoped to be able to work with the Gov again but I didn't really believe it would happen, any more than I put credence in Jake's occasional comments that, despite my lowly status at the firm, I would "make partner" before my fortieth birthday. I learned through the grapevine he was incredibly busy traveling around the country and even overseas on Wainwright's behalf, bringing in substantial new business clients.

So I was surprised when Jake came into my office unannounced one afternoon. "I'm bringing the Indian Minister of Agricultural Affairs to Wainwright. India's going to do a five-year, multi-million dollar rice contract with American Rice and First City National Bank will back the contract. You'll need to take a look at the deal."

I laughed. "I've been trying to get Reedwell to let me look at the bank's deals for months. I might as well ask to explore his private parts."

"You'll look at this one, the Minister will demand it. They'll want a bankruptcy opinion from Wainwright." When he saw my puzzled look he explained. "That would be a formal letter giving Wainwright's opinion regarding the legal consequences to this deal if American Rice had to file for bankruptcy. I'll put the bug in their ear. Wainwright specializes in opinion letters, they analyze tax consequences and securities law issues for clients. Now they'll analyze bankruptcy consequences. It's a natural for them."

31

Trip In The Dark by Kaaran Thomas

Jake looked at me and grinned. He pulled a cigar out of his jacket pocket and offered it to me. I shook my head.

"You did it," I said. Jake hadn't forgotten about the partnership prediction, or about me and all those bankruptcy discussions we had. I learned, for the first of many times, that he seldom forgot anything, including his promises. While he listened to my bankruptcy lectures he was figuring the best way to take advantage of my expertise.

"Did what?" He smiled. "That's why Congress passed this new Bankruptcy Code you've been talking about, isn't it? Bankruptcy's not criminal anymore. It's a—a 'business restructuring tool.' And there's big dollars for them that know how to use it. And you do. So Wainwright should use you. Right?"

"Right. But there's no such thing as a bankruptcy opinion, Jake."

He leaned towards me, "There is now, Tommy. Hell, we just invented it!"

Jake smiled a happy smile and waggled his cigar in triumph.

Chapter 6: My Opinion

The Indian rice deal was my chance to get in on the First City National Bank business and show Reedwell how profitable bankruptcy could be. My bankruptcy opinion would be reviewed by both First City and the Indian Government. The bank hired me but they would pass along my fees as a charge to the Indian Government. I worked for days outlining a bankruptcy opinion, using one of Wainwright's tax opinions as a model. Jake asked to see the draft. I showed it to him with some hesitation, a little concerned about what he would think. He read it carefully and asked if he could make suggestions. As we discussed the details of the opinion I realized he was brilliant in a way I would never be. As a former Secretary of the Treasury he brought insight into the international implications of bankruptcy; the difficulties that arise when one of the parties to a deal is a foreign government; the intricacies of foreign exchange rates and several other issues I would never have been able to identify on my own. During the week we worked together to finalize the opinion, I learned more about business than I had in all my years of law school.

Jake was a wonderful teacher. He was never demeaning, always challenging and complimentary and funny. He posed the questions and let me find the answers myself, so that in the end the opinion letter was mine—a product of a week-long crash

33

course in international finance I would gladly have paid a fortune for. But it was free. Actually, I got to bill the whole week.

On the day I was to present the opinion letter to the bank I was a nervous wreck. I had only slept about thirty minutes the night before and hadn't been able to eat much for several days. Beth forced some breakfast into me and made me wash it down with black coffee.

"You come right home after it's over and get some sleep," she scolded.

The presentation was in the main conference room. Jake had told me to bring my business cards, hand them out to everyone and sit at the head of the conference table. When I arrived a group of seven bankers and three other Wainwright lawyers, including Reedwell, were already gathering. Reedwell introduced me and I handed out my cards. I got seven bankers' cards in return. Jake had taught me a memory trick—arrange the cards in the order the bankers are sitting, beginning with the one on your immediate right. Use the cards to help remember each person's name.

As we took our seats, I worried about Jake's absence. Reedwell took charge of the meeting and attempted to outline the business opportunities that could come from backing a deal with the Indian government. He was clearly nervous. I could tell the bankers were getting bored. I was looking for a polite way to cut in when the door opened and Jake walked in. He apologized to the group and, without a word to Reedwell, took control of the meeting. The atmosphere electrified. Jake explained the deal in a few clear, stimulating sentences. Then he nodded to me.

"Mr. Nielsen is a bankruptcy expert. Wainwright is the first major firm to anticipate the implications of the current recession. We hired Mr. Nielsen to address the economic problems we expect you'll be facing in the next few years. It's essential, of

course, for our clients to be able to identify and anticipate the possible insolvency of the people they do business with; just like they plan for the tax consequences of a deal. That's what makes Wainwright the best law firm in Texas. We're ahead of the curve. We develop solutions for tomorrow's problems. Mr. Nielsen has prepared a discussion draft of an opinion letter to be provided to the Indian Minister of Agriculture that identifies the insolvency issues involved in this deal. This type of letter—a bankruptcy opinion—shows that Wainwright has looked at any problems that might arise if American Rice were to become insolvent or have to file for bankruptcy and has structured the financing to protect the bank and its client, the government of India, should that occur. You need to sign off on this before it's sent to the minister. I'll let Mr. Nielsen explain the details."

With that he turned the floor over to me. I was a little hesitant at first, but warmed to the topic as the bankers asked questions. The discussion took off, with the other Wainwright lawyers—the experts in international affairs and banking—contributing to the presentation and Jake adding his unique insights and suggestions. Two hours later the meeting was over and the opinion letter on its way to final draft. We rose and I shook hands with the bankers. I expected them to leave, but several stayed to ask me about some of their other deals. Jake and Reedwell and the other attorneys left, but another hour passed with the bankers asking about problems with their borrowers, and me suggesting a bankruptcy audit of their largest loans. I also passed along basic tips on restructuring troubled loans. David Ward, the Executive Vice President for Credit, asked if I could give a series of lectures on bankruptcy issues for their loan officers.

I couldn't resist telling Reedwell.

"Interesting," he mused. "I suppose we can accommodate that sort of thing."

Within a few weeks I had become recognized as the leading bankruptcy expert in Houston.

This was a new Wainwright reality. I called Reedwell's secretary to arrange a meeting to discuss staffing of the bank audits. I was immediately put through to his Presence.

"Good morning, Tom. I'll be meeting with David Ward today to discuss the bank audits."

"That's great, Harry. I think we need to . . ."

"Don't worry about it, Tom. I'll take it from here."

"I really think I need to be involved, sir. I know what to look for, what type of attorney would fit the bill . . ."

"We'll definitely coordinate with you. I'll call you after the meeting."

My first reaction was to call Jake. Then I realized I needed to learn to handle my own problems. "What would Jake do?" I asked myself. I retrieved Ward's business card, dialed his number and got his secretary.

"This is Tom Nielsen. Could I speak with Mr. Ward?"

"Let me check."

Ward picked up a few seconds later. "Hey, Tom. How are you?"

"Good morning, David. I'm fine. I wanted to follow up on our audit idea."

"Your timing is good. Reedwell and I are meeting this afternoon."

"Wonderful. I'll prepare an outline of what should be reviewed, the procedures and so forth. You can use it for the meeting."

"Great."

"I'll bring it over in an hour or so." Ward's office was on the sixth floor of our building.

"OK. See you then."

I put all my calls on hold and pushed out a ten-point check-list. It was simple for someone who was used to dealing with loan defaults, but not something Reedwell or Ward would think of. I walked it to Ward's office and asked if I could see him to discuss it. His secretary was explaining that he was about to leave for a meeting when the door opened.

"Oh, hi, Tom."

I handed him the memo.

"Should I just leave this with your secretary?"

"Actually, I'm on my way to a credit committee meeting. I should probably take this with me."

He read the memo.

"Hmmm . . . very interesting. Very concise. Good work. Barb, can you make me ten copies of this?"

I had put my phone number at the top of the memo. I told him to call me if there were questions. An hour later my phone rang. It was David.

"Tom, the Committee had some questions about your memo. Could you come down to the meeting? We're on the eighth floor in the conference room."

"On my way."

By the time Reedwell met with Ward the audit process was firmly in my control.

"I wonder why we never discussed this idea before?" David mused as we returned to his office.

"Times have changed, David. Banks haven't had to worry about these issues 'till recently. But Wainwright is ahead of the curve on this, as Jake said. They're the only big firm to hire some-one like me."

"A great decision, I might add. But does Reedwell really understand the problems . . . what these audits are supposed to accomplish?"

"He's going to rely on me for that. He'll help me allocate the manpower. With your input, I'm sure."

Reedwell called me after his meeting.

"I understand you met with Ward and the credit committee this morning."

"I assumed you'd want me to help them understand the issues before you discussed staffing."

Reedwell paused. I could almost hear his brain weighing what to say next. I was pleased. Whatever had happened between him and Ward had been good for me. Reedwell had realized he couldn't just run over me.

"Could I make a suggestion, sir?"

"What?"

"I think we need to form a subcommittee of the banking group. You've never attached me to a specific practice group. Maybe now's the time? Our little subcommittee can start with the lawyers you identify for the audit team. Perhaps wrap in some folks from corporate, oil and gas and real estate? This could be a consciousness-raising opportunity. We can market the group to other clients."

"And I suppose you think you should head up the subcommittee?"

"Who would you propose?"

"Let me think about it."

In the end, Harry reluctantly formed the "Interim Bankruptcy Practice Subcommittee" and with even more reluctance, appointed me as its "interim chair." I was the only committee chair who was not a partner.

Chapter 7: Teacher

National economists said the recession ended in 1982; but that year was the beginning of Texas' problems. By 1985, Houston was experiencing record unemployment and unprecedented loan defaults. Savings and Loans were failing at a dramatic pace. As the price of oil sank to twenty-seven bucks a barrel, all the leveraged business deals cratered. The crash affected housing, office buildings, fine art, shopping centers, restaurants—every aspect of Houston's economy. Whole neighborhoods went dark as homes were foreclosed. New office high rises became "shotgun buildings"—so empty a bullet could pass through without any risk of hitting someone.

My bankruptcy practice committee (people quickly dropped the "interim") had expanded to include the heads of all Wainwright's practice groups. I was honored when Reedwell instructed me to give weekly brown bag lunch sessions to the firm's leaders. Then, when they all walked into the first lunch with their own dog-eared copies of the Bankruptcy Code, I realized they had tried and failed to learn the intricacies of bankruptcy law and practice for themselves. They only called on me after they realized they needed my help.

An interesting dynamic was taking place in the firm. The business lawyers were out of work because all the business deals

39

had dried up. The banking lawyers were out of work because none of the surviving banks were making loans. The only type of work available was litigation, tax and bankruptcy. So partners in the formerly prestigious business and banking sections were joining my interim subcommittee and trying to remake themselves into bankruptcy lawyers. I had to laugh, remembering my solemn unwritten promise to Reedwell that I wouldn't try to become a banking or business lawyer. I should have asked for a reciprocal agreement.

After a few months, members of my subcommittee convinced themselves they could take on bankruptcy cases without my help. That is, until they did something wrong. When their deals fell apart or they were in danger of being sued for mishandling something they would come to me, sheepishly asking for my "suggestions." At first I gave them help willingly, figuring it was a way to gain friends among the partners. Then Jake pointed out that the people I was helping never gave me any credit— monetary or otherwise.

"Your advice is worth what they pay you for it, Tom. Stop giving it away free and they'll respect you. Right now they're just using you."

"I'm really busy right now, Joe," I said to the head of the real estate section the next afternoon when he came to "get a quick impression" on a complicated real estate workout. "Why don't you send me a memo about your issue and a billing number so I can prepare a proper opinion?"

Joe stomped out upset but he sent me the memo and the billing number. I stopped giving free advice.

"What's your billing rate, Tom?" Jake asked one afternoon.

"Two hundred an hour," I replied. That seemed like a lot to me.

"Hell, the partners are billing three and four hundred an hour for their time and all they're doing is repeating what you tell them. I'm going to get them to raise your rates."

In no time, I was billing at three hundred dollars an hour.

At my suggestion, David Ward arranged for me to conduct classes for the First City National Bankers. Soon I was being asked to speak at bankers' conferences. At first I refused. I was working sixty-hour weeks. But by then, even Reedwell saw the business I was bringing. He insisted, so I gave in. The banker seminars turned out to be an excellent business development tool. When I answered their questions I learned about their deals. They often stayed after the seminar to ask more questions about a particular loan. A few days later the loan file would appear on my desk as a new matter.

Beth's teaching career had also taken an interesting turn, which earned her the nickname "Dragon Lady." She had always been tough and demanding on her students and a vocal supporter of professor's rights at university meetings. But her reputation took off when she spoke on a prestigious panel at the State Bar Convention in Houston. I didn't think I'd be able to attend, but at the last minute I had a chance to pop over to the auditorium to catch her presentation. Her panelists included a famous trial attorney and a federal judge. The judge dared to contradict Beth's opinion on a particular topic.

"That's ridiculous," Beth snapped. The audience gasped. I cringed.

Beth was undeterred, cross-examining the startled jurist on the basis for his opinion until he was reduced to an embarrassed mumble. I watched, holding my breath, from the back of the room.

The trial lawyer (fortunately not from Wainwright) interrupted the fiasco, attempting to distract Beth.

"Little lady, you'd make a great addition to our firm."

"Really?" Beth replied sarcastically. "Then why did your firm tell me the only way they would hire me was if I agreed to work for half the salary you pay male attorneys?"

"And don't call me little lady," Beth added.

Laughter rippled through the audience. Beth's co-panelists were obviously angry and embarrassed. She appeared not to notice. After her presentation, she greeted friends and responded to comments from the attendees. I decided to leave without making my presence known.

That night I told Beth I had seen the presentation.

"Why didn't you come up and say 'Hi'," she said. "Did I embarrass you?"

"Of course not!" My denial sounded a bit artificial.

Well—the audience loved it! I got two invitations on the spot! The State Bar likes to have lively presentations. I'm going to speak in Austin next month and Dallas after that.

"If only I could be as forthright as you," I said, wistfully.

"You can, sweetheart," she laughed, "but you'd have to quit your day job."

Chapter 8: Their First American Bank

The Kennedy conspiracy first oozed into my life like crude oil from "pay dirt," just as I was beginning to become important at Wainwright. At the time I had no idea of what was to come. I was concerned with my future, not with Jake's past. The formation of my bankruptcy subcommittee, the increasingly profitable bank work and the confidence First City executives placed in me had impressed everyone—even our managing partner.

One morning I received a call from Reedwell's secretary: her boss wanted to see me in his office at ten sharp. He greeted me at the door, clearly excited about something.

"Tom, we have a wonderful new opportunity with a potential client, First American Bank, and I'd like you to join me on a conference call. This is a relatively new bank that's headquartered in DC. Their chairman is a former Secretary of Defense, Clark Clifford. They're being pursued by all the big East Coast law firms but they heard about us and want to give us a shot at representing them."

"That's great, Harry. Why do they want to talk to me?"

"Apparently they loaned money to a real estate developer in the Washington area and he's just filed for bankruptcy. Seems he borrowed from lots of banks and those other banks have already locked up the good East Coast law firms for themselves.

43

They don't want to share their lawyers with First American. There's a meeting in DC next week for all the lenders, to try to develop an exit strategy, see if there's a way to cooperate with each other to minimize their losses. Any thoughts?"

"It sounds like a real opportunity. I'd like to review the developer's bankruptcy files, see what his assets and liabilities are; review his financial statements."

Harry interrupted me. "I can see you're the man for the job, Tom."

I was about to ask how I could get the files when Reedwell's secretary announced the conference call with First American representatives. I learned at that moment that I would have no chance to review the information before getting involved. I'd have to wing it.

As it turned out my lack of preparedness didn't matter. The bank was desperate to find representation. They needed to get ready for the bank meeting and were out of time. The following Monday I was on a plane to DC.

I stayed at the Mayflower Hotel where the meetings were to take place. On the plane trip I studied all the material I could gather for this important assignment. It turned out the developer, Mario Antonini, was quite a character in the Washington area. In fact, he was a part owner of the Mayflower Hotel. Antonini had made his fortune building and managing parking garages. Unfortunately, he used the revenue from his garages to acquire real estate in Washington and surrounding suburbs; making small down payments and borrowing the remainder of the purchase prices at high interest rates, expecting to quickly flip his acquisitions for a profit. He made millions when the real estate market boomed; then over-expanded and over-leveraged his business empire until it crumbled under a load of debt when the bust came.

I had read as much as I could find on First American Bank. There had been quite a few reports about the bank when it was first chartered. The Treasury Department had enacted strict regulatory barriers designed to insure accountability and prevent criminal elements from infiltrating America's banking system. First American Bank had passed the regulators' scrutiny with flying colors. One of the reasons was undoubtedly the presence of two distinguished Americans on their board. The first was Clark Clifford. He had been President Johnson's Secretary of Defense and continued to serve as a distinguished advisor to many other presidents. The second was Benjamin Lanier, financial advisor to former President Jimmy Carter, a man known for his integrity. The bank had opened three years earlier and its performance had been stellar—the Antonini affair was the only black mark in an otherwise sound balance sheet. The bank played up its connections to prominent politicians with its symbol, an American flag, and its slogan: "A Bank For All Americans".

I arrived late Monday afternoon, finished reviewing my material and called Beth to check in. I awoke Tuesday feeling refreshed with not a trace of jet lag. I was excited to be part of the Washington scene and looked forward to delving into the details of the Antonini case. I decided to have breakfast in the hotel restaurant rather than ordering room service. My first meeting with the bank was at ten so I had time for a leisurely meal. The elevator doors opened to a lobby buzzing with conversation. I made my way to the restaurant and picked up a copy of the Washington Post at the hostess station. I took my seat, ordered breakfast and opened the paper to a banner headline, "First American Bank Involved In International Scandal."

The article contained pictures of Clifford and Lanier and a third gentleman, a Saudi named Armand Baijan. It detailed how regulators had been duped by the Bank of Credit and Commerce

Trip In The Dark by Kaaran Thomas

International known by its acronym, "BCCI", an international criminal enterprise run by Mr. Abedi, a Pakistani, and a group of Saudis led by the Baijan family. It was engaged in money laundering and worse. The article contained three pages detailing BCCI's history and evolution from a small Pakistani bank to an international conglomerate involved with arms trading, international drug rings and dictators from Saddam Hussein to Manuel Noriega, the drug-smuggling Medellin Cartel and terrorist Abu Nidal.

BCCI had a clandestine division—the "Network," which functioned as a global intelligence operation and a Mafia-like enforcement squad. Operating out of the bank's offices in Saudi Arabia and Luxembourg, the Network used sophisticated spy equipment and techniques, along with bribery, extortion, kidnapping, torture and murder.

BCCI had allegedly acquired First American Bank using Clifford and Lanier as straw men, shielding its actions through use of prestigious legal and accounting firms and politically well-connected representatives.

The plot had been uncovered quite by accident, by a CIA agent in South America. As part of his investigation of the Medellin Cartel, he interviewed a banker in Columbia who told him BCCI was in the process of acquiring their "first American bank" in Washington DC. The banker boasted that prominent American citizens were acting as front men. Allegedly, BCCI loaned these Americans the money to buy stock in First American, with the shares pledged as collateral, like home buyers give mortgages to their lenders as security for a home loan. The stock loans, however, were "nonperforming." They weren't being repaid. Apparently the loans were also "non-recourse," meaning Clifford and Lanier had no personal liability on the loans—the only source of repayment was the First American stock. Neither man had disclosed the details of the financing to the regulators. Foreclosure

was a certainty. BCCI got the straw mens' stock and the owner-ship of First American without anyone knowing about it.

A secret investigation had been underway for months and the Department of Justice was being asked to issue warrants for the arrest of several members of the Baijan and Abedi families, al-leged ultimate owners of BCCI. Meanwhile the Treasury Depart-ment was interdicting the transfer of all funds into and out of First American. The bank's doors were closed.

I got up slowly, folded the paper under my arm and head-ed for my room.

"Sir." A waiter grabbed my shoulder. I hadn't heard him calling after me about paying my bill. "You have ordered your breakfast. You can't just leave. You need to pay please."

"Oh dear, I'm so sorry. I have an emergency. Can you charge the breakfast to my room? I mean, the whole thing. It doesn't matter what I ate."

"Yes, sir," the waiter was still suspicious. I signed the charge slip and gave him a big tip and he left mollified. I felt even more like a criminal conspirator. On the way to my room I decid-ed there was only one thing I could do. I called Jake.

"What the hell was Harry thinking?" Jake exploded when I told him the story. "There's only one reason the big East Coast firms wouldn't take this case—they got wind something was up. They knew to stay away. We've been set up."

"What should I do?"

"Come home. Now. Catch the first plane out of there."

"But I need to talk to Harry. He has no idea what's going on."

"I'll talk to him. You change your reservation and cancel your hotel."

"What about the bank meeting?" I was still hoping that somehow I could play a role in the Antonini bankruptcy.

"If you go to that meeting your name and ours—Wainwright's—will forever be associated with this thing. We'll be the laughingstock of DC. Get the hell out of there."

I told the hotel I had a personal emergency that required me to get back home as soon as possible. They were sympathetic. They even helped change my return flight.

Jake came to my office the next day.

"I'm glad you got out of there, Tom. That's a bad situation. The Baijans are a bunch of criminals. It's hard to believe they were able to reach into our banking system. We've been aware of them and their network since I was Secretary of Treasury."

"This will bring them down," I predicted.

"Don't be so sure," Jake said. "They've been involved in lots of crimes and scandals and they always manage to escape. They tend to leave others holding the bag. Poor Clark. He must be going through hell."

That same afternoon, I was called to Reedwell's office to discuss what had happened. Jake was already there.

"How can we make sure our name is not associated with this matter?" Reedwell was asking Jake as I walked in.

"Who knows we were hired?" Jake asked.

Harry fiddled with the papers on his desk, refusing to look directly at Jake.

"I told quite a few people."

"In the firm?"

"At the club."

"Christ. What did you say?"

"That we had a big new case in DC."

"Did you mention First American Bank?"

"I may have."

"Shit. Did you tell them we were representing the bank?"

"I think so."

"Shit."

"How was I to know, Jake?" Harry's face was red. He kept looking sideways at me. I realized I should probably excuse myself but the opportunity to witness Harry's comeuppance was irresistible.

It was the first time I had ever heard Jake curse. He did it repeatedly on that day, which should have tipped me off that something extraordinary was going on.

"Okay. Okay. You're right. The worst that can happen is that people around here will know we got taken for a ride," Jake continued. "Probably no big deal. Unless it gets past your friends at the club. Did you tell anyone else?"

"No."

"Who at the bank knows we were hired?"

"I talked to one of their in-house lawyers."

"How did he learn about us?"

"Actually, he said he was referred to us by Clark Clifford, a friend of yours."

As if on cue, Reedwell's secretary buzzed him.

"I told you we were not to be disturbed."

"It's Mr. Clark Clifford, sir. He says he's been trying to reach Mr. McCarty all day. Mr. McCarty's secretary transferred him here."

"Shit." Jake's cursing became louder. He got up and paced the room.

"Put him through. Tell him I'm in a meeting with our managing partner discussing this case."

Clifford came on the line.

"Jake, I'm so glad I reached you. I'm in a big mess here . . ."

Jake interrupted him. "Hi, Clark. I'm here in

49

Harry Reedwell's office with Tom Nielsen, the bankruptcy lawyer who was going to represent First American in the Antonini case. We were just discussing the case. Quite a shock."

"Greetings, everyone. Yes, we were shocked as well. Jake, I wonder if you and I could talk privately."

"I really can't discuss this case with you, Clark. We're in a pretty difficult situation here. Apparently we got hired because of a reference from you. We had no idea who was involved."

"I didn't know either, Jake. You have to believe me."

Jake just scowled into the phone.

"We don't know how big the investigation is going to be, or whether our firm will be damaged because of this. I'm sure you can appreciate our position."

"I'll do everything I can to protect you, and your firm. You have my word on that."

"For starters, Clark, you can find whatever paper trail there is that connects us to First American and get rid of it."

"That will be very difficult, Jake. The investigators have closed the bank. I can't even get into my own office. I really need to speak with you privately."

"I need to finish my meeting here, Clark. I'll give you a call. Where can I reach you?"

Clifford gave his contact info and Jake signaled for Harry to end the call.

"What could he want from you, Jake?" Harry asked.

"No idea. Possibly a referral for a good criminal defense lawyer in DC."

I couldn't believe that was it. Clifford must know every law firm in the capital. He had been an insider since his days as Secretary of Defense in the Johnson administration. Suddenly I realized the tie between them. They must both have been friends of

Johnson. I wanted to ask questions, but one look at Jake's face killed the idea. He was clearly distracted, heading for the door.

Later I asked him casually if he was able to help Clifford find an attorney.

"What?"

"Remember, he was going to call you to get a referral? Too bad our firm couldn't handle the case."

Jake laughed out loud. "That's rich." He said to himself.

"Did I say something funny?"

He looked at me like he had forgotten I was there.

"No, Tom. Sorry. It's a private thing."

The First American Bank scandal was headline news for weeks. As Jake had predicted, the government convened a grand jury. Clifford and Lanier were indicted based on their own admissions regarding their failure to disclose the terms of their stock purchase. The bank was closed. Indictments for the alleged perpetrators were not forthcoming, however. The agent who had uncovered the plot, the star witness, disappeared before he could get out of Columbia, along with all the evidence he had collected.

Chapter 9: Hypothetically Speaking

Fortunately, Wainwright was never contacted by the authorities and their name didn't come up in any of the publicity surrounding the scandal. I soon had other, bigger things to worry about, though. I began getting signals that Jake was in financial trouble. The first sign came as a result of my banker seminars. One of the bankers stayed after the seminar to ask about a real estate loan that had gone into default. I was in a hurry, so I asked him to just send the file over so I could review it and get back to him. He was embarrassed.

"Actually, we are going to send this to another firm. I was just trying to get your opinion on an informal basis."

"Why would you send the loan somewhere else?" I asked.

"Well, actually, it involves one of your partners."

"If he's defaulted on a loan maybe he shouldn't be a partner," I joked. Then I realized my mistake. The banker turned scarlet and looked down.

"I doubt that would happen, Tom. The borrower is one of Mr. McCarty's partnerships."

I realized I had probably said too much, so I said I had to get back to the office and left as fast as I could.

I went straight to Jake's office.

"Jake, I was teaching one of the banking seminars and a First City loan officer said one of your partnerships' loans was in default. Is everything all right?"

"Nothing to worry about, Tom," Jake replied. But I could tell he was perturbed at my discovery. "I'll get it taken care of in no time. It's just a snafu."

I suspected something more serious. I kept my ears open when I was at the bank, trying to pick up information on Jake's loans without letting on. It wasn't hard to do. Jake's financial problems were growing. Bankers would stop talking when I walked into a room and look at each other nervously. Then one of them would ask a "hypothetical question." I tried to select a hypothetical answer that would be the least harmful to Jake but the process made me nervous.

"Tom, hypothetically speaking, if a person has guaranteed a loan secured by commercial real estate and the value of the real estate has declined almost fifty percent, should the bank try going after the guarantor, even if the guarantor is a prominent person? Even if the bank might get some political flak for filing a lawsuit against such a prominent Texan-er-person?"

"Well," I would answer thoughtfully, "the decision to sue a guarantor should depend on what the bank feels is the best way to collect on its loan. For example, suing a guarantor might be seen as an election to abandon the real property that secured the loan. And the guarantor might be having their own problems, so I would suggest, hypothetically, that the bank try to work with both the guarantor and the owner of the real property to develop a plan to work out the debt in the most efficient and least confrontational way. And remember, property values are low right now. If the bank forecloses they'll probably have to book a loss. On the other hand, the value's likely to go back up at some point; so if you can work with the borrower and guarantor, stretch out the

loan, get some minimal payments, get them to pay insurance and carrying costs, you can wait 'till the economy improves. Hopefully that type of strategy will also minimize the bank's exposure to any flak, as you called it."

After several weeks of these sorts of hypothetical questions, I did something I would have considered unthinkable a few years earlier. I went to see Reedwell. He was the managing partner of my law firm, after all. It was up to him to decide how to handle disputes between our largest and oldest client and our most famous partner.

"May I ask what this is in reference to?" Linda responded to my request with the same hauteur she had exhibited at my first interview.

"It's about Jake McCarty and it's very, very urgent and confidential," I replied and was rewarded with a look of shocked submission.

"He happens to be in right now. Let me buzz him to see if he can make room for you."

A minute later I was seated before his Presence.

"What's this about McCarty?" Harry inquired cautiously.

"You mean you don't know about Jake's loans with First City," I responded.

"Of course. Of course I do but I didn't think it was common knowledge, Tom."

I repeated some of the so-called hypothetical questions that had come up in my seminar.

"Who asked those questions?" Harry wanted to know.

"Some of my students, I don't really remember who." I knew exactly who was asking the questions but didn't want to get my banker students in trouble.

"Well, tell them to lay off Jake. Hypothetically, of course."

"I can't do that, Harry. I try to give the advice that will be most helpful to both Jake and the bank but in the end I have to protect the bank, don't I? They are our client, after all."

"Hell," Harry replied. "I thought you were Jake's boy."

"I'm a loyal friend of Jake McCarty, sir, but I'm also an employee of this law firm so I guess that makes me the firm's boy."

"So what do you propose, Tom?" Harry looked at me closely.

"I propose we do what I suggested the bankers do—try to find a way to help Jake solve whatever financial problems he has. We can't represent him, though. And we can't represent the bank either. I guess you know that. We have an irreconcilable conflict of interest."

"Damn!" The word exploded from Harry' lips. I wasn't sure if Harry was cursing Jake's problems or our loss of the bank's business.

"Sir?"

"I can't believe we're in this position. Jake is a powerful man. He has very influential friends. I can't believe the bank is even thinking of pursuing him. I never thought it would come to this. Surely his political connections can get him out of this mess and we won't have any lingering issues."

"I have no idea how serious his problems are," I said skeptically. I remembered, though, the scene in Judge Clark's chambers after the Crutchfield hearing. I wondered exactly how far Jake's political connections could carry him—how much financial difficulty they could save him from.

"I just need to know what to do when the bankers ask those kinds of questions," I carried on. I had come looking for answers, not more questions.

"I'll let you know, Tom. I'll have to consider this." Harry picked up a document and began reading it—a sign the interview was over.

The problem wasn't over, however. Harry didn't try to develop a solution. He went to Jake immediately. It was Jake who came to see me.

"Howdy," he announced himself at my door less than three hours after I had departed Harry's office. "Have time for a chat?"

"Of course."

Jake came in and closed the door behind him. He looked at me with a half-embarrassed smile.

"Harry came to see me. I understand you're getting hypothetical questions about me from the folks at First City."

"I'm sorry, Jake."

"Nothing to be sorry about, Tom. It's not your fault. Hell, I did it to myself, I guess. I've gotten into a liquidity problem. Too much money tied up in real estate projects no one wants to buy or rent. I'm trying to work it out."

"You need to meet with the bankers, Jake. Let them know you're working on a plan. Don't keep them in the dark. That's never a good strategy. It makes the bankers nervous. And when they're nervous and uncertain they're likely to do irrational things. They're acting out of fear. Everybody's terrified these days."

Jake tipped his chair back on its hind legs and surveyed the ceiling for a minute. I wondered how he would react. I suspected he was facing a serious financial crisis. Most people I had worked with in these situations went into a state of denial. They expected things to get better; somebody to come along and bail them out; some dramatic occurrence to save them. All they had to do was hold on. That type of attitude usually resulted in a disaster. I

could only hope Jake was different. He was so much more intelligent and experienced than any borrower I had ever known, after all. I waited.

"First thing we have to do is protect you," he said, thoughtfully. I was shocked. I couldn't believe Jake would be concerned about me at a time like this.

"You need to stop giving those seminars. Stop the free advice. Didn't I talk to you about that before? Don't give your advice away, especially where it involves one of your partners."

I just listened. Jake had a way of circling around problems and making it appear as if it was in your best interest to do what he wanted. I was afraid where Jake was going with his expression of concern for my billings.

"From now on, Harry can be a conduit between you and the bankers. You can give the hypothetical answers to him. He and I will talk about what to do."

"No." I couldn't believe I had to defy both Jake and Harry. The office was dead still for a minute.

"What do you mean?" Jake asked, finally. He clearly believed my response would be different.

"I mean, I can't give indirect hypothetical advice to you any more than I could to the bank. For one thing, any hypothetical advice could be disastrous. The hypothetical question is never complete and the missing facts could be critical. How would I ask clarifying questions to Harry? There's too much chance for miscommunication. And, besides, regardless of which Wainwright partner the advice comes from—Harry or me—it's still advice and we can't do that, Jake."

Jake was watching me closely, appearing to weigh what to say next. I decided to make the pill easier to swallow by volunteering to comply with half of his suggestion.

"I do like the idea of discontinuing the seminars, though. I have way too much to do anyway. And they're obviously too likely to lead to problems."

"That's a good idea," he agreed too readily. "That way you'll get out of the middle of this thing. I'm sorry to drag you in."

"I owe you a lot, Gov. I would do anything to help. I'm just so sorry that I can't do it. I can refer you to a very good attorney who is experienced in workouts and bankruptcies . . ."

Jake recoiled. "Bankruptcies? What the hell are you talking about, Tom? I'm not going to go BK as you guys call it. That's not gonna happen. Jesus Christ!"

"That's not what I meant. I was talking about your partnerships. Not you. They need advice on how to work things out with the bank in a way that will give you maximum protection and leverage."

He relaxed visibly. "Oh, Jesus, Tom, I thought you meant me. You scared me for a minute. Of course, the partnerships will need representation. They just need to buy time until this economic problem works itself out. Hopefully we can stall for a couple of years."

I had meant Jake, of course, but I couldn't let on. He was clearly in denial. He displayed all the symptoms. I put him in touch with the best bankruptcy attorney in town next to me. On paper the lawyer was representing Jake's various partnerships but he was also trying to help Jake. I had a very off–the-record conversation with him, sharing my fears. He was unbelievably grateful for the work and promised he would keep me informed without letting Jake know. I knew our agreement was in and of itself a breach of professional ethics but I couldn't let Jake go. I was way too worried about his future. And mine, for that matter. He had been my mainstay in the firm. His reputation, like his fate, was inextricably linked to mine.

I stopped the bank seminars, pleading too much work. For a year I kept informed about Jake indirectly through my friend. Jake and I continued to work together occasionally but our relationship had clearly changed. It was more formal, less intimate. And we never discussed his personal issues.

In a way, I felt left out. I had introduced Jake to bankruptcy law and he had taken me under his wing. Now he was going through serious personal financial problems and I was no longer "Jake McCarty's lawyer."

As the year came to a close, my friend's reports about Jake became more grim. I stood by helplessly as Jake's lenders demanded that he pay on his personal guarantees and threatened to file lawsuits. Other creditors were also causing problems. Jake had made a run for president in 1980. He had financed his presidential campaign with personal loans. He owed for the food and liquor served at some of his big fundraising dinners. He thought of the people he owed as "donors" to his campaign but they didn't feel the same way—not after he lost to Ronald Reagan. They were filing lawsuits against him and the accusations weren't pretty.

According to the complaints, Jake had left a trail of unpaid bills all across Texas. Some of his creditors were small ranchers. One cattle rancher had provided a dozen beefs for a big fund raiser. He was furious when he learned that Jake had bought several expensive Santa Gertrudis cattle but had stiffed him for his beefs. The lawsuits were damaging Jake's reputation as well as his finances

Chapter 10: Exposed

A cartoon of Jake graced the cover of the January, 1987 edition of Texas Monthly Magazine. Inside was an expose` on Jake's financial situation, describing every problem, every unpaid campaign debt, every foolish investment in lurid detail. The article treated Jake like some Hollywood star in a supermarket rag. The information had come from third parties. The article indicated that Jake had declined an interview, which made the revelations all the worse.

I learned about it when Beth brought home a copy from the grocery store.

"Tom, have you seen this?"

I took the magazine and sat down to read the article.

"Shit." I slammed the magazine on the kitchen table.

"I guess that means you didn't know," Beth replied. "This sounds serious."

"It's devastating, Beth. I can't believe Jake's political capital has fallen so low that he couldn't prevent this. To splash his financial problems all over the pages of a magazine as though Jake were some soap opera star. It's despicable. It'll destroy him."

Didn't they have any respect? The expose` hung like a dark cloud over what should have been the proudest moment of my career. In December I had learned of my election to the Wain-

wright & Snow partnership. In June I would celebrate my fortieth birthday. Jake had kept his word. My elevation was big news in the legal community. Forty Wainwright lawyers were eligible to become partner and only seven made it. The fact that I had been an unknown solo practitioner who specialized in bankruptcy made my selection even more newsworthy. But my personal triumph was once again eclipsed by Jake. It was a strange turnabout of the events surrounding my coming to Wainwright in 1981, when the news of my joining the firm was buried in all the publicity surrounding Jake's becoming a partner.

"I can't believe you're letting Jake McCarty spoil your celebration," Beth complained. "This is something you've dreamed about for years. Thousands of lawyers would give anything to be in your shoes. You're moping around like you just lost a big case."

"I did lose a big case, Beth. I lost Jake."

"Jake lost himself, Tom. You had nothing to do with that. Did you read the article? Did you see how much money he spent? How stupid his decisions were? How much he borrowed? "

"That's why he needed me. He needed some perspective, some good advice, some . . ."

"Are you crazy? You're acting like some pathetic movie star fan. You think he would have listened to you? You think your advice would be so important to him? Tom, you need to get over this. I mean it. You're making me nervous. You've lost touch with reality."

I tried to take Beth's advice, but I couldn't let go of Jake. My wife had pegged one thing dead on—Jake was like a movie star for me and I was a groupie. The next morning I went to see him.

"Tom, come in." He seemed glad to see me.

"How are you, Gov?"

"I'm fine. Why do you ask?" The blue eyes looked into mine with innocent amusement.

I hesitated—unsure of how to approach the subject.

"Could it have something to do with the fact that I made the cover of Texas Monthly?" His tone was jocular. He was the same Jake.

"I was just worried about you—worried there was nothing I could do to help you."

"Hell, Tom. There was nothing anybody could do except Jake McCarty. He got himself into this mess. Pretty unbelievable, isn't it? I still don't know quite how it happened. There was so much money, so much credit. Everybody wanted to throw it at me like it was nothing and of course I found a use for it. All of it. And then it was gone. Just gone." Jake's hands made empty gestures in the air.

"Is your lawyer doing a good job for you? I mean, is he taking good care of you?"

"You know I would rather have had you, Tom. That wasn't possible. I did that to myself, too. I shouldn't have borrowed the money from First City. Never piss in your own back yard, so they say. I just never believed it could all come crashing down. But, to answer your question, he's doing a good job. Nobody could have saved me from this. In a way I'm glad you're not involved. This would have been a real bad start to your partnership. Congratulations, by the way."

"Thanks. I have a feeling you had something to do with that."

"Hell, no. You would be wrong on that, Tom. You did it. I'm practically a pariah around here at the moment."

I silently chided Beth for her cynicism about Jake. He was everything I could have expected him to be.

"So what's the next step for you?"

"Meetings. Lots of meetings with lenders to try to come to some resolution. I'm gonna be out of the office most of the

time for the next few months. I think I can find some investors in New York who might be willing to take me out of the better deals so I can cut my losses. Then I'll arrange a payout plan for whatever's left. It won't be fun but I'll get it done. Don't worry, Tom."

I left Jake's office a happy man. I had everything, my new partnership and my friendship with Jake and he was going to be fine. He would go through some hard negotiations but he would make it and things would be like they used to be.

I told Beth about the conversation. She was surprised.

"I have to admit, I didn't expect that of him," she mused half to herself. "I hope he's right and everything will come out OK. I know how much that means to you."

Chapter 11: A "Tewst"

Our attention turned to the ceremonies surrounding my admission to the Wainwright partnership. It was quite an affair: a month-long celebration, commencing with a cocktail hour in the firm's lounge where I was invited to join the other partners for the first time. Next, the new partners attended a weekend retreat at an exclusive resort outside of Austin. Friday evening everyone gathered in the limestone and glass bar for cocktails and dinner. The room looked out on Lake Travis. The view was spectacular, the setting sun, the golden lake, the hills in sharp relief as shadows played across their faces. I wished Beth could be there. Then I noticed what was strange about the gathering. It was all male. Not one woman had been admitted to the partnership. On second thought, it wasn't too surprising. Though the firm had grown to three hundred lawyers since I joined, less than thirty were women. Few of those had ever achieved prominence. Most were hidden away in the library. Their job was to write legal documents, not to meet clients or get business. I could not recall seeing a woman at any of my meetings with firm clients.

I thought about Beth a lot that evening. She had graduated number one in our law school class, but none of the big firms would hire her.

"After all, you women will all be leaving the practice of law once you get married and start a family," she was told again and again. Ten years after our graduation she was a full professor with a reputation as a brilliant and articulate advocate and we still hadn't started a family. I knew many male associates who had left the firm two or three years after they joined. I wondered how long it would take before women joined us at a partnership retreat.

People wandered off after dinner to take advantage of Austin's night life. I was invited to attend but the invitations were lukewarm. I watched the other new partners interact with each other and with the senior partners and realized I still felt like, and was treated like, an outsider. I had never been invited to dine with any of these men. Of course, I had never invited any of them to dine with me, either. I was so busy working I hadn't given much thought to social interaction. Now, watching my new partners set off in groups for a night on the town, I felt left out. I was still an outsider. I went to my room and called Beth.

Saturday morning after breakfast we attended lectures on the firm history and the partnership agreement. We learned about the compensation and sharing ratios. And we were shown the billings and collections of all Wainwright attorneys. I was stunned to see that I was the most profitable attorney in the firm. I was bringing in almost seven times my annual salary. As the numbers were circulated I caught other partners looking at me carefully. I smiled at them and they quickly looked away.

After the meeting we adjourned to lunch. As I walked to the restaurant Reedwell came up and put an arm around my shoulder. "Welcome to the partnership, Tom. You're going to make a tremendous contribution to the firm."

"It appears I already am."

"Well, yes. Of course. You have a unique set of talents. And Texas is going through a rough patch. Of course, when the economy turns around other partners will be doing better and your business will slow down."

"I expect that's the way things work, Harry," I replied. "And when that happens will the other partners be educating me so I can do some of their work to help my profitability?"

Harry almost choked. "We admitted you to the partnership, Tom. That's in recognition of what you've done for us. Jake pointed out . . ."

"Jake?" I interrupted Harry. Jake was missing from the retreat but he still cast a long shadow. He had downplayed his role in Wainwright's decision to make me a partner. It must have been more significant than he had let on.

"Surely you know how high Jake was on you. He supported you as a partnership candidate and of course he was very persuasive. As usual. And back when we were making our decisions, his voice carried great weight in the firm."

"Are you saying I'm here today because of Jake?"

An uncomfortable scenario played itself out in my mind. The partnership decisions had been made at the end of 1986, before Jake's problems became public knowledge; before his reputation and status had diminished; while he was still able to exercise his clout to recommend me for partner and to make his recommendation stick. So I had become partner but my patron and sponsor had now suffered a dramatic setback. How many of the men at the retreat resented me? How many would have wanted me—an outsider, a Johnny-come-lately, as their partner if Jake hadn't insisted on it?

"I'm not sure what you're implying, Tom. "

"I'm implying that when I joined Wainwright I was told I was a temporary employee. I was led to believe I would not even

be considered for partnership. I've been here a while now and I've seen people come and go. I realize not every deserving attorney is made partner, even one who has a skill set as important as mine. I wondered why I was chosen. I thought it might be because of my expertise. Or my scintillating personality. Or the fact that I bring in a lot of money in a bad economy. But what you're implying is that Jake made this happen. My earnings, my expertise had nothing to do with my admission to the partnership. Is that true?"

"I'm sorry, Tom. I've probably already revealed too much about how you were selected. That's not something we make public. You're a partner now. We need you. Enjoy it." And with that he walked away.

After lunch the partners adjourned to the golf tournament. I felt even more an outsider—I didn't play golf.

"We noticed you didn't bring your clubs, Tom. Did you forget?"

"I've never picked up the game," I admitted sheepishly.

My companions exchanged knowing smiles.

"Of course, you've been too busy to take up a game like golf." The words were friendly but the tone was insulting.

"That's true; someone has to keep the firm afloat."

"That's ridiculous, Nielsen. You bring in a lot of money for a few years and think you're the big star? Wainwright has been here for seventy years. It will be around for many more. And the economy is going to turn around and when it does you'll be cooling your heels."

"Well—then I'll have time to learn golf, won't I?" I said jokingly. "Meantime can I drive the cart? And maybe pick up some pointers from you guys?"

"Sure," they all laughed and I laughed with them.

"I'm sure I drive a mean golf cart." They laughed some more.

"You're all right, Nielsen," they said. They were appeased for now. But I was not and would probably never be a member of their club even though I was their partner. And my patron was probably not in a position to protect me anymore. And they were right—the economy would turn around some day and when it did I might be out of work. Maybe even out of Wainwright.

I spent the rest of the weekend trying to make nice. I asked about their wives and got questions about my wife "the dragon lady" in return. I soon realized spouses were not safe subjects of discussion. My wife was not pregnant with our second child. She was not a member of the Junior League. She did not preside at church bake sales or attend Little League games.

"She's a ball buster, Nielsen. You must have a hard time keeping her in line."

All the other new partners' wives did wifely things and knew each other. Other partners got together to watch their kids play baseball, to go to church, to attend charity auctions. I didn't know what to do about it.

"Why does your wife want to work?" one man asked in perfect seriousness. "Can't she have kids?"

I swallowed the reply that came to mind and said, "We've decided to wait for a few years before we start a family."

He looked at me like I was crazy.

I discussed the retreat with Beth. It was the first real talk we had had about my career at Wainwright since Jake appeared on the scene.

In some ways, Jake had replaced Beth as the most important person in my life. Beth had always been my best friend since we met in law school, when we discovered each other's quirky sense of humor and love of old musicals. What really

68

bound us together during those early years, though, was our shared perspective on our chosen careers. We were both unwelcome intruders in the legal community: Beth because she was a woman and me because I wanted to be a bankruptcy lawyer. We shared a common perspective on our profession—we saw its faults and pretensions, its limitations and potential, as only outsiders could. Our marriage was a union of kindred spirits. But we had never realized until Jake came along that my alienation was revocable; hers was permanent.

After her rejection by the big law firms, Beth got her doctorate and found her place as a professor at the law school—the refuge of brilliant misfits. I remained in voluntary exile as a solo practitioner in an unpopular field until Reedwell's offer of employment and Jake's intervention. Suddenly I was on the inside of the establishment and my wife was looking at me from the other side of an impenetrable divide.

Jake's imminent departure changed the landscape. With Jake in trouble, I had lost my mentor and chief supporter at the firm. And I was at risk of losing my other source of influence when the economy improved. The divide between me and my wife wasn't as impenetrable as we had thought. It had already started to crack. I needed Beth as an ally against the establishment.

At first Beth tried to make light of the whole affair. "I'm sorry people think you're married to a hellcat. I guess now I can't just quit work and get pregnant like I planned," she joked. "I might have to work to support us."

"You will always have to support me, Beth my darling. I need you." I wrapped my arms around her.

Her reaction was not what I thought it would be. It was not "I love you" or "Don't worry" or something like that.

Trip In The Dark by Kaaran Thomas

"Let's howl like wolves," she said. She believed howling was a primal form of human expression, able to work restorative wonders. So we held each other and lifted our faces to the ceiling and howled. Then the howling turned to kissing and the kissing turned to more primal behavior.

"Are there some of the new partners you like," Beth asked much later. "Why don't we invite them over for dinner some night?" I said that would be a good idea, but I already knew how uncomfortable such a meal would be. Eventually we dropped the subject-we had to get ready for the culmination of the partnership celebration. Dinner at the Reedwells.

Wainwright lawyers spoke of this event in the sort of hushed tones one would use to describe dinner with the Queen of England. I joined in their anticipation, realizing I needed to behave like one of them. At home we joked about it. "We're off to see the Wizard," Beth sang as we departed for the great event. But we had both prepared carefully for the dinner, realizing it was important for us to make a good impression.

Beth and I drove up the curved, tree-lined drive to the Reedwell's mansion in our old car and were greeted by a valet. The look on his face clearly showed we needed a new car. Mrs. Reedwell greeted us at the door. She was a stately and well-preserved lady with a bouffant hairdo that had been sprayed to a sheen and looked like a steel helmet. She wore a lot of makeup, very red lipstick, false eyelashes and an obviously expensive gown. All the other partners had acquired new suits and their wives new cocktail dresses. We had on our usual Sunday-go-to-meetin' clothes.

"We've underachieved, dear," Beth whispered as we were escorted into the living room. The "Class of 1987" shook hands, introduced their wives and were served flutes of champagne for a toast to Wainwright. Actually, it was a "tewst." Mrs. R raised her

70

glass and said, attempting to balance a British inflection atop her deeply Southern accent, "Let's all tewst the firm, y'all." Beth coughed, trying to hide her laughter, and held her hand over her mouth to keep the champagne from spewing over her dress.

After a few minutes we were escorted to the dinner table. No time wasted on social chit chat. Dinner was a four-course meal served by a wait staff. Conversation consisted of Mrs. Reedwell asking the wives if they had any children and what were their names and isn't the Houston weather atrocious and don't you love the azalea trail in the spring and isn't Wainwright a wonderful old firm. When she got to Beth, she appeared flustered. Someone must have told her about the dragon lady.

"I've heard quite a bit about you, my dear," she said, hesitantly.

"Really," Beth replied, all innocence and charm. "What have you heard?"

The whole table held their breath.

"I've heard you have an ... an exciting career."

"How sweet," Beth smiled, delighted.

"Um . . . yes . . . sweet." Mrs. R. mumbled and moved quickly to the next guest.

Aside from the interchange with Beth, the conversation was as impersonal as it was possible to get in someone's home. I looked around in amusement at my new partners who were outdoing each other trying to impress Reedwell and their star struck wives trying to befriend Mrs. Reedwell. I couldn't help comparing them all to Jake. None of them could hold a candle to him, including Reedwell, who forgot everyone's names.

When the front door opened and we were reinstalled in our car, Beth said, "You can breathe out now" and we exploded with laughter. "I'd like to propose a tewst, y'all," Beth said in a perfect imitation of Mrs. R. "Ahem. Wainwright is a fine old firm,

I said a fine old firm y'all," I replied, trying to mimic Mr. R. We howled all the way home.

Chapter 12: Out On A Limb

Inside the Wainwright establishment my admission to the partnership made almost no difference in my status. The only change was in my income—it went down. I was no longer an employee with a guaranteed pay check, I was a co-owner of the firm, responsible for payment of all the overhead and all the employees before I could receive any distribution. To the rest of the world, though, I had joined the ranks of the elite. We were inundated with calls from real estate agents with high-end properties we might like to see; investment advisors offering to manage our portfolio and help us plan for retirement; car dealers offering us preferred credit. In a city coping with record unemployment and massive loan defaults we were probably the best credit risk in town.

We adjusted to life on a different social scale. We decided it would not be extravagant to buy a new car. Our old one was on its last gasp anyway. And we found a home we both loved in West University, an old part of town full of tree-lined boulevards. It had a yard full of big old live oaks and a magnolia, a huge fireplace with a wooden mantle and lovely aged wooden floors. We took a look at our budget and our savings and decided we could afford it.

Trip In The Dark by Kaaran Thomas

Our excitement over our new possessions was tempered by the disaster all around us. "We have so much more than everyone else," Beth sighed as we decided where to put the new living room furniture. And I reminded myself that our income was as tenuous as the economic downturn. I was not a member of the Wainwright club—my social status might not last any longer than the recession. We told each other it wasn't a good idea to get too deep in debt. "Like Jake," was the unspoken thought.

The week after I became a Wainwright partner Jake filed his Chapter 11 bankruptcy. As I was picking out my new partner's furniture he was packing up his office, getting ready to leave the firm. I'm sure they would have asked him to resign if he hadn't volunteered. His presence was causing major friction with First City. Jake had guaranteed millions of dollars of the bank's real estate loans. His guaranty was clearly a conflict with Wainwright's interest in First City, but the bank had waived that conflict in the good old days when Jake was courted by Wainwright. Now the loans were all in default and times were different. The firm demanded the bank use Wainwright as their counsel. The bank required Jake's resignation as a condition of letting Wainwright handle the representation.

On the day he filed his bankruptcy case he and I said hellos, then he excused himself. Even his bankruptcy lawyer had clammed up.

So when he asked me to come to his office that March afternoon in 1987, a few days after his bankruptcy filing made national headlines, I didn't suspect anything. I assumed he just wanted to say goodbye, perhaps to leave me with some parting words of wisdom. I had no idea of the trip that was in store for me.

Chapter 13: Two Roads

When I walked into Jake's office he was rehearsing for his appearance the next day before the same Bankruptcy Judge Clark who had handled the Crutchfield case. It was a status hearing for Jake to inform the court and creditors how he planned to emerge from bankruptcy. He wouldn't use the hearing as a forum to complain that his business partners suckered him into guaranteeing their highly-leveraged real estate loans. He wouldn't discuss any of that; or blame anybody but himself. He would look the judge square in the eye and say: "I made mistakes, your honor. Let's move on to how we get these folks repaid."

He shared his plans with me. He would propose a remarkable strategy for paying his debts—a nationally-televised bankruptcy auction of all his possessions. He would be the star attraction, regaling the bidders with the intimate details of his most valuable possessions; things he had treasured all his life. And he would congratulate the buyers, shake their hands and walk away proud. And when Jake's statements and actions were reported in the press, millions of Texans who had lost everything but their dignity in the goddamned depression would love him for it—for being just like them, just like they wanted to be.

He was able to joke about the whole thing. "Economics, son. That's what laid me low. I was shot in the back twice—once by a presidential assassin and once by a goddamned banker. I survived the first wound and I'll survive the second."

"I'm glad you see it that way, Gov."

"That's exactly how I see it, Tom, and that's how I' gonna make my fellow Texans see it. From now on, bankruptcy will be a badge of honor here in our state; a purple heart for a financial wound."

"I'm impressed with your plan. Your lawyer must be doing a good job for you."

"He's alright, but we're not close. I need your help."

"What can I do?"

"I need you to take these personal items to Dean Schumer. Tonight. They're too important to mail. He'll be waiting for you at the law school."

Jake handed me a box sealed with packing tape.

"I can't do that, Gov."

"Why the hell not?"

"As of yesterday, whatever's in there probably doesn't belong to you. It belongs to your bankruptcy estate."

"You mean some trustee is going to paw over my private stuff, sell it like some steer at an auction?"

"That's right. Didn't your lawyer explain that to you?"

"I didn't think he meant my personal property. Hell, that's private. My private business."

"In a bankruptcy nothing's private, Jake."

"If this stuff gets sold . . . if people find out what this is . . . all hell will break loose. It could cause an international crisis, Tom. I can't let that happen. Neither can you."

"Why? What is it?"

"You don't need to know, Tom."

I just stood there, crossed my arms in front of me and waited.

Finally he added, "Its tapes. About what happened in Dallas in 1963."

"You mean the assassination?"

"What the hell else would I mean?"

"You mean there's something in that box the public doesn't know about the assassination?"

"Right. It's tape recordings. Recordings of calls to Johnson."

"President Johnson?" I felt like an echo.

"Lyndon recorded all his calls. Meetings, too. He had conversations with some very important, very famous and powerful people. About Kennedy's assassination. He also talked to some very unpleasant people, people you've dealt with before. Mr. Abedi and Mr. Baijan, the people behind BCCI. Anyone who's on those tapes and who's still alive would do anything to get a hold of them. Unfortunately, BCCI knows about them."

"Are you saying President Johnson and BCCI were involved in Kennedy's assassination?"

Jake didn't answer. I couldn't take my eyes off the box.

"How did you get these?"

Jake just looked at me.

In the silence, things about Jake—idiosyncrasies buried in my subconscious—began to surface. Things Jake had never talked about: his desertion of LBJ and the Texas Democratic party, the party of his mentor and friend Lyndon Johnson, for example. It was a slap in the face to the man and the party that had made him famous. It defied logic unless there was something behind it. Unless Johnson had betrayed Jake first. And the fact Jake never mentioned Johnson. His office was full of pictures of himself with

the rich and famous. But not Johnson. And his strange behavior with Clark Clifford after the First American Bank fiasco.

Jake still wasn't talking. I asked another question: "How was BCCI involved?"

"Not BCCI. They didn't exist back then, but Abedi had another bank in Pakistan. Later it became part of BCCI. The First American Bank bribe wasn't their first. Not by a long shot."

"How did you get these," I asked again.

He took the cigar out of his mouth and laid it carefully on the elephant hoof ashtray on his desk. I could tell he was deciding what, how much, to say.

"That's my business."

"How could Baijan's family know about these?"

"You don't want to know. It's better, safer for you if you don't. You'll have to trust me. The cigar was back in his mouth in the lock-and-load position—pointed directly at me. I knew enough to stop asking questions.

"You'll do it."

It was a pronouncement, not a request. In the silence, Jake had been assessing me. Something about me, some indefinable thing, must have convinced him I would go along with his scheme. The box was an apple and I had bitten.

* * * * *

I could have gone Interstate 10. It was well-lit and heavily traveled. That would have been much faster, but after my conversation with Jake that afternoon I felt my trip should be on the back roads, alone. So I drove down Highway 290, trying to go sixty but braking to forty to avoid losing control when I hit the potholes. The highway cut through the hill country, connecting the

long dark miles between little towns whose occupants went to bed with the sun.

As I have so many times in the past, I summoned Jake's presence. I envisioned his right hand on the wheel, his left hand stabbing his cigar at some landmark whizzing from windshield to rear view mirror. The voice of my mentor and hero played in my head when the radio signal got lost in the hills. We would be driving Jake's Porsche, of course, catapulting along at seventy, dodging the occasional errant cow. "You fly right over the potholes, Tom. Don't even feel 'em. And cows know how to get out of the way."

But that Jake was gone. Instead, I was dealing with a different, dangerous man; as inscrutable as the package on the seat beside me. It sat there on the seat, an inanimate object that kept forcing me to glance over at it, like the barrel of a gun.

I had planned to leave at six, but when I got home I had to explain my mission to Beth. It's not every day you depart for the University of Texas after work, and she noticed my package immediately. I had treasured our recovered intimacy in the weeks after the partner's retreat. Now that closeness would have to be destroyed. I would have to lie to my wife. I wasn't good at deception, especially when the victim was Beth.

"What's in the box, Tom?"

"Just some tapes."

"Tapes of what?"

"Tapes Jake wants me to take to Dean Schumer."

"The dean of the law school?"

"Right."

"In Austin?"

"Obviously."

"Tonight?"

"Yes. I have to call him to tell him I'll be late." I hurried to the phone, hoping to throw her off the scent, but she followed me, listening to our conversation. Schumer was waiting for my call. His conviction reinforced my courage

"Are you worried about getting involved in this, sir?" I asked.

"This is for Governor McCarty," he answered, as if that settled the question.

"But do you know what I'm delivering to you?"

"I don't need to know. I probably will never know. The package will be stored in the LBJ library archives with instructions to be opened upon Jake's death."

Beth was not distracted by the call or persuaded by the dean's rationale. He wasn't her dean, she huffed. Thank goodness she worked for the University of Houston and not the University of Texas. She had turned into the Dragon Lady.

"This is stealing from a federal bankruptcy estate, Tom. It's a felony. You could lose your law license. You could go to jail."

I knew the consequences, of course. Beth was right, as usual. The punishment was five to ten years in the federal pen.

"And secrets don't always stay secret, Tom," she said sagely. "Things happen."

"I've got to do this, Beth. I owe Jake. I owe him everything." Beth pulled out her ultimate weapon—tears. She hardly every cries, so that was pretty dramatic.

"Jake is a bankrupt loser," she sobbed. "He's using you. You don't owe him anything. And you're going to help him steal something that's obviously valuable, that could probably bring a lot of money at his bankruptcy auction—money that belongs to his creditors, to your client, First City National Bank. And now he

has Schumer involved? Does the Dean realize this is illegal? That the University of Texas could get in serious trouble?"

As usual, Beth had slashed through all the decorations, directly to the truth of things. But sometimes, I told myself, great causes demand great risks, even great sacrifices. And despite all that had happened, I knew Jake was not a loser. Yes, he did have to file bankruptcy. I recounted Jake's credentials to Beth, and to me, to build up my nerve. Jake was Texas' Governor for Life, the man in the car with President Kennedy in Dallas—wounded by the assassin's bullet. Kennedy's Secretary of the Navy. The man who persuaded Texans by the millions to vote Republican when he formed "Democrats for Nixon." A national political figure, presidential candidate and decorated war hero. A proud son of the Lone Star State brought to his knees, like the state he loved, by the plummeting price of oil and the devastation of Texas' economy. Jake represented what was left of Texas' dignity.

Beth was unmoved. She followed me all the way to the car, trying to change my mind. My headlights reflected on the tears in her eyes as I backed out of the driveway. I set out towards Austin in a foul but determined mood.

Houston's brightly lit freeways turned into unlit country roads an hour into my journey. Alone in the night I was visited by second thoughts that even Jake's imagined presence couldn't deter. As if on cue, headlights appeared over a hill far behind me, gaining on me fast. I wondered why they would be speeding at night on a dangerous road. Was someone trying to catch up with me?

For a few minutes I thought it might be Jake. A knot I didn't know was in my stomach loosened up. Perhaps Jake changed his mind and was trying to stop me, to save me.

Trip In The Dark by Kaaran Thomas

Then reality set in. Jake wouldn't change his mind. Someone else was after me, maybe to arrest me or even worse. It was too late to back out. I'd be caught red-handed.

Was it worth it? To protect a legend?

In the dark, on Highway 290, as the car racing through the night behind me got closer, its red lights began flashing and I realized it was a highway patrol car. I was terrified. I envisioned the headlines, the next installment of Texas Monthly with me and Jake on the cover. "Co-Conspirators!" I saw my career in ruins. I was shaking so hard I couldn't control the steering wheel. I pulled over in anticipation of the arrest and lost control as the car almost rolled in the soft dirt of the shoulder.

Then a remarkable thing happened. The red lights flashed by and disappeared down the road. They were gone so quickly I wondered if I had imagined the whole thing. It didn't matter. I was safe. I almost did myself in, though. My car careened off the road before coming to rest in the middle of a field. There we both sat, my car and I, engines idling quietly. I rolled the windows down. A night breeze came up, carrying a smell that was cold and crisp, like champagne. As my eyes adjusted to the dark I realized the smell was coming from clouds of bluebonnets that carpeted the area around me. I took in the air in great, healing gulps until my heart stopped racing. After some time, I considered the road ahead, murky and treacherous. Behind me, the highway led east—back towards the rising sun, a new day and home.

Sometimes you can see best in the dark. Beth's parting words finally made it to my brain: "Tom, you're crazy. Think about it. He could just hide the tapes—not tell anyone he has them. Why is he getting you involved? And the University? Something else is going on here—something you don't understand."

I replayed the afternoon's events. Sitting in Jake's office that day I had been flattered. I would be playing an important role in the Gov's comeback. Naively, I thought I was helping him the way he had helped me. And I had been captivated by the tapes and the thought of playing a role in a grand conspiracy.

But why couldn't Jake do as Beth suggested; just hide the tapes and lie about them; why give them to me—a Wainwright partner? And why didn't he answer my question? How did he get these tapes? With a flash of insight, I saw how clever he had been. How he had used me. By making me his delivery boy he had involved the biggest firm and the largest university in Texas in his crimes. Now if he was caught, he would not be alone; he would have the strongest and best allies in the state on his side. My tenuous new partnership position could evaporate out from under me if Wainwright was implicated in the plot. People called me "Jake's boy" and Jake probably thought of me that way. I finally had to admit the truth: Jake wasn't worried about keeping his promise to deliver his memorabilia intact to the University of Texas. He was worried about getting caught, and probably even more worried about the tapes getting into the hands of BCCI.

I wasn't Jake's friend, or his co-conspirator. I was a dupe. I was involved in something over my head; something I didn't understand. That would stop. Tomorrow morning.

Growing up involves realization, but it also requires action. I took one more breath of the pure night air and turned the car back towards home.

After a while Houston's lights appeared on the horizon. Beautiful. The live oaks, the magnolias in my neighborhood. Beautiful. Our gracious old house. Beautiful. I let myself in. In the bedroom, in the golden light of our old Tiffany lamp, Beth sat on the bed, knees curled to her chest, hair plastered to her face

with tears. Runny nose and swollen eyes. Wrinkled jammies.
Socks to keep her feet warm. They were always icy cold.

Beautiful. So beautiful.

"I didn't do it."

She cried even harder.

Chapter 14: Morning

In the middle of the night I had longed for the new day. Now it was finally here and I was afraid.

"What are you going to tell McCarty?" Beth was pouring my breakfast coffee.

"That I couldn't go through with it. It's a crime no matter how you cut it."

"He's going to kill you."

Of course Beth was speaking figuratively. When I walked into McCarty's office an hour later I feared she was right.

Jake looked at me, then turned back to his task. Since our meeting the previous day, he had almost completed packing. His comfortable leather office chairs were gone, along with the pictures, the rugs, the Remington sculpture, the elephant hoof ashtray, all the memorabilia that made his office so imposing. They had all been packed up and sent to the auction house in preparation for the sale. I was forced to stand at attention as he finished boxing the last of his books, ignoring me.

"Good morning, Tom." His voice knifed up my spine. "So— the Dean waited up all night for you but you never showed."

"I couldn't do it." Until that moment I had completely forgotten the Dean was waiting for me.

Trip In The Dark by Kaaran Thomas

"Just like that. You couldn't do it. You decided this - when? After a little chat with your wife over dinner? You cuddled on the sofa and watched the evening news and said the hell with it—I'll just leave the Governor and the Dean in the lurch and go enjoy a good night's sleep. Is that about it?"

"No. I . . ."

"You what? You coward. You idiot. You fucking idiot. Do you have any idea what you've done? Any idea at all? And you didn't even have the courtesy to call me. Or the Dean. You just waltz in here after a good night's sleep and say you're sorry. Jesus Christ! I can't believe I trusted you. I'm a fool. I guess now the Gov can't do anything more for you, now he's broke, now he's a nobody, you don't owe him anything. Not even a phone call. Jesus Christ."

"I know exactly what I've done, Jake."

McCarty and I faced off across an empty desk in his barren office. The cold morning sun, undeflected by the previous cushy contents of the room, fell harshly across the features of a powerful, dangerous man who did LBJ's dirty work, who fought his way to the top of the most vicious political machine in the country; who had tried to steal property belonging to the United States.

I, on the other hand, was an expert in human failure, and in human greed. I had spent my life counseling clients who lost their businesses, their jobs, their family fortunes. Almost all of them wanted to hide something from their creditors. It's a common thing, the desire to keep something special, something they think their creditors won't miss. Deprived of the trappings of power, left in a naked space, Jake was at a disadvantage, I told myself. I was not. I knew, I understood his feelings. He had no idea about mine.

"I've avoided becoming involved in two crimes," I continued, looking him straight in the eyes. Your theft of these tapes

from the White House and your attempt to cover up what you've done by committing a second crime—stealing from a federal bankruptcy estate. Didn't the Watergate scandal teach you anything about cover-ups, Jake? But in spite of all that, I'm still your friend."

"What makes you think I stole them from the White House?"

"How else would you get them?"

"I didn't steal them, for your information." He looked down. "Not exactly."

"What the hell does that mean?"

"Nixon, he had already taken them. He was going to use them to bribe the Democrats into stopping the Watergate investigation. I convinced him that was a bad idea.

"How did you manage that?"

"I told him the tapes were a nuclear bomb. From what Nixon told me, if they were made public, they could destroy the country. Even Nixon wasn't that cold-blooded."

"What did he tell you?"

"The tapes have lots of conversations with people high up in the government. Even the man who would replace Nixon— Gerald Ford. He was Johnson's stooge. He was put on the Warren Commission to cover up the truth. Even Hoover, the FBI, were in on the plot."

"Gerald Ford?"

"That's not his real name, by the way. He was born Leslie King, Jr. The FBI found out they could revive his original identity and use it to funnel money to him. They used Mr. Abedi and the Baijans. Later on, Abedi and his relatives started BCCI, with a little help from Bank of America. The Baijan's still control BCCI. What would they do to be able to buy these tapes at the auction? What if they told the FBI they had the evidence to show Hoover and

other FBI folks, their friends, were involved in the Kennedy assassination? How much power would that give them?"

"Jeezus. The FBI? They were involved in the assassination, too? I mean, was the whole fucking world involved?"

"Lots of people, Tom. And, yes, Hoover was in on it from the start."

"I knew Hoover was a friend of Johnson, but why would he get involved in something as risky as this?"

"Hoover was a cross-dresser, you know. And worse, probably. Liked to deck himself out in ladies' lingerie, play with little boys. There was a hotel in Del Mar, California, near the racetrack. Hoover's Texas friends owned it and they controlled who could stay there. That's where Hoover went to cut loose. He would have had to do what they told him, but it wasn't necessary. He detested Kennedy. Kennedy knew about his habits and he knew about Kennedy's women and they were at a standoff. Hoover was happy to get him out of the way. And what J Edgar wanted done his ambitious young boys at the FBI did. They all worshipped him.

"And as for Abedi and Baijan, they moved a lot of money for Johnson and the FBI and even the CIA. All the bribes that were paid to the conspirators and the people in charge of the cover up, and there were a lot, went through their banks. So what do you think they and their friends would do to eliminate the evidence that ties them to the greatest crime in history? Or to use the information for their own ends? Look what they did to get rid of the First American Bank evidence. Have you figured out yet that they've destroyed the evidence of that particular crime? That they've managed to eliminate the federal agent who was the star witness? You think these guys play by the rules? They're facing a mountain of other allegations and a horde of federal investigators

pouring over the First American books and looking into the murder of that agent."

"You're just trying to scare me." I tried to remain calm, but visions of unforeseen risks gathered like storm clouds in my brain. I remembered a recent news story about the CIA agent in Columbia, the one who had uncovered the First American Bank scandal. His body had been recovered. Actually, it had been dumped on the steps of the US consulate in Medellin, dismembered. The story was grisly. His limbs had been removed while he was still alive.

"And you think the BCCI people know about the tapes?"

"Who do you think's been calling me this past few months, leaving messages about helping me out of this goddamn mess?"

"You don't mean BCCI?"

"You got it, son. Armand Baijan, the latest family representative. I didn't take his calls. He left five messages asking to speak to me about something very sensitive. What do you think that something might be? How willing would he be to pay off all my debts in exchange for what I have in that box?"

"How the hell would he even know what you might have?"

"Who's the former director of First American Bank, Tom? The guy who borrowed money from BCCI? Clark Clifford. Who did Clifford work for? Lyndon Johnson. Who was he friends with? Nixon. Me. Is Clifford being investigated by the Federal Reserve Board for this First American fiasco? What would he do to get out from under this mess? Spill secrets about what Johnson did? Perhaps about tapes? Why do you think Clark wanted to talk to me so desperately that day in Reedwell's office? Think about this. Connect the dots you idiot."

If there had been a chair I would have sat down. I leaned against the wall.

"Hell," Jake said mostly to himself. "I'll just destroy the damn stuff!"

"You can't do that. You can't destroy property of a federal bankruptcy estate; evidence of the greatest crime in history. It has to be returned to the estate, Jake."

"God damn you! The hell I can't. I paid for those tapes with my blood, Tom. My Goddamned blood. Nobody. No damn body is gonna tell me what to do with them. Do you hear?" The fist came down so hard on the desk I thought it would crack.

"Why weren't you in on the plans? Or did you get in to that limo thinking you wouldn't get hit?

"Hell, no. I had no idea. They decided not to tell me. I couldn't contribute anything, I guess. I wasn't in a position to help them."

"So they didn't care if you were wounded? They put you at risk? I thought they were your friends."

He reacted as if he had been punched.

"I thought they were my friends. My best friends. I was wrong. Now, are you my friend? Are you going to help me?"

"Why not get some of the guys who were responsible for this mess to raise the money to buy the tapes at the auction? They have more to lose than you, even."

"No. BCCI can outbid 'em all. They could even in the old days. And now, now it won't even be a contest. There's not going to be a bankruptcy auction with some sleazy sale to a bunch of criminals. Just because I'm broke doesn't mean my mistakes have to hurt this country. I can lose all the property—all the trinkets. But not what I am. Not what I've accomplished in this world, not after what I've suffered. You value honesty above all else, I guess. Well, there's things I'm not prepared to give up, things I value more than honesty. Besides, there is no way my friends can raise the money it'll take. "

He looked straight at me. I saw him—really saw him—for the first time. He would do anything to protect his reputation, to

90

avoid being branded as a thief, a criminal. He had tried to use me; to keep things from me.

And I think that Jake really saw me. Perhaps for the first time—full frontal nudity in the chilling light of the Texas morning. Something flashed across his face, something more than respect but less than fear. I think at that moment we both realized with some surprise that Jake could not bully me. Something had changed overnight. I remembered what my father said about becoming a man. He was right. That night in the field was my real coming of age. At almost the same moment, I realized how much Jake had contributed to the man I had become. He was almost like a second father to me. And I cared about him, even after what he had done. I wanted to be his friend. For the first of many times in my life, I hated myself for caring so much. I was afraid of where my feelings would lead me. And for the first of many times, I could no more explain my feelings than change them.

"Where's my cigars? Damn it! I put them somewhere— probably packed them away in some damn cardboard box. What the hell . . ." He couldn't look me straight in the eyes. He patted his jacket and his face broke into a smile as he pulled an obviously expensive stogie from his breast pocket.

"Nothing like a good cigar—eh, Tom? I could never get you to take it up. You don't know what you're missing."

I had to keep quiet and wait. Give him his space. He bit off the cigar tip and rolled his lips over its length before sticking it in his mouth.

"I wonder if they'll let me keep any of these. I haven't reported these to the bankruptcy trustee either, Tom. Am I destroying property of a bankruptcy estate if I smoke one? Is that a felony, too?" He was grinning again. He lit the cigar, taking his time to slowly blow a stream of smoke in my face. We both knew cigar smoking was against firm policy. Neither of us mentioned it.

91

"Bankruptcy is about losing control of your assets so you can get back control of your life, Jake." I continued after he had indulged in a few puffs. "It's also about finding ways to accomplish both those ends. Bankruptcy lawyers . . . we're very creative. We have to be. Your plan doesn't get you what you want. It just makes the problem worse. Under your plan you lose all your property and commit a felony and I help you and the University gets involved in a dirty cover-up. And BCCI knows you're hiding the tapes. We'll all live in fear forever. You're digging the hole deeper, not solving the problem."

"I'd agree with you, Tom, if it were anything other than this."

"Why did you ever take the tapes in the first place, Jake? Why didn't you destroy the damn things when you found them?"

"I thought they might come in handy. If I became president." Another cloud of smoke billowed between us.

"You still haven't explained how you got the tapes. You convinced Nixon not to use them, but what happened after that? Did he give them to you?"

"Sort of."

"Meaning what?"

"We decided to stash them away in a safe place in case Nixon changed his mind. We discussed a hiding place—somewhere no one would think of. We finally put them in the Lincoln bedroom. Under the big bed Lincoln died in. Pretty clever, don't you think? Hide the evidence of one assassination under the bed of another assassin's victim?"

"But how did you get them?"

"At the end, the impeachment proceedings caught up with Nixon. He decided to resign. He was so busy defending himself, he forgot about the tapes. I didn't."

"So you took them? From the Lincoln bedroom?"

"Yep." Jake's cigar tipped up, along with the corners of his mouth, into a wicked grin.

"So you could use them? For what?"

But I knew the answer as soon as I asked the question. For blackmail, for extortion. For all the reasons the powerful need more power.

It was a rhetorical question. The smoke obscured his eyes but not mine. I remembered a saying—all great men have great flaws. With the results of his greed, his scheming, staring me in the face, I realized what it meant. I certainly couldn't leave the tapes in his hands.

"Well, I've got the stuff now and what happens next is my decision." I headed for the door.

"Wait one damn minute, Tom."

He came around the desk to stop me but I was halfway out the door before he reached me.

"What are you going to do?" he hissed.

"I'm going to leave you in the dark, Jake."

People were in the hall—there was nothing Jake could do. I headed for the elevator and for home.

* * * * *

Beth was heading out the door as I arrived.

"Can you wait a minute?" I asked.

"What happened? Did the two of you come up with a plan?"

"Not exactly."

"What does that mean?"

"Jake wanted me to give him back the tapes. I refused."

"Why ever would you do such a thing?"

"They're too dangerous, Beth. I have to keep them safe till I can figure out what to do with them."

"What exactly do you mean by dangerous, dear?"

For a second I almost told her about BCCI and its Network and the CIA agent in Columbia. But I changed my mind.

"I just mean that Jake wouldn't return them. He'd probably destroy them. The property belongs to Jake's bankruptcy trustee and I can't trust him to return it."

Just then a car honked outside. I started.

"Calm down, Tom, It's just Jennifer. She and I are going shopping for a new purse."

"Didn't you buy a new purse last week?"

"I did, but when I got it home I discovered it was a knockoff—not a real Prada. Thank goodness it was a flea market find so I didn't get burned too badly. But now I need to look for my real Prada bag."

I decided to forego the discussion about why a real Prada bag was required. I needed to come up with a plan before the McCarty auction.

"I'll be back in a few hours. You should get some rest. You didn't sleep at all last night." She patted my arm. "Don't worry. We'll figure something out when I get back."

"Have fun," I said weakly as she set off on her quest.

I went upstairs, and crawled into bed. I was exhausted but it was impossible to shut off my brain. I was angry at Jake, at my friend who had messed up his assignment as Jake's bankruptcy lawyer, at the whole world. I was even resentful of Beth for deserting me for a shopping trip and the people who would pass off a fake Prada bag, whatever that was, for the real thing.

I tried to comprehend everything I had learned. Hoover. Ford. BCCI. And Jake's Texas friends. They were part of this, too. Who else might be involved? Some of my Wainwright partners?

Clients? Jake was right. I probably didn't want to know. But now I did know. I knew too much.

I should go to the FBI and tell them everything. But what if some of those same FBI people, the higher-ups, were in on the plot? What would happen to me? To Beth, who still had no idea of the danger I had placed her in? Was there some other way to protect the tapes, avoid committing a second crime and protect myself? Was there a way to get the tapes into Jake's hands legally? He had kept them safe for years. I certainly didn't want to keep them. That would just get me deeper in trouble. Thoughts swirled around in my brain; I fell asleep and they turned into dreams, then nightmares. Then, somehow, they turned into a plan.

I woke up just as Beth returned from her shopping trip. She and I fine-tuned my plan. We learned the McCarty assets were being auctioned off in two lots. The first was to be sold at Houston's leading auction house—a Sotheby's affiliate. The second lot, the McCarty ranch, furnishings and livestock were to be sold later, on site outside of San Antonio. Beth and I waited till the first lot was delivered to the auction house and the staff were busy arranging everything for the televised sale. I showed the guard my Wainwright business card and introduced Beth as my associate. As counsel for First City National Bank, Jake's biggest creditor, I could inspect the goods without arousing suspicion. The place was heavily guarded against someone removing something, but nobody was checking to see if property was being added or rearranged.

It took time and creativity to avoid attracting the attention of the guards. I thanked my lucky stars that Beth saw nothing wrong in what we set out to do. She was an eager co-conspirator. And she didn't ask a lot of difficult questions about the tapes. I told her a half-truth. I said they involved some state secrets Jake

had learned as Secretary of the Treasury and she accepted my explanation without question.

 We had two tasks—one of them involved an obvious move, the other required a lot more creativity. We flipped for the right to pick our task. I won. I undertook the second task.

Chapter 15: Sold

The Houston auction was a huge event. Sotheby's was mobbed with bidders, lookie-loos and reporters. When Beth and I arrived, Jake was previewing select items with the TV crew. He drew a crowd, of course. He still loved performing, even for people who would buy his personal treasures at a bankruptcy auction. He regaled his audience with stories about his life, tying each tale to some item tagged for sale. I recognized his wife, Belle, sitting alone in a folding chair in the front row, her back straight, her hands folded in her lap. She and I had never been introduced. Her eyes briefly met mine and I smiled. She didn't return the smile; her eyes continued their inventory of the items in the room, sometimes following Jake and sometimes lingering on objects that must have held sentimental value. I kept my distance from her and her husband.

Until that moment, I had looked at all the property as things to be sold to raise money. The look on Belle's face reminded me of what the McCartys were losing, how they must be feeling. Jake hid his emotions well, but the loss, the pain, was written in Belle's eyes. I really saw the property for the first time. It was a clue to Jake, to what sort of person he was. What did it reveal about the man who had selected them to furnish his life? I had

time before the auction started. Beth was walking around, too, looking at everything. I joined the crowd of voyeurs.

Jake lived large, there was no doubt about that. Sofas, chairs, beds, Aubusson tapestries, oriental rugs, hand-carved desks, military swords with carved handles that clearly indicated they were antiques, paintings, mostly oil, mostly landscapes that reminded me of Texas, all in expensive frames. I thought about the contents of our house: the mission furniture we had finally decided to splurge for; the rug we had inherited from Beth's mother; our big old pine farmers' dining table; the grandfather's clock from my parents. Every item said something about us. People who visited, who joined us around the big pine table, often commented, "This house is so you." It was true. Our home bespoke our love of well-crafted furniture; of things old and well-worn; things with family ties. What did Jake's furniture reveal about him? It was arranged in room settings. Each display looked like a room in Architectural Digest. There were none of the quirky things that differentiate a house from a home. No old, worn tables, no ratty comfy chairs; no items that bespoke of a life. I looked more closely; perhaps I had missed something. Did these things have a certain predominant character that said "Jake McCarty"? They were all large, expensive, imposing. Was that the motivation for buying them? To impress? Surely he had enough sense of himself to want his home to reflect his individuality not the whim of some interior decorator. Or perhaps he had let Belle do the decorating. I walked through the aisles searching for additional clues. In a corner, arranged on an obviously expensive antique English sideboard, sat a wooden box that clearly looked out of place. I recognized the type, it was used to hold a silver service. I opened the lid. The set was old but not antique. It was not ornate but it was well-made sterling. The patina indicated extensive use.

"That's our wedding silver."

I jumped like I had been caught stealing. Belle McCarty had come up behind me.

"Ma'am?"

"It's our wedding silver. Jake's and mine. It was a present from Ladybird Johnson."

"It's beautiful."

"Yes."

"I'm Tom Nielsen. I work with Jake at Wainwright."

"Tom? Oh, yes. He's mentioned you."

I kept quiet, hoping she would reveal what he had said about me.

"Most of these things were picked out by our decorator for our Houston house when Jake joined Wainwright. Jake is making up stories to get all the buyers worked up; but in truth, we couldn't care less about them."

"I see."

"Some of the things, though, like this . . ." She ran her hands lovingly over the box that contained her precious wedding gift. "We brought this to Houston for some reason. I don't remember. So it's here now. Like his papers. What's done is done, I guess. Probably it would have been sold anyway, when the auction moved to the ranch."

Her voice was quiet, flat, the voice of a person in shock. I searched for some words of comfort.

"I've heard some folks are planning to buy things to give back to you."

Her reaction was embarrassed, almost angry.

"We don't take charity. We'll start over. It won't be easy at our age, but we can do it."

"I'm sure you can. You have so many friends, and Jake's conduct through all of this has made him the pride of Texas. The

99

whole state loves him. So many people here have lost so much. They identify with him. With you. That counts for a lot, it will count for a lot in the future."

"Yes. The future."

Her eyes looked past mine into the emptiness of some unimaginable future.

"Nice to meet you, ma'am."

"Nice to meet you, Tom."

I meandered through the crowd and spotted someone I thought was Armand Baijan. I had seen newspaper photos and the man's Middle Eastern features and expensive dress distinguished him from the rest of the audience, who were decked out mostly in western gear. He lingered at the edge of the crowd following Jake and the TV crew. Mike Schumer, Dean of the UT Law School, had also joined the people in Jake's circle. Jake and his entourage finally reached his file cabinets.

'It had always been my intention for the University of Texas, the LBJ Library, to become the repository for my papers and memorabilia," Jake commented to the cameras. "The bankruptcy trustee has agreed that these cabinets and their contents will be sold as one lot to preserve their historical significance. The University has received donations from alums so that they can bid at the auction. I'm sorry the alums had to come out of pocket for this. Especially during these difficult times. I hope other bidders will show respect for the University's and my wishes."

Jake and the crowd moved on to other objects. Jake stopped to point out his briefcase, made of elephant hide. He said it had been a gift from the Maharajah of Jaipur, along with an elephant hoof ashtray. Both mementos had been hand crafted from the remains of a bull elephant who had charged the Maharajah while he and Jake were on a hunting expedition in East India. The Maharajah's shot had wounded and enraged the animal and

caused it to charge. Jake had dropped it with a clean shot through the eye. It collapsed at the terrified ruler's feet. The briefcase had been made to order by Louis Vuitton in Paris at the Maharajah's special request.

"Elephants are a symbol of good luck. This will bring good fortune to you," the Maharajah had said. The crowd was spellbound by the tale of the charging elephant, the crack shot, the grateful maharajah. Baijan missed the story. He had lingered behind by the file cabinets. He opened several drawers and finally found one labeled "1960-1965." Behind the tabs, stacked in neat piles, were a set of white boxes. Baijan took out one of the boxes and inspected it, opened it and quickly returned it to the drawer. I looked over to Jake and saw he had noticed what Baijan was up to. After Baijan moved on, Jake excused himself and circled back to the cabinets to see what Baijan had been examining. When Jake saw the boxes he blanched. His eyes searched the crowd until he found me. His look was unmistakable: cold fury.

The cabinets and their contents came up for bids towards the end of the evening. A surprising thing was happening. Jake's showmanship had paid off. His property was selling for ten times its market value. The auction had already brought in several million dollars. I knew how much was required to pay off Jake's creditors in full, and began to wonder if Jake might be able to preserve some of his assets. I hadn't thought it was possible before the auction, but, surprisingly, the possibility of full repayment grew as item after item went for eye-popping prices. I had spent a fortune to buy Jake's elephant hide briefcase. Many people wanted souvenirs of their Gov and bidding was brisk.

Dean Schumer was the first to bid on the cabinets and contents—a hundred thousand dollars. There was a respectful pause. Most of the Texas crowd wanted to honor Jake's wishes. Then Baijan raised his paddle. "One hundred fifty thousand." As

the crowd murmured disapproval I saw Jake walk to the phone bank and pick up one of the receivers used for telephone bids. He dialed a number and began talking.

The bidding continued between Schumer and Baijan until it reached three hundred thousand. Jake had finished his call and went over to speak to Schumer.

"I understand we have a significant new alumni contribution that I can use to increase the University's bid to four hundred thousand dollars," Schumer announced to the auctioneer.

Baijan left his seat and approached the auctioneer, asking for his microphone. "I would like to let the Dean and the Governor know that I do not intend to keep all of the cabinets' contents if I am the successful bidder. I would be happy to donate most of the contents to the University. I would simply like the opportunity to inspect them and perhaps retain anything that might be of interest to my family. I would like to bid a million dollars. I will donate an equal amount to the University for the privilege of reviewing the material in the cabinets and retaining some few items."

The crowd gasped, then broke into applause. Meantime, Schumer and Jake had a brief conversation, after which Jake announced that he wanted all of his papers kept together and asked whether Baijan would agree.

"Of course, if I were going to donate them all I would not pay a million dollars for the privilege," he smiled, and the crowd laughed. But the laughter was good-natured now. Baijan had them on his side.

"Then the bidding must continue," the auctioneer said. The room became silent until the telephone bank operator announced a bid from a Mr. Wallace for a million one hundred thousand dollars. That set off another buzz. Jake smiled. He conferred with Schumer.

Baijan must have suspected something was up and realized he needed to shut the bidding down before Jake's telephone network could raise even more money.

"Two million dollars," he announced, "with the same agreement regarding turning over the files and a matching donation to the university."

Amid a burst of applause and cheers, another man approached the auctioneer and asked for the microphone.

"I am the McCarty bankruptcy trustee. At this point I'm pleased to inform everyone that the amount of money bid by Mr. Baijan, together with the money already bid for the other assets, is sufficient to pay all of the creditors of the estate in full, with interest. The auction can terminate. The remainder of the property will be returned to the McCartys."

Everyone cheered, expecting Jake to be ecstatic. Belle was beaming. Her husband clearly was not. He and Schumer whispered furiously to each other, but there was nothing they could do.

"Going once! Twice! Sold to Mr. Baijan!"

Jake slumped into a seat as the gavel came down. People slapped him on the back and left, puzzled at his response. The TV crew tried to get through the crowd around him for an interview. He shooed them off.

Beth and I had gotten separated during the proceedings. She finally found me at the head of the line in front of the registration desk filling out the papers for the briefcase. I had rushed over to get there first so I'd have time to catch up with Jake.

"What an incredible auction! What's with Jake?"

"Jake doesn't know."

"You haven't told him?"

"Not yet—I'm waiting for things to calm down."

"Wait 'till he hears! You have overachieved, darling."

"Yes, but I spent enough for five genuine Prada bags," I said as the auctioneer delivered my prize. "I got worried when the crowd was so entertained with Jake's maharajah story. A lot of people wanted that briefcase."

"I forgive you. Everybody should go on a shopping spree once in a while." She hugged me and laughed.

Finally the crowd disbursed and Jake stood up. I gave Beth a quick kiss. "Wait here, sweetheart."

"Are you happy now, Tommy? Has justice been served?" Jake was so bitter, so angry, he didn't care who might be listening.

"Jake, what's the matter?" Belle had joined us.

"Nothing, honey. Go wait in the car."

"Hi, Mr. Nielsen," Belle said joyfully. "Isn't it wonderful? We get to keep the ranch and all our furniture. Even the silver. I can't believe it."

"It is wonderful, ma'am. I'm so pleased for you."

"Y'all have to come and visit us after the dust settles," she said with a happy smile.

"You go on ahead, Belle. I'll be there in a minute." Jake's tone of voice clearly meant "get lost." Belle nodded docilely and turned to leave just as Beth came over to join us.

"Mrs. McCarty, Mr. McCarty, I'm Beth, Tom's wife. It's so nice to meet you. Tom, I'll wait outside."

Jake barely acknowledged her, but Belle greeted her with a warm hug.

"It's so nice to meet you, Beth. Your husband is my husband's favorite lawyer. We'll meet you two outside. Come on, dear."

She and Beth headed for the exit together and Jake turned back to me.

"Well?"

"Here." I held out his elephant hide briefcase. "I bought it to give back to you—to thank you for everything."

He scowled at me, incredulous. "Get out of here. Just go. Haven't you done enough?"

"Not before I leave you holding the bag. You deserve it."

He snatched the bag from my hands.

"Open it."

He acknowledged my command with a curt nod, fiddled with the latch and realized the combination lock had been activated. He glanced at me in irritation, then concentrated on the tumblers and finally got it to open.

He found the treasures, grinned at me in amazement and started laughing. The TV crew turned around and started back towards him.

"What's up, sir?"

"Nothing, never mind, fellows. It's a private joke. Very private."

"I thought you would get what happened when you saw the boxes in the file cabinet," I said. "Didn't you notice the presidential seal was missing?"

"Hell, I was so nervous I didn't really check. All I saw was the boxes with the dates on the edges and the look on Baijan's face. How the hell did you decide to hide the real tapes in my briefcase?"

We didn't have a lot of time to find a good place. Beth planted the fakes in the file cabinet. I knew that would be the first place you and Baijan would check, so I couldn't put the real ones in there. This briefcase was the only thing I could find. And it was out of sight of the guards at the entrance."

"I'll tell you a story about this briefcase. I told you about the day Nixon resigned the presidency; how I went up to the Lincoln bedroom, hoping he had forgotten about the tapes in all the

confusion. They were still there, all right. I got them from under the bed and put them in this very briefcase. I guess it really is my good luck charm."

I wanted to ask a lot of questions, but the conversation was clearly over.

Jake and I made it to the exit where Belle and Beth were waiting. As we got outside, he stopped.

"What's in those boxes Baijan was so interested in?"

Beth answered: "A little Willie Nelson, a little Waylon Jennings . . ."

As we were all laughing I looked back into the auction house and saw Baijan watching us. He was standing in the line at the registration desk waiting to get his cabinets.

Chapter 16: Picosa Ranch

For two weeks after the auction I was a nervous wreck. Baijan had seen me with Jake. He must know by now that he had paid two million dollars for a bunch of great country western music instead of the White House tapes. He might suspect me of having some role in their disappearance. He might be able to learn my identity. Of course! I had signed the auctioneer's registration book. I was at the top of the list. He had seen Jake leave with me; he might assume he could get some leverage over Jake through me. He might assume Jake and I had a special relationship; that Jake would be concerned enough about me to deal with him. Unfortunately for me, that wasn't true.

"When are you going to get over it, Tom?"

Beth knew nothing about my fears, and she was frustrated. I was nervous, truculent, defensive. I jumped every time the phone rang or someone knocked on the door. Even worse, Jake was gone. He was no longer at the firm and I couldn't find another phone number for him. I couldn't even discuss the problem with him.

"I thought Jake would at least call to say thanks. Or come by for a visit. Or something." I had made Beth believe Jake's loss was the source of my black mood.

"You've got to stop this, Sweetheart. Jake McCarty doesn't know how to say thank you. He thinks the world owes him a living."

She was right. I remembered the conversations Jake and I had driving through the hill country, about all the things people had done for him. Apparently, I was just one more fan and the tapes were just one more act of tribute.

Beth didn't know I had given up on Jake. I was secretly waiting for something to happen to Baijan, for some sign that I could stop worrying. Or some sign that I should really start worrying.

The first hint of trouble was a call from Dean Schumer. Thank God he called my office instead of the house.

"Mr. Nielsen. Remember me?"

"Of course, sir."

"You missed our meeting a few weeks ago. You were supposed to deliver a package to me, I believe. We discussed it just before you left for Austin."

"I'm so sorry, Dean Schumer. Listen, I wasn't able to get to a phone that night. I was stuck in the middle of the hill country. I had to turn around. I . . ."

"That's water under the bridge, Nielsen. I'm calling you about a different problem. Maybe they're related somehow, though. I thought I'd at least ask you."

I told myself to keep calm. Take a deep breath.

"Oh?" I tried to sound curious but casual. "What's your problem? I'll be glad to help, of course, if I can." I cursed myself for sounding too apologetic, too pathetically eager.

"Mr. Armand Baijan was the successful bidder for McCarty's file cabinets."

"Yes, I heard."

"Weren't you there?"

Trapped. The dean must have found out I was at the auction.

"Yes, but I wasn't paying that much attention to the file cabinets. I was with my wife."

"Perhaps you heard he made a pledge of two million dollars to the University."

"I did hear that someone had made a pledge at the auction, but I didn't know the details. That's wonderful."

"He's refusing to honor his pledge. Says we pulled a fast one on him."

My hands had turned to ice. "What do you mean?"

"He says not all of McCarty's papers were in the file cabinets. Some of them are missing. He refused to say what, exactly, but he was very sure. I know you were going to deliver a package of some sort to me a few days before the auction. I thought that package might be what Baijan is looking for. Do you have any idea?

"I don't. Sorry. I returned the box to Jake, so you'll have to check with him. Or that bidder, Mr. Baijan should, if he thinks he paid for something he didn't get. I don't think he has any right to refuse to pay just because something he thought was in those cabinets is missing. He bought the cabinet and whatever was in there, I expect. Since I represent Jake's biggest creditor I happen to know everything was sold as is, with no guarantees."

"I've already talked to the auction house and the trustee. They both assure me you're correct. But this doesn't concern the auction house or the estate. It's his pledge of two million I'm worried about."

"I understand."

"I had hoped to be able to settle this informally. I don't think we can force Mr. Baijan to honor his pledge. It was just a statement made on the spur of the moment. Not even in writing.

Trip In The Dark by Kaaran Thomas

He's willing to honor it if we can come up with the missing contents, but that's hard to do since he won't say what's missing."

"Sounds to me like he's just invented a reason not to pay. What a jerk."

"Maybe so. I thought I'd at least check with you, to see if you had anything to add to the story."

"Sorry I can't help you, Dean. Have you talked to Jake?"

"He and his wife are off somewhere. I haven't been able to reach him. I'll keep trying, though."

When I hung up, sweat was pouring off my forehead. I had dodged the bullet. Even better, Jake was away on a vacation. Maybe he hadn't forgotten about me. Then another thought occurred to me. Schumer knew I had bought the briefcase. He knew my name and where I worked. That meant Baijan either knew or would shortly know the same thing, even if he hadn't learned my name from the auctioneer. He knew where to find me. Where to find Beth. Maybe he could put two and two together and start looking for the briefcase. I had to talk to Jake.

I was finally able to get Jake's new contact information from the personnel office. I learned he had set up shop as a consultant, along with his former secretary, Kathleen. I called his new number. Kathleen answered the phone.

"Tom! How nice to hear from you. Not many Wainwright folks call these days. How are you?"

"I'm fine, Kathleen. But I need to talk to Jake. Something's come up. It's kind of urgent. Is he around?"

"Sorry, Tom, he's out of the country right now. He'll be back next week, though. I'll have him call you first thing."

I was limp with relief.

"Thanks so much, Kathleen. And you should come by for a visit when you have time. We miss you at Wainwright."

That wasn't strictly true, of course. No one had mentioned Kathleen or Jake since the auction. But it sounded good. And she was delighted.

"I'm so glad to hear they didn't forget about me, Tom. I'll stop by for lunch one day."

I was on pins and needles for a week. Then, just as Beth was about to kick me out of the house, Kathleen called back.

"Jake would like for you and your wife to join them at the ranch next weekend."

"Can I talk to him?"

"He said to tell you he's really tied up right now, but you'll be able to discuss whatever it is at the ranch."

Despite all my worries I was elated. Presidents, movie stars and celebrities of all types had been Jake's guests at the Picosa Ranch and now we were to share the pleasure. Beth was as excited as I. She spent twenty minutes on the phone with Kathleen discussing dress codes and etiquette.

Their conversation produced a list of items that neither of us had and a list of social events for which we were unprepared. The highlight of the weekend would be an exotic game hunt for the men ("Don't forget to tell Tom to bring his big game rifle and hunting boots") and a clay pigeon shooting contest for the women.

Vice President and Mrs. Bush were among the guests. Two other couples, the owner and the CFO of Spracklin Oilfield Equipment Company and their wives, were also invited. I wondered how Jake and I would be able to find the time to talk about what had happened with all the distinguished guests around. But I'd deal with that problem when I got to the ranch. I told myself not to worry. I was much better off than I had been just a week before. I was almost able to relax and enjoy Beth's frantic preparations.

I agreed to buy a good pair of jeans and some cowboy boots but I absolutely refused to buy a big game rifle. Beth seemed a bit disappointed.

"Just think, dear, you could bag a tiger skin rug for our bedroom."

"I doubt they let tigers roam around the ranch, sweetheart. More likely elk or deer or something that won't eat you."

"Well, an elk antler set would look nice above the fireplace."

Beth had never even asked to visit the zoo to see wild animals. Now she wanted me to kill one. The only animal I had intentionally killed was a mouse. I made my own call to Kathleen to tell her I did not own a big game rifle.

"Well," I could sense the puzzlement in her voice, "just bring your regular one then, I guess."

"Kathleen, I don't own a rifle. Or pistol. Or BB gun or bow and arrow or any lethal weapon."

"I'll let Mr. McCarty know. Perhaps he has one he can lend you."

Beth and I were invited to fly to San Antonio, the closest airport to the ranch, in the Spracklin corporate jet. On the appointed day we boarded the plane and met Spracklin's owner Joe Spracklin, the CFO Sam Frick and their wives. Spracklin and Frick seemed more interested in drinking than talking and their wives spent the flight studying twin copies of Vogue. Beth and I enjoyed the experience of flying in a private plane in solitude, concerned that we had already violated some unwritten code of conduct and offended our fellow guests. The silent treatment continued as we transferred to a helicopter at the San Antonio airport for the short hop to the ranch. I was surprised to learn the chopper belonged to Jake. The pilot told me, and added that he worked for Jake full

time. Apparently, Jake had recovered quickly from his bankruptcy.

I also had no idea what to expect when the chopper landed. Though I grew up in Texas I was a confirmed city slicker. I had never actually visited a working ranch. I imagined Jake's house would be imposing—rather like the "White House West" another wealthy Texan had commissioned. When the helicopter landed, all I saw was an unobtrusive dwelling that hugged the crest of a small rise. The house sat in the distance, in the middle of a sea of grass.

A bevy of golf carts met the chopper—another sign of Jake's improved finances. I barely had time to marvel at everything before we were dropped in front of a spacious verandah arranged with bentwood furniture upholstered with Indian blankets and big ceramic pots of aloe, sage, rosemary, and other succulents.

Hand-carved wooden doors opened onto a massive great room with adobe walls stretching up twenty feet to a beamed ceiling. A natural stone fireplace anchored the stone wall at the far end. Dead animals in various stages of amputation were mounted on the stone - heads of large carnivores, heads and shoulders of medium herbivores and stuffed bodies of a gazelle, a fox and a weasel. At least two dozen chairs—some of bentwood, some of richly carved mahogany, all upholstered in either leather or animal hide- were arranged in casual groups. A gigantic leather sofa with nail head trim fronted the fireplace. Animal skin and Navaho rugs dotted the mesquite floors. Original paintings and drawings—all with Texas themes—filled the walls. The entire room was bathed in a golden light from the afternoon sun, a collection of Tiffany lamps and an antler chandelier. The furniture was mismatched in an elegant sort of way—old chairs and worn tables mixed with newer more expensive furniture.

Trip In The Dark by Kaaran Thomas

Belle McCarty appeared wearing a suede skirt and a beaded Indian vest. She carried big gasses of lemonade and a small pitcher of vodka "for anybody who wants something stronger." The Spracklins and Fricks spiked theirs. We declined. Beth complimented Belle on the paintings.

"Jake and I picked these out ourselves, over many years," she said. She was in the middle of conducting a tour of the room when Jake appeared, grinning broadly. He looked the part of the wealthy rancher, sporting a pair of fancy embossed leather boots, a buckskin jacket that looked like Kit Carson had worn it, perfectly faded jeans and a cigar.

"Tom, Beth, how the hail areya?"

I had never heard Jake speak in "Redneck dialect" except in jest. Here he was serious. He greeted the others with the same expression, kissing the ladies and slapping the men on the back.

"Dinner will be at seven unless the Bushes are delayed. Why don't you unpack and get comfortable," Belle said, escorting us to our room. We settled into a bedroom with thick adobe walls and mesquite floors with a thick feather quilt on the bed. Two chairs and a table sat in front of a window overlooking the courtyard. A huge live oak outside our window provided shade from the evening sun. Over the bed was another amputee—a buffalo whose eyes expressed mild surprise at being beheaded. We unpacked our bags under the baleful stare of "Hortense." Beth decided on the buffalo's name.

I tried to get time alone with Jake but it was impossible. The Bushes arrived on time, shortly after we had unpacked. They were accompanied by a coterie of secret service men. Everyone gathered in the "big room" as Jake called it. The men congregated around a bar at the opposite end of the room from the fireplace, where the ladies had formed their own klatch. I immediately wished my boots were more comfortable and expensive, my

114

jeans less shiny new, my shirt adorned with a string tie. Jake's secretary had not mentioned string ties and I did not own one. Nor did I own the kind of large silver buckle that decorated each of the other men's belts. My companions looked me over, nodded and went back to their plans for the morning's hunt. I feigned interest. If I ever imagined a conversation with George Bush, which I had not, it did not involve the best place to aim for a quick kill on a wildebeest. But the VP was engaged in animated dialogue on that very subject. His secret service men stood at the edge of the bar separated from the rest of us men, probably thinking about their own kills. They constantly scanned the room for threats to their charge.

I had studied up on each of the guests to get a head start on possible topics of conversation.

"So, Mr. Vice President . . .

"Call me George, son, what was your name again?"

"This is Tom Nielsen, George," Jake cut in. "He's a fine young partner over ta the Wainwright firm. A damn fine lawyer. I guarangodamteeya."

I gaped at Jake in disbelief. Surely he was making fun of someone's accent? But he continued to look perfectly serious.

"As I was saying, Mr. Vice Pres—uh—George—I really enjoyed your recent speech on tax policy. As a bankruptcy lawyer I've learned . . ."

At that point George turned to the bartender to refill his drink, then began discussing the best place to have a wildebeest head mounted. I had been dissed by a Vice President. I was humiliated.

Jake noticed my dismay and rested a fatherly hand on my shoulder. "We don't talk politics here, Tommy maboy. Or bidnuss. We come here ta get tha hail away from all that bull shit." "Bull" was pronounced with an explosion of the lips and

Trip In The Dark by Kaaran Thomas

"shit" became a two-syllable word. The rest of the men nodded vigorously. A murmur of "damn straight" snuffed any further attempt at civilized conversation. We returned to the gripping topic of wildebeest murder. I amused myself with visions of Baijan and his hunting party planning my demise as these men were calculating the end of some wildebeest, minding its own business out on the prairie.

While Beth was comfortably seated, happily conversing with her newfound friends, I had to stand at the bar and suffer the revenge being wreaked upon my feet by whatever creature had been sacrificed to make my boots. My toes had gone numb and spasms were shooting up my calves.

I thanked God when we sat down to dinner. I was surrounded by Mrs. Spracklin and Mrs. Frick, who talked to each other as though I wasn't there. Dessert was interrupted by a butler carrying a phone. President Reagan was calling. Jake picked up: "Howdy, Mr. President. How tha hail areya?" We could hear Reagan chuckle through the phone. The two chatted about Jake's Santa Gertrudis cattle and Reagan's new quarter horse. Then the President asked to speak to his VP.

"Shit" muttered Bush under his breath as he took the phone. As he had feared, he was recalled to Washington immediately. The secret service ordered a helicopter to take him to San Antonio where an air force plane awaited him.

"Don't shoot all the wildebeests now, Jake!" he said with a parting wave.

The Bush's departure signaled the end of the meal. I was gratefully anticipating the imminent removal of my boots when Jake suggested the men stop by the "gun closet" to help me choose my weapon for the next morning. I assumed this would be a quick stop. It was not.

Trip In The Dark by Kaaran Thomas

The "gun closet" was a twelve by sixteen foot room with custom animal hide tiles and mahogany paneling, specially fitted with racks for guns of all types. The weapons were interrupted at intervals by heads of their victims like dots on upside down exclamation marks. There ensued an enthusiastic discussion about the best weapon for me to hunt the mighty wildebeest. My size, weight, nearsightedness, inexperience were excruciatingly analyzed while I tried to ease the agony by shifting from one foot to the other. I didn't have the nerve or heart to explain I had no intention of firing the thing. All I could think of was how I would manage to walk in the morning.

Finally, after an eternity, I was equipped with a rifle of the appropriate gauge, weight, site and stock for the task. I was told to report for duty at 5:30 a.m. Any thought of meeting with Jake that night was abandoned.

All I could think about was removing my boots. I have never experienced anything so wonderful as taking them off. Actually, Beth did it - bending over each throbbing leg with her back to me, clutching each booted foot between her legs, she performed the maneuver with an incredibly sexy wiggle of her behind. Sadly, the pain relief overwhelmed any desire to take advantage of the pain reliever. I washed the aching appendages with cool water to try to control the swelling and fell asleep almost immediately under Hortense's unwavering gaze.

117

Chapter 17: Willie

Five thirty arrived seconds after I had closed my eyes. I staggered out of bed and tried to put on my boots. My feet would have none of it. I would have to hunt in tennis shoes. I didn't really care. Besides, I figured, no one would notice my footwear in the dark.

"Mornin'," Jake handed me a cup of black coffee. "Help yourself. What happened to your boots?"

The men were selecting items from a huge breakfast buffet, then sitting at a long table in the kitchen. I looked for the Wheaties. Finding none, I put a few slices of toast on my plate and headed for the table. I tried to think up a reasonable answer to Jake's question but failed.

"They're too tight."

"You kidding me?"

"I just bought them."

"You brought a new pair of boots on a hunting trip?"

My stupidity provided a source of entertainment for the crowd.

"You a greenhorn, son? What if a horse steps on those tennies? You'll wish to God you had your feet in some big ole boots."

And so on while I munched my toast and contemplated how I would deal with a horse.

"You'll want to eat more than that, Tom. We have a long morning ahead of us. You need something to stick to your ribs. " Jake returned with a plate stacked high with scrambled eggs, toast and sausage and plopped it in front of me.

"I'm really not that hungry. I'll be fine, thanks."

Shaking his head, he put the plate back on the buffet.

My next challenge was mounting my horse. Another round of jokes accompanied my failed attempts. Apparently I frightened everyone by waving my gun around while trying to find the stirrup. Jake finally relieved me of my weapon "So you don't shoot poor ole Trigger."

"We'll go slow so greenhorn here don't fall the hail off." More laughter.

We set a sedate pace in the darkness. The horses engaged in companionable nickering and the men exchanged two-word phrases.

"Nice mornin'"

"Damn straight"

"Bit breezy"

"Yep. Chilly."

"Okay, though."

"Damn nice."

The Texas prairie emerged in the half-light of early dawn. Waves on waves of grass stretched on either side and I realized why people wandered lost on the plains. A line of cottonwoods marked the distant river and stands of live oaks dotted the fields.

"It's beautiful," I said, realizing I had fallen into the two-word syntax of my companions.

"Damn straight," Jake nodded.

Another hour passed before we stopped in front of a twelve-foot-high barbed wire fence with a locked gate. Jake opened it and we followed him through single file.

"Critters can jump over anything shorter," he said as we craned our necks to see the top. "Don't bump into the fence, it's electrified. Won't kill you but you'll know you touched it."

The horses were apparently familiar with the fence. They skittered through quickly and without touching.

The herds of cattle became herds of zebra, impala, gazelle. The first twinges of saddle soreness struck at the same time my stomach noticed that the toast had vanished.

I had originally hoped our search for the wildebeest would be unsuccessful - praying his or her life would be spared after a long and fruitless hunt. Now, with increasing discomfort in two key parts of my body, I wanted to find the damn thing, kill it and get on back to the ranch, ASAP. Another hour dragged on before we sighted our prey. I was required to dismount—an experience almost as agonizing as amputation. We left the horses under some live oaks.

We were separated from a wildebeest herd by a stream and more live oaks. Jake wet his finger and held it up to test that we were "downwind." My nose assured me he was right. Jake and the others crossed the stream easily, protected by their boots. I tried to skip across on the rocks to keep my tennies dry. I slipped and ended up with soaking feet.

On the other side of the stream we had to scoot forward on our elbows to the cover of the trees—careful to avoid any movement that would startle the herd before we were ready. My attempt to scoot while holding my gun generated more teasing. "Git your ass down, Tommy! We don't want them wildebeests to see a fat rump moving through the grass. Kee-rist! They'll be off like lightning!"

We finally reached the trees and sat in the shadows to re-connoiter. The wind was still in our favor and my butt had yet to attract wildebeest attention. The others surveyed the herd and selected an old bull standing guard at its edge. Apparently the hunters could not fire randomly into the crowd of fifty or more creatures. They had to mark one for death. Ole Harry's number was up. I had named the wildebeest after Reedwell. Next came the order of shooting. Jake said he would only shoot in case "there's a problem." I didn't want to imagine what the problem might be. That left Spracklin, Frick and me. I deferred to common sense, so Frick and Spracklin flipped for the honor. Frick won.

My watch showed eleven o'clock. We were laid out on the prairie like steaks on a griddle under a broiling sun. I waited anxiously for the first shot to be fired. Unfortunately Harry must have sensed the danger because he suddenly bolted back into the herd. So we had to wait for another candidate. None appeared and the herd began to meander away from us. The gods heard my frantic prayer that some dimwitted, death-deserving wildebeest would lag behind. Sure enough, Willie volunteered. Frick realized he'd better act quickly and fired a round. Clean miss. Now the herd was milling nervously, ready to bolt. Spracklin fired. Willie was wounded. He wasn't down but he was limping. Must have taken a bullet in the leg. Jake looked at the two disappointed marksmen, nodded and dropped Willie with one shot.

The rest of the herd had vanished by the time we reached Willie. He was still alive – gasping for breath. Jake grabbed one of Willie's great horns, lifted Willie's head, whipped out his hunting knife and slit Willie's throat. Willie looked at me as his blood spurted everywhere. His eyes rolled back in his head. I realized I would faint or throw up. I sprinted back to the cover of the trees and heaved whatever was left of my breakfast. In my discomfort I didn't realize I was standing on a red ant hill. I was wiping my

mouth when my legs began to sting. I looked down to see a red ant army assaulting my ankles. I screamed.

Jake came running. "Red ants. Quick—get the Benadryl. It's in my saddle pack." Jake was all business—yelling directions and trying to sweep the ants off me with his gloves, leaving smears of wildebeest blood across my legs. I decided I was going to be sick again. Fortunately there was nothing left to throw up.

Somebody arrived with the Benadryl and water to wash it down. They removed the damp, ant-infested tennies and used more water to wash the ants off my feet. Jake used the satellite phone to call the pickup truck—relaying our location, the kill and the medical emergency and telling the driver to "git here on the double."

Willie and I rode back to the ranch together. He smelled a lot worse than me but I hurt a lot worse than him. The ranch paramedic and a worried Beth helped me to my room, doused my feet with calamine lotion, wrapped them in ice packs and put me to bed. I told Beth I would give anything for a sandwich. I got a ham and Swiss on rye and a blessedly cold Coke. I passed out. Next thing I knew it was twilight. Beth had come into the room.

"Are you okay, Honey?"

"Fine, just fine. Where is everybody?"

"They're in the big room playing pool. Everybody's worried about you. Do you feel up to joining us?"

I was damned if I was going to stay in bed, no matter how bad I felt. And I didn't feel that bad, thankfully. I could even put on socks and boots—the Benadryl and the meal had worked wonders. A quick shower and hair comb and I followed Beth into the big room.

The conversation stopped. It had obviously been about me.

"Tommy—How the hail areya?" Jake's voice was concerned but his eyes were twinkling.

"Fine—just fine. What's for dinner?" I refused to show weakness.

"Wildebeest hocks. I'll fix you a plate." Then seeing me turn green he laughed—"Just kidding, Tom. It's plain ole barbecued steer." Everybody chuckled.

"Sorry to spoil your hunt. I guess I should look where I throw up next time."

"No problem, son. It happens. You did great for a greenhorn." The others nodded with placating grins and returned to their pool. The game ended just as I finished dinner.

"How about some poker—Texas Hold 'em?" Jake suggested, moving towards a card table in the corner."

"I'm in." Spracklin followed Jake.

"Me, too." Frick followed Spracklin.

"Got room for one more?" I got up to join the party.

"Sure you're up to it?"

"I'd like to give it a try."

"Ever played poker?"

"Just a few times." Why should I tell the truth? The great professional poker player Amarillo Slim was my uncle. I was studying poker hands when most children are learning to read. Poker paid my way through college. Revenge would be sweet. I sat down at the table to end the debate.

Some people say poker is a game of skill. Some say it's a game of chance. Among players of equal skill, poker is a lot about luck. I was willing to bet on my skill with these guys. Guarangoddamteeya. All three of my victims had been drinking, though they were not drunk enough to make me feel like I was taking advantage of them. I was dead cold sober and had that most important advantage—a long afternoon nap. Beth came

over and started to say something that might have tipped them off. I gave her a look that would have stopped a charging wildebeest.

"Take it easy, Honey," said my mistress of double entendre in a worried voice, backing away. "I'm turning in early."

"Don't wait up for me," I replied with another meaningful stare.

Hold 'em is the most challenging of poker games. Players get only two concealed cards in their hand (the "hole cards"). Two of the players "ante" up with initial bets, then the hole cards are dealt, then there is a round of betting. Next, the dealer deals three "common" cards face up on the table (or "board")—the "flop." Then another round of betting. Then the fourth card comes—the "turn" card, followed by more betting. The final card—the "river" card—is dealt. Then the final bets. The best five-card hand made from any combination of a player's two hole cards and the five cards face up on the board wins.

Jake gave each of us a stack of chips worth five thousand dollars.

"Those are some big dollars," I said, trying to sound nervous. "Are we playing for real money?"

"Hail, yes," Spracklin said. "And this is no limit. You want to back out?"

"No . . . no," I faked a nervous laugh. "I better get lucky."

Jake was the first dealer. Spracklin, sitting on Jake's left, and Frick, to Spracklin's left, posted the antes. I got a ten and four of spades in the "hole." The "flop" helped my hand just a little, giving me a pair of fours.

Spracklin bet first. He threw in fifty dollars. Frick called and I raised to a hundred. Everybody called, then the "turn" card came: nothing helpful.

Spracklin bet $100, Frick folded and I called. The fifth "river" card was a two of diamonds.

I had nothing but a pair of fours. Spracklin bet another hundred and I raised another hundred, faking a worried look. Spracklin looked at my face, smiled and called. He had a pair of jacks. I appeared flustered and threw my hand on the board, showing him my hole cards. "Damn! I thought I could bluff you," I said with an embarrassed grin. "I shoulda known better."

"Damn straight," Spracklin smirked as he raked in the chips.

"I 'spect you lawyers can afford to lose a little to us businessmen."

I played a few more hands the same way—always showing my hole cards when the game was over to make everyone believe I was a "bluffer." Serious poker players never show their hole cards unless they win—the cards are a giveaway to their strategy. Once other players learn how a player plays particular hands they can anticipate what will happen. I figured that since I was showing my cards everybody else would, too, just to be polite. I was right.

"You'll get the hang of it, kid," Jake commiserated, "if you don't run out of money first."

I only felt a little guilty.

The evening wore on and the other wives went to bed. The room became quiet except for our bets and a few occasional comments. The silence and lack of stimulation was having its effect on my victims. They had all been up since before dawn and had been drinking most of the day. I could see their eyelids getting heavy. They were losing the ability to pay attention to the cards.

During the next several hands my bets were small—I would win a few just to stay even, then lose again on another

bluff. Meanwhile I assessed Jake and his friends. Most amateur card players give their hands away with subconscious gestures—"tells." Since I was seeing their hole cards after every hand, I quickly learned what they did when they had good, mediocre or bad hole cards. Spracklin and Frick bet quickly when they had good hands, but hesitated before betting if they were uncertain and grinned if they had nothing in the "hole." Jake's "tell" was more interesting. His cigar dipped for just a second when he was bluffing, pointed straight at you if he had a good hand and wiggled if he was uncertain. The tells were infinitesimal but obvious to a pro.

Two hours into the game I had them all figured. On my next deal I got a pair of jacks as my hole cards. Jake threw away his hole cards; he didn't even 'check'. Spracklin bet $50, Frick raised to $150 and I called. The flop produced a board consisting of the jack of spades, ten of diamonds and ten of spades. That gave me a "full house" (three jacks and two tens).

Spracklin bet $800, the biggest bet of the night. Frick folded and, after a slight but obvious hesitation, I called. The turn card was a six of spades—no help that I could see.

Spracklin bet $500 and I raised to $1,000. Spracklin just called, probably suspecting I had made a spade flush. The river card was the ace of spades.

Spracklin twitched. He and I engaged in another three rounds of raises and re-raises. Typically there's a limit of four raises for each round of betting. Without thinking, I asked "how many raises"—then realized I might have given myself away. Only a poker expert would know to ask that question. Jake looked at me sharply.

"I mean, can I raise all night?" I tried to sound dumb.

"The limit is four," Jake replied, still looking at me intently.

"OK then, now how many have we done so far?"

"Three," Jake said.

Spracklin responded, "All in," and pushed his final chips into the pot. I called. The pot was over nine thousand dollars.

Spracklin threw his cards on the table. He had an ace and a ten. We both used the "common cards" on the board, but I could make a better hand with them. Spracklin made a "full house"—three tens and a pair of aces. That would ordinarily be a great hand. He started raking up the chips before I even showed my cards.

"Doesn't this beat your hand?" I asked, trying to keep a straight and innocent face. I used the jack and pair of tens on the board and my hole cards, the pair of jacks to make a bigger "full house", jacks over tens.

"Damn!" Spracklin swore as I stacked the chips on my pile. I had pretty much cleaned him out.

"Jake, loan me five grand so I can put this youngster in his place." Spracklin demanded.

"You sure you want to do that?" Jake asked. It's getting late – maybe we should turn in.

"Hell no—I'm gonna win back my money."

Jake reluctantly agreed. Twelve meaningless hands later my deal came again. The flop came queen of hearts, ten of spades and seven of hearts.

Jake bet $200. Spracklin immediately raised to four hundred. All of us called.

The turn card was ten of hearts. Jake bet five hundred and Spracklin immediately raised to a grand. Frick hesitated a second before calling. I called and Jake called, his cigar rock-steady.

I dealt the river card, the seven of clubs. The board was electric with potential—two tens, two sevens and a queen.

The air shimmered. The two ladies—luck and skill—hovered over the table. They smiled at me. Great poker happens

when everybody thinks they have a great hand and you have the best. Then it comes down to bluffing the other players and not "telling" your hole cards.

Jake folded, throwing in his cards—king and ten of diamonds—face-up for me to see. I was fairly sure I knew Spracklin's hole cards. He couldn't have a pair of tens in his hole because Jake had a ten. He probably had a queen and ten. His quick raise before he ever saw the river card (the seven of clubs) had "told" two pair with the cards already on the board. If I guessed wrong and he had a pair of sevens he would win with four 7's. If he had queen/ten I had him beat.

Spracklin bet his entire pile of chips.

"I call," I said. Frick folded.

Spracklin threw a queen/ ten of clubs on the table—a "tens-over-queens" full house.

"Got ya!!!" He was excited, confident.

I laid out my hole cards—a pair of queens.

My hand, three queens over a pair of tens, a bigger full house, was the winner.

Spracklin had lost ten grand.

"Damn!" Spracklin cursed. Then, grinning sheepishly at Jake, he slurred, "I guess I'll turn in." He made out a ten grand IOU payable to me and walked away. Frick and Jake also gave me their IOUs and turned in.

Chapter 18: Greenhorn

It was two in the morning. Beth was pacing the floor in our room.

"What happened?"

"What do you mean," I mumbled defensively, trying to hide the IOUs.

"You know what I mean, Tom Nielsen. What did you do to those guys?"

"They're adults, Beth. They can take care of themselves."

"Against a poker shark? With an ego problem?"

"What?"

"You blamed them for making you look foolish today and you took it out on them. How much did they lose?" Beth snatched the IOUs from my hand.

"Jesus! Seventeen thousand dollars. Are you kidding?"

I shrugged.

"What kind of a guest are you? Is this how you repay your host? "

"Jake invited me here so he could take me down a notch – make me look like a fool in front of the Vice President and his buddies. They can afford it."

"You're crazy, Tom. First of all, they can't afford it. I was talking with Judy Spracklin this afternoon. I got worried about

129

how they treated us on the plane; they were so stand-offish, I thought we had upset them or something. She finally let on that Spracklin Oilfield Equipment is about to close. It's been their family business for three generations and it's defaulted on its bank loan. They're going to have to file personal bankruptcy, too. They put everything they owned into that business to try to save it. Jake invited them here to introduce them to you and maybe cheer them up a little. This is kind of their last hoorah before they lose everything. I hope by morning you'll be ashamed of yourself. You need to find a way to make it right with the Spracklins, and with Jake, even if it's the last thing you do for him, which it probably will be."

My night was filled with disturbing dreams of Jake handing me cups of wildebeest blood. Beth shook me awake just before sunrise.

"I bet Jake is up—you go talk to him. And make it right, Thomas Aloysius Nielsen. Hear?" When she used my full name like that she meant business. I cringed.

This was not the conversation I had intended to have with Jake. But it had to be done. Perhaps there was a way to discuss both crises—the Spracklins and Baijan.

I walked to the kitchen. Only the cook was there, starting breakfast.

"Is Jake up?"

"He was here a few minutes ago. Got himself a cuppa coffee and headed out. He's probably sitting on the deck. That's where he likes to park himself most mornin's."

I grabbed a cup of coffee and headed down the path to the deck—a separate covered wooden patio with chairs and a few tables for people to sit and enjoy the evening breeze or watch the sunrise. Jake was sitting in a rocker with his coffee, looking out over the prairie.

"Howdy," I said tentatively. "Can I pull up a chair?"

In response he patted the seat of the neighboring rocker.

"Nice mornin'," I said.

"Yep."

"Thanks for having us."

"Sure." Jake was looking out at the prairie, his face expressionless.

"Interesting card game." I tried to sound casual.

"Damn right."

"I have these IOU's here . . ."

"Give'em to me. I'll take care of 'em."

"It was just a game. I didn't intend to take real money off anybody."

He finally turned and looked at me, but I couldn't read him.

"You're kidding. They sure intended to take money off you. Would have, if they'd won. Me, too, for that matter."

"Well, I'm your guest and I don't want to upset you, or them, or anybody for that matter."

"What makes you think I'm upset?" He was still looking at me, his expression turned quizzical.

"Actually, I've played poker most of my life. Amarillo Slim's my uncle. I assume you've figured out by now I was sandbagging everybody."

Jake guffawed. "You sure pulled one on us. I wondered about you, just from the way you played, and when you asked the question about the raises, but then you looked so damn innocent I decided I was imagining things. Amarillo Slim, huh? I've always wanted to meet him. What a colorful character."

"He taught me poker when other kids were learning to read. It paid my way through college."

Jake was bent double with laughing.

131

"Wait 'til I tell the boys about this." His laughter ended with a bout of coughing.

"Beth says I made a fool of myself yesterday—then made it worse by taking you guys in the poker game. I guess I got upset over the whole hunting thing. I hate looking like a fool, which I sure did yesterday."

"You're one hell of a poker player. And you have one damn thin skin and vengeful heart. Reminds me of a former friend of mine. Name of Nixon."

"Speaking of Nixon, we have a problem. Actually, that's why I called Kathleen. She said you were away but would call when you got back. I've been trying to find the time to discuss it with you but everything's been so crazy the last day . . ."

"What sort of problem?"

"Dean Schumer called."

"Schumer? What did he want with you?"

"Seems Baijan has refused to honor his two million dollar pledge to the university. Says we cheated him. Important stuff is missing from the files."

"We meaning who . . .?"

"That's what Schumer was calling about. He thinks the box I never delivered might contain what Baijan's looking for. Schumer called to see if you could go ahead and deliver the box to Baijan, assuming that's what he wants."

"What did you tell him?"

"I told him the sale was without warranty. Baijan got whatever was in those cabinets and nobody had any obligation to hunt for stuff he said was missing. I also said I thought Baijan was a jerk, just looking for a way to get out of the pledge. I played dumb about what was in the box, I told Schumer to talk to you."

"So that's what he wanted. Thank God I haven't had the chance to return his calls."

"Jake. I'm worried. If Schumer told Baijan about me, about my connection with you and the box I was going to deliver, Baijan might draw certain conclusions. He saw me with you and that briefcase at the auction. He could have read my name on the buyers' list. I was the first to register. Maybe he'll decide he can get to you through me."

"I'm sorry you got so deep into this. It wouldn't have happened if you had just delivered the damn things to Schumer, you know. I told you there'd be trouble."

"Is there some way you can use what's on the tapes to stop Baijan?"

"Like what?"

"I don't know. I don't know exactly what's on them."

"You mean you never played 'em?"

"No. They didn't belong to me."

Jake turned away from me towards the prairie. What did he see out there as he looked past the waiving grass, to the line of cottonwoods in the far distance that marked the edge of the creek? Whatever it was turned his face soft and sad. His eyes, the color of the prairie sky, finally turned back to me.

"You're not like other folks, Tom."

"Meaning what?"

"I can't think of anyone who wouldn't have tried to learn what's on those damn tapes, given what I already told you. The knowledge itself is worth a king's ransom."

"Even now? After so many years?"

"Even now. There's dozens of names on those tapes. The owners of many of those names are still around and lots of them are damn rich or damn important or both. They're like a bunch of chickens waitin' to be plucked. "

"You mean so many people back then wanted to see Kennedy dead? Or wanted to help the cover-up? I only remember how everybody loved the Kennedys."

"Oh, he had a great public image, that's for sure. The press loved him and they kept a lot of his secrets. But he was no angel. And he didn't like Lyndon and his Texas buddies. And that's what started the whole thing.

"Meaning what?"

"Meaning Kennedy got bent outta shape when he learned Lyndon's Texas friends had bought themselves an Iraqi dictator. A fellow named Abdul Kassem."

"Never heard of him."

"Right. That's no accident. You can thank the CIA and Kennedy's friends in the press corps for that. Kassem was Texas' man in OPEC, for a price, of course. OPEC was just getting organized back then, and Texas was left out. We were damned upset about that but there was nothing we could do except try to find out what was going on. Which we did do, of course, through Kassem. He told us what they were up to. Sometimes he was even able to affect what they did. To help Texas, of course."

"And Kennedy didn't agree?"

"Hell, no. First of all, he didn't know. He found out when Kassem tried to extort more money by getting Kennedy involved. Kassem thought the money was coming from the President, not from Texas. Johnson led him to believe that, I guess. But after a while he got greedy. Thought he could do better by goin' right to the top. Which meant Kennedy. Of course, Kennedy didn't know anything about the deal. Kassem thought Kennedy was playing stupid, which just made things worse. Kassem threatened to buy nuclear weapons from the Soviets if Kennedy refused to increase the bribes."

"So what happened?"

"Kennedy got bent outta shape. He thought Lyndon and the Texans were a crude bunch with way too much power. He decided to use the Iraqi situation to make a big political statement. At least, that's what I've been told. And it's something Kennedy would have done—show the world how he stood for truth and justice and throw Johnson and the Texans under the bus. He was spiteful in that way. He forgot he came from a family of bootleggers. No difference between oil and likker as far as I can tell. But the Kennedys thought they were high and mighty. And so did the Texans. They didn't like anything about each other. Looking back, it was almost bound to cause trouble. At least Lyndon managed to cover that whole mess up after he became president."

"So what happened to Kassem?"

"That started a whole 'nother problem in the Middle East. Kennedy got the CIA involved. They decided to take out Kassem, to avert a nuclear threat, they said. They made friends with a bunch of Iraqi renegades, the so-called Baath party and their leader, Saddam Hussein. You've heard of him. The CIA paid Hussein to eliminate Kassem. Along the way Hussein killed a bunch of other people, the Kurds, a bunch of tribes who controlled a lot of the Iraqi oil fields. When Kassem was killed it created a power vacuum. Thousands of Iraqis died and many more became refugees. They were a huge problem for the neighboring countries, especially the Saudis who got blamed for everything the US did in the Arab world. That's why your friend Baijan and his family were in on the assassination. They were furious with Kennedy. Thought he was an idiot. They wanted their buddy Johnson in control of things."

"How did the Baijans get involved?"

"They're Saudi, relatives of the royal family the al Sauds. Faisal, who was the Saudi Prime Minister at the time, was good

friends with Lyndon and the Texas crowd. He could bitch to them about what Kennedy had done and I 'spect he bitched quite a bit. The Saudis were important allies. Kennedy should have been worried about pissing them off but he wasn't. So Faisal talked to Johnson. I suspect Johnson and the Baijans brought in Abedi. I guess the bitching finally led to a plan to kill the President. Handling the payoff money was nothing new for Abedi and his crew. They dealt in dirty money. They found Oswald. Got him set up. Then they took care of him afterwards. Believe me, they're up to their necks in the assassination."

"And this is on the tapes?"

"Just about all of it. Including calls from Faisal and Abedi, though Faisal is dead now—another assassination victim. I always wondered if Faisal's death had some relationship to the Kennedy plot. We'll never know."

"But what about all the Americans who helped with the cover-up? President Ford? Hoover? What would make them do such a thing?"

"You have a very naïve idea about what goes on in Washington, Tom. How pragmatic, amoral politicians and bureaucrats can be. Would they have supported the assassination? I doubt it. But what's done is done. And it was easy for them to talk themselves into keeping the whole thing quiet. Think of what would have happened if the truth had come out. You bankruptcy types use the expression 'too big to fail'. Well, that was the Johnson administration, our government. We were at the beginning of the Vietnam war. There were race riots, economic upheaval. It would have been chaos. And we were in a cold war with the Soviets at the time, don't forget. People believed it was best to hush the whole thing up. And besides, there was a lot of money that changed hands to ease the consciences, so to speak."

"I can't believe Johnson would let all this be tape recorded."

"I don't think he thought about it. The tape recorder was just there, you know. Nixon didn't think about it either. And it wasn't like there was one long conversation where everybody was talking about how to cover up the assassination. It was lots of calls where people talked about things. Unless you know what was going on you might not realize at first what they're talkin' about. When you listen to the calls you'll see how they tried to be abstract when they talked. When Hoover says to Johnson we have to stop this thing, or Johnson says to Baijan, 'We need to move some money', or Johnson asks Baijan if they've taken care of their problem, they might mean lots of things. But someone who knows what happened can piece it together fast enough. "

"But Armand Baijan wasn't involved, obviously. He couldn't be found guilty of anything."

"It doesn't matter, it's his family's money, his bank."

"But his bank is already in trouble. How much worse can it get for them? They'll be banned from the US forever."

"Tom, Tom. You're so young. So naïve. You have no idea of the power of money. The kind of money these people have. The First American thing is just a wrinkle, something to be dealt with. Mark my words. They'll survive. But a tie to the Kennedy assassination? To the cover-up? No. They couldn't live that down. And the tapes are proof. Baijan's father is on there. Talking to Lyndon about moving the money, paying the bribes, getting rid of Oswald. It's a whole different thing to be tied to the most famous crime of the century. They could never get over that."

"So what are you going to do?"

"First, I'm going to get you out of the hot seat. I owe you that much. And I have plans for you. I need to keep you alive."

Jake saw the color drain from my face. He laughed.

"I'm kidding. Mostly. And as for Baijan and the university, I need to think on it. Baijan's not our only problem. Schumer's involved now, too. I need to find a way to get him his money."

"I hope you're not thinking of having me win it in a poker game."

He laughed again, but didn't respond to my comment.

"We have a new handle for you—Greenhorn."

"So, about that poker thing, you're not upset with me? They're not upset?"

"They didn't need to lose the money, that's for sure. You cleaned out Spracklin."

"I heard. Beth told me. That's why I was worried."

"He'll be calling you next week. Spracklin Oilfield probably needs to file bankruptcy. Spracklin, personally, for that matter."

"So their IOU's won't be worth anything anyhow. They're just like any other debts, discharged in their bankruptcy proceedings. I'll just tear these up."

"Shoulda thought of that when I loaned him the money last night, but Joe's been my friend for years, since we were in college. I don't mind losing a little bit for a good cause. I wanted them to get to know you. Spracklin—Frick too for that matter. It takes time for them to warm up to somebody. They're not goin' to confide in some big city lawyer. On the other hand, telling your troubles to Greenhorn—somebody who's spilled his guts under a tree on top of a red ant hill, then whooped their ass at poker"—a little chuckle—"that's another matter . . . that's okay."

"You mean, you invited me here to get acquainted with them, so I could help them with their financial problems?"

"I invited you and Beth, whose one helluva lady, by the way, to show you the ranch. I didn't intend for you to step in the anthill or get sick. Or take seventeen grand off us." He laughed softly. "This was as good a time as any for you to visit, though.

138

Folks who've come out here lately—seems more often than not they're in trouble. Serious trouble. Maybe you can help."

"You seem to be doing all right."

Jake coughed, covered his mouth, coughed again and stuck the cigar back between his teeth.

"If you're asking if my IOU is good. It is. I'll write you a check."

"Can't I just forgive it, to thank you for your hospitality?"

"Nope."

"Isn't it a little early in the day for cigars?"

"Nope." The cigar went into attack position as another coughing spell took him. I watched the prairie turn gold with morning while he took out a kerchief and wiped his mouth. We sat and rocked in silence for a while. Another breeze came up and the sun was above the horizon. It was quiet as a church and we were together, just the two of us, and everything was all right between us.

"So, are you getting on okay, Gov?"

Before he could answer, Beth came up behind us.

"There you two are! Enjoying this lovely morning, I see. We should start packing, Tom. The Spracklins are having breakfast, they'll probably be ready to leave before long."

"I don't think they're in much of a hurry," Jake mused. "Their bank will be repossessing their plane when it lands in Houston. This is their last private flight. For a while at least. Come and sit with us a spell. Enjoy the mornin'."

Beth took another of the chairs. Three pairs of eyes looked off into the distance, the only sound the prairie birdsong and the gentle squeak of our rockers.

Finally, Beth said, almost to herself, "This range land—the wide open space—it catches your heart, doesn't it?"

"Lots of cowboys are artists, you know," Jake responded. "Places like this, they make poets out of ordinary men."

Beth spoke softly:

> "The world stands out on either side
> No wider than the heart is wide;
> Above the world is stretched the sky-
> No higher than the soul is high."

"That one wasn't written by a cowboy," Jake said with a little cough. "It's by Edna St Vincent Millay." He rocked a bit, remembering. "I met her in the forties. Her husband was Dutch. I was in Washington on leave, visiting Lyndon when the Nazis invaded Holland. Her husband lost everything. She came to DC to try to get some help from Roosevelt. He had her give a recital for some folks and Lyndon gave me his invite. She was quite a lady. Another one of her poems is my favorite."

"Which one," Beth asked.

> "My candle burns at both ends;
> It will not last the night;
> But ah, my foes, and oh, my friends--
> It gives a lovely light!"

"Everybody likes that one," I said. "I never realized she wrote it."

We rocked in peace a while longer, then Beth broke the spell, rising to peck Jake on the cheek. "Your place—it's magic. Thanks so much."

"Y'all come back often," Jake called after us. "We'll get Tom into shape—make a proper cowboy of the man."

After we got home I asked Beth if she had ever heard of Abdul Kassem.

"Never heard of him," she replied. I left the topic, but I had piqued Beth's curiosity.

"I found out about your Mr. Kassem," she informed me over dinner a few days later.

"Who?" I tried to appear nonchalant.

"Abdul Kassem. Remember, you asked me about him?"

"Oh, yeah, sort of. Just a name that came up the other day."

"Well, it's quite a story. He was the ruler of Iraq before Saddam Hussein. A real tyrant. He was killed by the Baathists, Saddam Hussein's bunch. It led to civil war in Iraq. Lots of people died."

"When did that happen?"

""Nineteen sixty-three. February, I think. Why?"

"Nothing. Never mind. Thanks for doing the research, honey."

"Sure. No problem." But she watched me out of the corner of her eyes as she carried the dishes to the kitchen.

Chapter 19: The Tycoons

Several months passed before we were invited back to the Picosa. By that time I had put both Spracklin and Frick through bankruptcy. We watched helplessly as the company they had built over eighty years was dismembered and sold by the banks. It seemed nothing could save Texas. The lenders weren't lending; they weren't even extending good loans. They were hell-bent on calling every note, foreclosing on every mortgage, suing every guarantor. The savings and loans had all failed, their assets conveyed to the Resolution Trust Corporation. The price of oil kept dropping. Houston restaurants featured "oilman's specials"—a meal for the price of a barrel of oil. The meals and the price shrank every month.

"Why don't y'all come out to the ranch this weekend?"

This time it was Belle who called Beth. I listened to their conversation.

"We'd love to, are you sure it won't be too much trouble?"

"Hell, no. Jake wants Tom to meet some folks. And we can practice some more on the clay pigeon range."

So we returned to the Picosa, this time on a large private jet owned by Neal Wallace, a legendary oil tycoon. I remembered he had been one of the bidders for Jake's file cabinets. I knew he and Jake were friends from way back. Wallace was widely known

as an outspoken ultra-conservative, one of the founders of the John Birch society. Once again, after casual greetings, Beth and I were left to entertain ourselves on the flight while the Wallaces read magazines and conversed with each other. I had read that Wallace's company, Capital Oil, was in default to its lenders and decided that the silence was a product of financial distress rather than political disagreement. I used the flight as an opportunity to study this man, another Texas legend. He was tall and impressive looking with silver hair and a craggy face. He resembled Jake in many ways, but his face had a crude edge to it. He looked and acted like someone who was used to being feared.

I assumed that "meet some folks" was Jake's code for helping them with bankruptcy issues. I worried about helping this man, who had a reputation for being unreasonable, demanding, unforgiving.

This time I was alert to undercurrents in our visit. On our arrival at the ranch, Jake introduced me as a "damn fine bankruptcy lawyer," and Wallace said he was familiar with Wainwright, though he didn't use them as his counsel. But there was no discussion of financial problems. The evening meal was again devoted to discussing the next morning's hunt, this time for zebra. I was better prepared. I knew not to discuss business with the guests. I had broken in my boots so I could use them on our hunt. The morning breakfast went smoothly, I consumed large quantities of bacon and grits, earning Jake's approving smile. Though I still didn't own a gun, I asked for and received Jake's permission to carry the one he had loaned me on the last trip.

"Don't tell me you intend to use it," he joshed.

"Only to kill ants," I responded, triggering chuckles. As we hit the trail, Jake retold the story of my previous visit. The tale was meant to produce laughter but Wallace didn't even smile.

"You're the man who helped Joe Spracklin," Wallace said.

"Yes, sir."

"Damn fine man."

"Yep." I assumed he was referring to Spracklin rather than me.

"Damn shame what's happened to him."

"For sure."

"Couldn't be helped, Neal," Jake chimed in.

"Shame what's happened to us all."

I opened my mouth, about to embark on my explanation of the disastrous effects of leverage and over-exuberant expansion but something in Jake's face stopped me.

"Too bad," I said.

"Damn politicians. We should shoot every one of 'em."

Jake's reaction was so physical, so abrupt that it made Trigger skitter sideways. I almost fell off.

"Sorry." Neal's apology was for me, not Jake.

"What's done is done, Neal. It's over."

"It'll never be over. Never for you. Never for me."

"It's best forgotten."

"How can we forget what dogs us every damn day? Maybe not you, Jake, but the rest of us."

"I'm one of you, Neal."

"The hell. We don't have a separate source of income. We've gotta depend on the price of oil."

"That's enough, Neal. We're on a pleasant ride, here. Don't spoil it."

Wallace harrumphed. He was quiet for the rest of the ride out, and once we got to the game preserve he concentrated on tracking and killing his zebra. I decided against naming it. Our trip back to the ranch was uneventful. I had forgotten about Wallace's outburst until we gathered after dinner. The ladies had just returned from the shooting range and were settled by the fire-

144

place chatting. The three of us sat at the bar sipping what I assumed to be extremely expensive scotch. Wallace had been drinking most of the afternoon and had consumed several straight shots of whisky with dinner. He spoke in loud, slurred sentences that must have carried over to where the ladies were sitting.

"What the hell happened to Pete Bass? Wasn't he supposed to be here?"

"He couldn't make it, Neal. Something came up."

"Th' hell somethin' came up. He's too depressed. Doesn't even want to leave th' house. He's a damn wreck. We all are. We're like the dinosaurs. Extinct. Our age is dead and gone. Oh, we had our chance. But they blew it for us. They fuckin' blew it. And for what? For what? That goddamned man. We shoulda' got ridda him in '62. We all knew he was trouble even then. Damn liberal. Spoutin' garbage about doin' good for humanity like some priest. Then startin' two of the worst civil wars in the world. He was a Catholic, for God's sake. We shouldda known. A goddamned Ivy League yellow bellied liberal Catholic. Takin' his orders from the damn Pope. That's what they do. Talk a bunch o' crap, then go about destroying everything. How could someone like that get the power? To mess things up for America? And it took him three years. Just three years to undo all the good Ike did."

"How did he mess things up?" I couldn't resist intervening.

Jake gave me his 'shut up' look, but Wallace rambled on like he didn't hear me.

"Kennedy, the CIA, their boys. They destroyed everything we built up with our own sweat and money. 'Cause we pissed Kennedy off. And that was the end for us. The end of the age of Texas oil. Poof."

Wallace slumped into the barstool.

Trip In The Dark by Kaaran Thomas

"Where are you thinking of hanging the zebra, Neal?" Jake asked.

"The zebra . . ." Wallace had forgotten the day's kill. "Iraq—all that destruction—the civil war—he didn't give a damn. That wasn't enough for him. He had to start it in Vietnam, too. The killing. Our name dragged through the mud. And it destroyed us, destroyed Lyndon and all he tried to do for Texas. He never lived it down. And it wasn't his fault. It was the damned liberal media pinned the thing on Lyndon so their dead idol, Kennedy, wouldn't get his name smeared. Kennedy, the fuckin' idiot. He deserved to die. Look where he's got us. He deserved to die."

"You need to get some rest, Neal." Jake took Wallace by the elbow and led him from the room, still muttering curses at Kennedy.

The following morning Wallace was in a foul mood, a bender of a hangover exacerbating his depression. Jake spoke softly, trying to sound sympathetic.

"I asked Tom to come to the ranch this weekend to see if he could help you, Neal. He's a fine bankruptcy lawyer. Best in Texas. He's happy to talk to you about your problems."

I realized I wasn't equipped to talk to Wallace. For one thing, my firm represented some of Capital Oil's creditors, so we would be appearing on the other side from him. I was looking for a way to gracefully back away from the situation when Wallace solved the problem for me.

"I don't need no fuckin' bankruptcy lawyer, Jake. I need money. Money. Nobody'll lend me anything. Not at any interest rate. Oil is dead, Jake. We're all dead. They killed us. I suppose you don't have anything you can lend me?"

"No, Neal. I just came out of my personal bankruptcy. I'm trying to rebuild."

146

"That's not true, Jake. You know it's not true. You have lots of money. Lots. And you have ways to get lots more, I've heard. You can tap those guys. Hell, you've tapped me in the past. You with your gentle hints about what you know about the assassination, what we did. Don't fuck with me. I know. I've talked to a lot of my friends, our friends. Hell, I've talked to Gerald Ford. Seems he came out of pocket to help you.

Jake looked at me frantically.

"What about Gerald Ford?" I intervened.

"Tom, this is none of your business. Please leave us."

"Wazza matter McCarty? Are you ashamed for your boy here to know what you've been up to? How dirty your hands are? Just fess up. You don't want to help, that's all. You still blame me, blame us. You just stand there like some damn judge and pass judgment on us. You're enjoying this, ain't you?"

"Neal, you're a guest in my home. I let you get drunk and angry. I tried to help you, but you've worn out your welcome. It's time for you to go."

Jake took Wallace by the arm and pushed him towards the front door, yelling for someone to help. A couple of ranch hands appeared around a corner and strong-armed Wallace away. Wallace was still screaming: "Haven't I been punished enough, Jake? Haven't I said I'm sorry enough? What the hell do you want from me? I've lost everything, everything, isn't that enough for you? Damn you."

Jake followed him and the ranch hands out the front door, leaving me to sit and stare at their retreat.

"What did you do with him," I asked when Jake reappeared.

"Took him out back and shot him." Then seeing the look on my face Jake started laughing.

Trip In The Dark by Kaaran Thomas

"You believe I would do that, Tom? That I'm as ruthless as that? I'm the victim here. I'm the one who got shot. I've suffered every bit as much as Neal and his buddies. I had a couple of the ranch hands take Neal to the bunk house to cool off. We're going to heli him to San Antone and let him fly himself home once he sobers up."

Mrs. Wallace came running into the big room. "I'm so sorry, Jake. We've been terrible guests. Please forgive Neal. He's suffered a lot. He's not himself. He talks crazy. I understand. I don't blame you for anything, don't ask anything of you. Please believe me."

"Forget it, Liz. Neal's badly hungover and probably drunk on top of that. He'll recover after a good night sleep."

"Please don't hold it against me, against us, Jake."

"Of course not. Why don't you get your things together and we'll fly you to San Antonio."

She looked at him, square in his eyes, for a minute. What unspoken question was she asking? I don't think she got an answer. Finally she looked down and walked away.

"We'll be going, Jake. I'll handle Neal."

"Thanks. That'd be good."

Jake turned back to me. "Like I was saying, Tom, I'm sorry you had to be a part of that. I didn't expect it. Should have. We'll make arrangements for you to fly home from San Antone."

"I want some answers, Jake. I think I deserve 'em. When I retrieved those tapes I didn't intend for you to use 'em for blackmail. Is that what's happening?"

"Hell, Tom. Don't tell me you believe that old scoundrel? As far as paying me money . . . Wallace and his buddies were happy to do it, and they had plenty to spend back in the good ole days. Not because they thought I would blackmail 'em, but because they were a bunch of guilty sonofabitches. They included

148

me in their deals to make themselves feel better, to try to make things up to me.

"And Gerald Ford?"

"Wallace doesn't know what he's talking about."

"But he must have talked to Ford."

"I don't know what Ford told him. I told you Lyndon offered him a lot of money and some of his Republican friends convinced him it was the right thing to do. Ford agreed. And he was a poor young congressman. From a poor family. With great big ambitions. And ambitions take money. It wasn't that hard to convince him, apparently. And other members of the Warren Commission, too. They did everything in their power to steer the investigation away from Lyndon and his friends. With Hoover's help, of course. And they succeeded."

"So you found out? You blackmailed him?"

"I has suspicious about Ford long before I got the tapes, Tom. When I was Treasury Secretary. I checked out the flow of money to all the members of the Warren Commission. It was easy to do with my security clearance. As I said before, once you know what happened, know what to look for, the trail's pretty clear. And yes, King-Ford found out what I was up to. But he didn't pay me any money. He let me have the tapes. He followed me to the Lincoln bedroom when I went to get 'em, during Nixon's resignation speech. I guess he noticed I had left the press room, suspected I was up to something. We didn't trust each other. He knew Nixon had wanted me to be vice president after Agnew resigned. The Republican Party convinced Nixon I would be a mistake. They wanted Ford. Of course, nobody knew at the time that Agnew's replacement would be the next president by default. Anyway, Ford found me with the box of tapes in my hand. Asked me what it was. I told him. He tried to take it from me. I threatened him. I told him if he took the tapes I would let

the world know what he'd done. He decided to let it go, let me go. He was minutes away from becoming President. He had bigger fish to fry.

"But in exchange for promising to keep quiet, which I would have done anyhow, I got him to promise to pardon Nixon. I felt I owed Nixon that much. I told Ford if he didn't want the Johnson tapes to surface he'd better stop the investigation into the Watergate tapes. One investigation would lead to another, I told him. I would make sure it did. And he agreed. So some good came of it. But I didn't get money. That's a bunch of crap."

I thought carefully about my next words. There was a lot I could have said; maybe even should have said, but I said none of that.

"Thanks for leveling with me, Jake. I needed to know. You can understand that."

"I guess you did, Tom. I tried to keep you out of all this, but this thing is quicksand. Once you set foot in it you get sucked down deeper and deeper. I understand why you want to know, what with Schumer giving you trouble and all, but you need to understand that the more you know the more you risk. And now Neal Wallace knows that you know about Ford and the other stuff he yammered about today. And Baijan might suspect you were involved with the tapes somehow. See how this thing wraps you up? See why I wanted to just get rid of those tapes; have you take 'em to Schumer and be done with 'em?"

"What's done is done, Jake. I'm not sorry for what I did, especially now that I understand about Ford and the others. I'm relieved you haven't used the tapes to try to get money from people."

I looked closely at Jake as I talked. He looked away. I decided to change the topic.

"I'm sorry I couldn't help Neal. I probably wouldn't have been able to represent him anyway. If there are others you'd like me to try to help, you might let me know their names in advance so I can check conflicts before I meet with them."

"Sorry, Tom, I guess I messed up all round. I should have let you know about Neal before you came out here. "

"Nothing to worry about. We enjoyed the visit. Even though I didn't win anything at the poker table. Kind of glad I didn't play Wallace. That would have probably put him over the top."

Jake smiled, but nothing could make him laugh.

"As soon as our pilot gets back I'll have him take you to San Antone. There are flights to Houston five, six times a day."

"No problem, Jake. We appreciate the lift to the airport."

We all sat in the big room making small talk until the pilot returned. We exchanged embarrassed, distracted farewells.

"Y'all come back soon," Belle called after us. Jake said something as well but it was lost in the roar of the copter's motors.

"What the hell happened back there?" Beth asked when we could converse in quiet of the San Antonio airport.

"Neal was trying to get Jake to lend him money. Jake refused."

"I heard Neal say something about blackmail."

"He was making a lot of wild accusations. None of it's true."

"Are you sure?"

"As sure as I can be, Beth."

Chapter 20: Fire

Neal Wallace's visit was the only unpleasant experience we had at the Picosa. In the following months we were frequent visitors. I got a better pair of boots and learned how nylons keep you from getting saddle sore. Embarrassing but effective. That next Christmas, Beth got me a big honkin' silver belt buckle and a string tie and a real cowboy hat, which I wore on every visit. I reluctantly got Beth a shotgun; she had become addicted to the shooting range. Belle made Beth into a crack shot, much to my chagrin. Beth taught the seventy-one year old Belle her favorite form of exercise—belly dancing—much to Jake's amusement.

I never got used to killing animals, but I came to love the early morning rides. I learned the value of monosyllabic conversation and the silence in between that leaves room for the keener sounds of a prairie morning. In the half-light there were subtler demarcations between the riders. We moved as one, like the line of cottonwoods along the river emerging from the morning fog. Here was a place for the heart and spirit. I abandoned my addiction to words and learned how trust was built from the primal bond of the trail.

The bond grew in the evenings, around the fireplace or, on warmer nights, around an outdoor fire pit, where Jake regaled the guests with ever-more-embellished retellings of my first hunt.

Jake's triumph over his personal financial crisis didn't seem to upset anyone besides Neal Wallace. For most, it gave him almost mythic standing. His guests wanted to hang with him and talk to me. They had no idea of my role in Jake's success, but they knew Jake admired my skill as a bankruptcy lawyer. After a day on the trail and the story of my comeuppance they could share their troubles and kick around possible solutions by firelight, the flickering flames half-concealing the worry lines etched around their eyes. Jake's prohibition of "bidnuss" talk was lifted—folks talked "bidnuss"—troubled bidnuss. And I, who had finally learned to appreciate silence, found myself at the center of those fireside conversations, as Jake gladly conceded the stage to me.

One cool evening in October, Jake, Belle, Beth and I were alone. The other guests had left and the four of us had gathered outdoors around the fire pit to enjoy a late snack and watch an approaching storm. Suddenly we heard a ranch hand scream "Fire!" Lightning had set the prairie ablaze just on the horizon. Jake and I grabbed blankets, fire extinguishers and shovels, tumbled into a jeep and joined the ranch hands headed for the glow. Beth and Belle said they would come along.

"You stay here!" Jake commanded. "Hose down the roof and get ready to leave if we need to. These things can move like freight trains."

"Do you think the girls will be okay?" I asked as we careened over the prairie.

"If it gets out of control we'll have to high tail it back to the ranch. Belle's had to fight these fires before, so she knows what to do."

I had never been close to a wild fire. As we approached I heard it roar like an angry beast. The flames were higher than my head. It seemed to be moving towards us. There were eight of us in all, including the ranch hands. We jumped out of the jeeps and

began digging a firebreak—a line across the prairie to slow down the flames. I had never done any serious shoveling, but terror was a great motivator. Out of our jeeps, we were vulnerable to the fire; unable to escape unless we could stop it. We dug like we were possessed. The flames lit our faces. When I looked up I saw Jake, about eight feet from me. He could have left the job to his ranch hands, but he was right on the line with us. I experienced a weird thrill. Jake had assumed I would stand with him, in the path of danger, by his side. We were warriors fighting together. A "band of brothers." We finished the firebreak and stood on the other side, gasping for breath, attacking any escaping flames with blankets and fire extinguishers.

In retrospect, the fire was not that big. The coolness of the evening let us work our hardest and the night was still. Had it been a windy summer afternoon we wouldn't have stood a chance. But the night was calm and we had discovered the fire before it got out of control. When the last flame had been beaten into the dirt, we found the energy for a celebratory jig, covered in soot, laughing like banshees. Jake and I jumped in the jeep and headed back to the ranch, still filled with the feeling of camaraderie.

"Thank God," Jake said. "I would hate to lose this place after all I've been through."

"Yeah, and I would have hated to see those tapes go up in flames." The words had just slipped out, unbidden, from some subconscious cavern where I had stored my curiosity. Jake stopped the jeep suddenly.

"Sorry, Jake. I didn't mean to mention, I mean, I don't know where that came from."

"What makes you think I still have 'em?"

"Just based on what you told Neal and me. And I know how worried you were about letting loose of 'em." The firefight,

the new bond, had loosened my sense of caution. Now I became worried that I couldn't see his face.

His chuckle warmed the darkness between us. "Yup. I still have 'em. I need to find a way to use 'em to get you and Schumer out of trouble."

"Hey, maybe we could leak the word to Baijan that the tapes were destroyed in a prairie fire. Then I could sleep at night."

"You don't kid about those tapes, Tom. I keep telling you, there's nothing funny about 'em."

"I'm not kidding."

"You're still that worried about Baijan?"

"Why shouldn't I be?"

"Well, for one thing, the investigation against his bank has stalled. And he would come to me first, don't you think?"

"I suppose so. So you still haven't figured out a way to deal with him, or to get the University it's two million?"

"I've been working on a few other things."

He leaned into the corner of the driver's seat to face me. As I turned towards him, I could see a few errant sparks in the ruined prairie behind us, rising from the ashes, reaching for the stars.

He coughed; he had coughed a lot that night from the smoke and the effort. I didn't know at the time what that night must have cost him; how the smoke and the exertion must have hurt his already damaged lungs. He pulled out a cigar and I could see his appraising look as the match flared.

"Forget about the tapes, Tom."

"Not 'till I know Baijan and Schumer are happy. When will you forget?"

"Forget what?"

"The assassination, the tapes, everything?"

155

Trip In The Dark by Kaaran Thomas

"Never. I lived it. I'll always have to live with it. It's here," he pointed to his lungs. "I was Kennedy's Secretary of the Navy, you know, 'till I quit to run for governor. Lyndon got me appointed. It's funny, in retrospect, knowing how Kennedy felt about Texans, how he would agree to appoint me. But he and I got along fine, though we never got to know each other that well. He kept to his own kind; his brothers, his Ivy League buddies. Didn't live by the same standards as us. For us, oil was everything, it was the foundation of America's wealth, her power, her position in the world. Kennedy had no understanding of the oil bidnuss. His daddy, the bootlegger, had other ideas. He sent his sons to Harvard and they came out all full of helping the world. But they sure messed it up all right. Messed me up, too."

"How did you find out? About the plot, I mean?"

He started up the jeep.

"Neal spilled the beans when he came to see me at the hospital. I looked pretty bad, I guess. I had suspected something, but wasn't sure. So when Neal showed up I figured I'd put a little pressure on him, see if he knew what was up. He's a funny man, Neal. I had watched the replay of the assassination by that time. I saw the gap in the motorcade between Johnson's car and Kennedy's car. When Neal came to see me he was real nervous – couldn't look me in the eye. Took about a minute to get him to crack. Neal Looks big and talks tough, but one suspicious look his way and he squawked like a jay bird. He apologized all over the place. Said they didn't think it was a good idea to tell me. They never planned for me to get hurt. They would make it up to me."

I can't believe Neal wouldn't have let you in on the plot. Or Johnson.

"Neal, Lyndon, the others, they were my friends. I couldn't believe it either. They couldn't look me in the face. Still can't. They wanted—hell, they still want to do things for me. Give

156

me money; include me in their deals. Now they're angry that I can't give it back, help them out."

We had reached the house. The conversation was over. Belle and Beth came running out of the house. Jake changed before my eyes, from an exhilarated warrior to an exhausted husband. As he got out of the jeep his coughing overwhelmed him. Belle put her arms around him and half-carried him into the house.

"Come on now, honey. The fire's out. Let's get you taken care of. You'll be fine. You need rest. And medicine." Jake was too tired to be embarrassed.

Beth and I couldn't go to sleep. We sat in Jake's big room and talked about the fire.

"I was concerned about you," she said, "but Belle was worried out of her mind. She kept saying 'Jake's not up to this. He's not up to this.' I thought she would have a nervous breakdown."

I told Beth about digging the fire break, and Jake's coughing fits. I didn't mention our discussion.

"Jake's not supposed to exert himself like that. His lungs were damaged by the bullet. He has pulmonary fibrosis. It's a fatal disease."

"Fatal?" My breath caught in my throat.

"Belle says it shortened Jake's life by five or ten years. It's not like he knows when he's going to die or anything, he just knows that he has a serious disease eating away at his lungs. Sooner or later they'll give out. Don't say anything. Belle was worried after she told me. I don't think she meant to let it all out like that."

"Why the hell does he smoke those cigars? That can't help his lungs."

"She says he does it as a cover-up. People think the coughing comes from smoking. She says Jake does a lot of things to cover-up his disease. He's too proud to let on."

We heard footsteps behind us. Belle sank into a chair.

"He's asleep."

"How is he? I didn't realize he had a lung condition."

"For God's sake, don't let him know I told you. He hates to talk about it. Hates for anyone to know."

"He does a great job of hiding it. I had no idea. I'll watch over him in the future."

"I doubt he'll let you. He's a proud man, Tom. In case you haven't noticed."

"I'll be discreet."

"I know you will, but his friends, they all treat him like he's a young man. He stays up nights, works himself to death. He won't hear me warning him. He doesn't want to face up to it."

I digested the fact that Jake had friends; that Belle didn't consider me one of them. The feeling of camaraderie vanished.

"It's time we went to bed," I took Beth's hand and pulled her from the chair. She was half asleep.

"Good night, Mrs. McCarty," I said.

"It's Belle, Tom. You should know that by now."

"Good night, then."

* * * * *

We had beaten back the prairie fire that night. But the flames of the depression were licking at the doorsteps of every Texan. By 1990, Midland was a wasteland of empty streets and rusting oil rigs; Houston was a ghost town of "see through" buildings and downtown Dallas was a thicket of "space for lease" signs. One by one, businesses closed, banks failed, and finally the fire

158

reached me. First City National Bank—our firm's bank and our largest client—was failing. The Office of the Comptroller threatened to close the bank unless a solvent bank was willing to undertake a supervised acquisition. Wainwright was at risk of losing more than ten percent of its revenue if First City failed, and such a blow, coupled with the loss of so many business clients, might destroy even the mighty Wainwright.

Beth's job teaching at the law school was safe because she had tenure. But the school suffered from major budget shortfalls and her salary was cut. Many of her untenured friends and staff were let go. Unable to find other jobs, about to lose their homes, their dreams, they called our house begging for advice, for help. We gave advice freely but, despite Beth's tearful pleas, I refused to give them money. I was worried about our own financial security.

"We can't put our own future at risk, sweetheart. There are no guarantees that we'll survive this, even though we're safer than most."

"But what will become of Lou? What will he do?" She was hunched over in grief, tears dropping onto her lap. Our good friend, Lou Muller, who hosted the faculty Christmas party, had just been fired.

"Lou will find a way. People do."

"But Lou's wife is pregnant. Their insurance is gone. They're about to lose their house."

I could only hold her, rub her back while she cried. Her tears flowed again when Lou and his pregnant wife vanished— Beth called their number to check up on them and it had been disconnected. Many others vanished as well–a horrific disappearing act that left worry and guilt in its place.

At night Beth and I lay beside each other, looking at the ceiling, trying to fall asleep. We whispered dreamily about retir-

ing some day and living someplace on the prairie, in a ranch like the Picosa, in a long low house shaded by live oaks with a river and a line of cottonwoods. Beth would give up her professorship and I would retire from the firm and we would buy horses and build a clay pigeon range for Beth to hone her marksmanship.

And we would have a pet wildebeest.

And we would name him Willie.

Chapter 21: Baijan

The 1980's were ending, but the financial crisis continued. Even though Saddam Hussein was rattling his saber in Iraq, threatening to claim Kuwait's oil fields as his own, the price of oil remained too low to lift Texas out of the recession. In the rare moments between bankruptcy hearings, frenzied attempts to save failing companies and hand-holding frantic bankers, I reflected on how things would have been if Kassem had remained in power and Texas had kept control of the price of world oil. But there was no speculation about these issues in the press or among the TV commentators. Despite the many editorials and specials detailing Saddam's brutal history, there were no discussions of Abdul Kassem or of America's role in his demise.

The first months of the year passed without any contact from Jake. I assumed he and Belle were visiting their daughters or relaxing on vacation somewhere. But once again, Jake managed to surprise me. In April, I opened the morning paper to read banner headlines praising his rescue of several hostages—"guests" of Saddam Hussein who had been imprisoned at various Iraqi military bases. Apparently, their incarceration had been an attempt to deflect attacks from allied troops. The whole world knew war was coming.

Trip In The Dark by Kaaran Thomas

Jake and his longtime friend, Charlie Harrell, got permission from President Bush to visit Hussein as unofficial envoys to try to persuade him to surrender the hostages. Their mission and its success amazed everyone, but no one delved into the reasons behind it. No one asked what leverage they had used in the negotiations. Americans were too happy with the result to question the means.

I had little time to speculate. Two months after the headlines trumpeting the hostage release another feature article disclosed the imminent sale of First City National Bank to a holding company that also owned First Chicago Bank. My initial reaction to the article was frustration. I was a partner and deeply involved in bankruptcy cases for the bank, yet no one at the firm had told me our biggest client was up for sale. I set off for work prepared to storm Reedwell's office. Before I could protest, however, I was informed of an emergency partners' meeting to discuss the situation.

"I am pleased to announce that our largest and oldest client, First City National Bank, has been successfully restructured. It will be acquired by an investor that recently acquired First Chicago Bank." Reedwell looked at me defiantly. "As you know, the bank has suffered from significant cash flow problems over the last two years. The FDIC has worked with our banking section to develop and implement a strategy that will permit this Houston institution to remain in business. We expect the new relationship with First Chicago Bank to provide the cornerstone for growth and expansion—the keys to the bank remaining an important player in the Texas economy."

I was about to ask a question, but another partner preempted me.

"Will the new owners keep us as the bank's lawyers?"

Reedwell coughed and looked down, a sign I had learned to recognize. The firm was probably at risk of losing its most important source of revenue.

"We're negotiating with First Chicago's owner, Mr. Armand Baijan. We've gotten encouraging signals from him . . ."

"Baijan," I blurted. I couldn't restrain myself. He had found a way to avoid all the scandals and investigation and now he would be in Houston, in control of our most important client. And able to pursue his investigation into what happened to the tapes. Able to pursue me. It was as though the old witches' brew of oil, Texas' economy and the Middle East had summoned the devil. Clearly, Reedwell knew who Baijan was. Surely the FDIC knew? How could they let this happen? Reedwell's flushed face, his shoulders hunched in the defensive position, told me this was not the time to ask pointed questions. I needed to let him finish with his presentation, then discuss things in a more calm, less public setting.

Reedwell was clearly trying to put the best face on a difficult situation. He commended the team of banking lawyers who had represented First City in the negotiations with the FDIC; negotiations that had involved the threat of closing the bank. It became apparent as he continued his remarks that First City was in bad shape. I had been aware of their many problem loans, of course. I had represented them in too many bankruptcies not to be. But I never saw the big picture, the scope and depth of the "nonperforming assets" in the bank's portfolio; the lack of sufficient capital; the dramatic impact of the large leveraged loans they had made to the oil companies. The overenthusiastic loan officers, encouraged by bonuses based on loan originations, had relied on appraisals of the companies' oil reserves that assumed the price of Texas crude would continue to climb unchecked for the next ten years, from thirty to a hundred dollars a barrel. When

prices went down instead of up, the value of the bank's collateral and their ability to collect on their loans was destroyed. As I listened to Harry, I reluctantly acknowledged his conclusion. We had to accept the inevitable. The bank was not an attractive asset in a distressed market. Its portfolio of loans was concentrated in the worst performing sector of the economy—oil and gas, oilfield services and Texas real estate. Potential buyers had not lined up to invest. The FDIC had to go looking for someone, had to "encourage" someone to make a bid by offering significant concessions such as loan guarantees and large discounts on the price. Even then, none of the good banks wanted to risk getting involved. Our largest client had become an unwanted nuisance, dumped on the only person interested—Baijan.

Baijan was not interested in acquiring a run-down bank in a depressed economy for its assets or its potential. He would try to use the bank as leverage to get what he really wanted—the tapes. That was the only logical reason for his interest.

I learned Baijan's family had also acquired First Chicago Bank. The Chicago bank was involved in the Charles Keating, Lincoln Savings & Loan fiasco. That colossal failure was already generating criminal investigations into securities fraud, racketeering and conspiracy. Financial panic was not limited to Texas. The Baijans had stepped forward, the only people ready and willing to take the troubled Chicago institution off the government's hands, saving twenty-three thousand investors and sparing the FDIC a major charge on its deposit guarantees. The regulators were not in a position to be choosy. As part of the Chicago acquisition, the Baijans had negotiated a release and waiver of all claims arising from the First American Bank scandal. As Jake had predicted, they escaped and left others, Clifford and Lanier, to suffer the punishment. Their Chicago bank had allegedly turned the corner to profitability. Now the Baijans enjoyed the status of saviors.

I recalled Jake's comment: enormous fortunes rendered their holders immune from retribution. Or perhaps it was something else? Perhaps the Baijans were the source of funding for Jake's new and improved post-bankruptcy lifestyle? Perhaps Jake hadn't told me the whole truth about what he was doing with the tapes? Somehow, BCCI and the Baijans had bought their way out of trouble, stopping the investigation of their money laundering activities in the United States. Was money alone enough to stop something that serious, even with the economy sinking and the federal government desperate to save the banking industry? Or had Jake sold them information they had used as leverage—information they needed to verify or pursue—information that they thought was on the tapes—information Jake hadn't shared with them?

By the end of the partners' meeting I was prepared to be understanding towards Reedwell and the banking section. Reedwell, however, was not ready to reciprocate the good will. He came over and said, curtly, "I want to see you in my office. Now."

"How dare you embarrass me in public, Nielsen." Reedwell was furious.

"I apologize, Harry. I reacted too fast. Your presentation was very good. The bank's situation was clearly desperate."

"Thanks in part to you, Nielsen."

"What?"

"You heard me. How many of these loans have you been able to salvage? You've had a miserable track record. First City 's recovery ratios are pathetic. It's partly due to the fact that you can't get any money out of the borrowers' bankruptcy proceedings. You've been far too sympathetic to the borrowers, no doubt due to the influence of Mr. McCarty."

"Jake paid his debt to the bank in full, with interest."

"Thanks again to Baijan. He overbid for the McCarty papers, apparently under the misimpression that he was acquiring all the material Jake had collected during his career. That's what he was told when he bid two million dollars. But that wasn't true, was it, Nielsen? McCarty deliberately misled him."

"What are you talking about, Harry? I'm not sure what people are telling you."

"Baijan told me. Some of McCarty's material, very valuable material that was supposed to be in the file cabinets Baijan purchased, was missing. It apparently turned up later, in Jake's possession. That's one reason Baijan was interested in Houston. He's moving here. Buying a ranch. He's going to find out about the missing material."

"Why doesn't he just ask Jake?"

"Jake's been rather busy for the past few months. I told Baijan you worked with Jake. I volunteered to ask you if you knew anything about this."

"I was not Jake's bankruptcy lawyer, Harry, as you know. And as far as my representation of the bank is concerned, I have followed the directions of their board of directors, which included you. I recommended trying to come to a deal with troubled companies in the oil patch; I wanted to negotiate for additional collateral to shore up our recoveries, in exchange for extending and reworking the loans. I was instructed that no such deals were possible. I was told to foreclose on the borrowers as soon as possible. No negotiations. Now the bank is suffering the consequences. I got their collateral but I never guaranteed they'd be able to sell it for anywhere near the loan amount. No one can do that."

"Are you accusing me of mismanaging the bank?" Reedwell was yelling, his face was purple, his fists clenched.

Trip In The Dark by Kaaran Thomas

"Of course not, Harry. Calm down. This recession is not your fault. It's not mine either. We both did what we thought was right; we made the best decisions we could. No one should be pointing fingers. It can only hurt the firm, especially with the FDIC and the Baijans looking over our shoulders."

After a minute of silence, the fists loosened as Reedwell's face regained its normal color.

"You're right, of course, Nielsen. I suppose we need to support each other at times like these. Our survival is at stake."

"I'll do anything I can to help, sir. You can depend on me."

"The person you need to help is Armand Baijan. We need to keep him on our side. Any way we can."

"Unfortunately, I don't know anything helpful. He'll have to talk to Jake."

I called Jake's office after the meeting. He hadn't returned from Washington. I left an urgent request for him to call me.

A few weeks later the sale was closed, Baijan introduced himself to the firm as a conquering hero. He knew Wainwright needed to keep the bank's business—they were our largest client. On the day after the takeover, Wainwright partners were "invited" to gather in the bank's main conference room. Once we were seated, the lights dimmed and a giant screen dropped from the ceiling, a military march blasted from the speakers and an announcer intoned, "This is Armand Baijan!" Scenes portraying Baijan's many alleged triumphs rolled before our stunned eyes. When the lights came on, Baijan strode into the room like Napoleon. The banking lawyers all stood up and applauded. The partner sitting next to me said, "Holy Shit. We're in for trouble." But we reluctantly joined our banking partners in a standing ovation.

Jake returned my call the day after Baijan's performance. I was still in shock.

"Where the hell have you been, Jake?"

167

The familiar chuckle, but this time it irritated me. "Just saving the world, Tommy maboy. One hostage at a time."

"Do you know what's happened here?"

"No, I've been in DC, accepting the thanks of a grateful nation, but from the tone of your voice I suspect it's serious."

"Baijan's bought First City."

"What?"

I had the satisfaction of hearing the shock in his voice.

"You heard me."

"That's not possible."

"Wanna bet?"

They're persona non grata with the Comptroller's office, after the First American scandal. There's no way . . ."

"Perhaps they found a way? Perhaps they bought some ammunition to help their case? And by the way, they also bought First Chicago Bank."

"What are you saying?"

"You know very well, Jake. Somehow, the Baijans were able to get immunity from prosecution of the First American Bank takeover. After that, there was no stopping them. Even as desperate as they were I doubt either bank acquisition would have gone through if the Attorney General was interested in pursuing the First American case. The allegations were fairly serious, after all."

"The feds couldn't prove anything anyway." Jake had gotten huffy. "The records had disappeared."

"You don't think Baijan played some part in that? And you didn't think it would do too much damage to give Baijan some additional ammo? Just in case? In exchange for some financial security? Some helicopters for the ranch? Some exotic African specimens for your big game operation? Some cash in the bank to smooth your recovery?"

168

"That's enough, Tom."

"Oh no, it's not enough. Because I can draw lines, make conclusions on my own, Jake. I don't need to be a former Secretary of the Treasury to figure out where the money trails lead. Bankruptcy lawyers are pretty good at that. So let me just speculate about a trail that leads from you to Clark Clifford to Baijan to First American to Saddam Hussein and the magical release of the hostages. Am I on the right track, here?"

Silence.

"But you never figured the deal, the process you put in motion, would end up poisoning First City. Or Wainwright. Or me. Actually, you never even thought about us, did you? You're done with all of us, aren't you? Just like poor old Neal Wallace. We don't matter anymore."

"I had no idea things had gotten that desperate at First City."

"Nor I. Reedwell blames me, by the way."

"You? How in the world . . ."

"I'm the one who represented the bank in all the bankruptcies, got all their collateral back, then caused them to suffer enormous losses when they had to sell it."

"So Harry holds you responsible for the economy?"

"I managed to calm him down, but I'm not sure I'm out of hot water. I reminded him he was a director of the bank and set bank policy regarding taking back the collateral for their loans rather than trying to work with the borrowers. He turned purple, but he knows that if he starts pointing fingers there's plenty of blame to go around. He also accused you and me of hiding assets from your bankruptcy estate."

"What the hell!"

"Apparently, Baijan's failure to honor his pledge to UT came up during the First City negotiations. I guess you couldn't

work a decision to honor that pledge into your little deal? Baijan told Reedwell he had been misled about the contents of your file cabinet. Certain very valuable property went missing, then apparently turned up later in your possession. Wonder how he knew about that? So now he wants more than information from you. He wants the tapes and he thinks he knows how to get them. Much better to have the tapes than to have to buy information piecemeal from you, right, Jake? "

"That scumbag."

"You trusted the scumbag, apparently. So now Reedwell is investigating, hoping to score points with the scumbag at my expense. Reedwell told Baijan I was your friend. Since Baijan saw me buy that briefcase and give it to you, he may have figured out I had something to do with the tapes. So you managed to hurt me as well, put my career at risk. I respected you. Hell, I worshipped you. You were my hero. And you've probably destroyed me. For what? I hope it was worth it. 'Cause you've lost me. And what you've set in motion, it's out of your control now; and if there's justice in this world it will come back to destroy you."

"What'd you tell Reedwell?"

"To talk to you, of course."

"We'll find a way to make this right, Tom. I promise. You don't know the whole story"

I thought I detected the smallest catch in his voice. A shadow, an undercurrent of sorrow I had seen only once before, when we talked about the tapes. For a minute I forgot how angry I was with him; perhaps the sadness was because of me? Could he possibly be concerned about me? I wished we could have had this conversation in person so I could see his face. The thought and the wish died before they could find their voice. The same thought-prayer-hope had visited me that night on the road to Austin, when the car came up over the hill behind me. The hope

that he was on the way to help me; that he cared enough to make the effort. It died the same death. Jake would never do that. It wasn't in his nature. He used everyone. There was no point in asking why.

"Who's 'we'." I threw my anger back at him."

"You called me. Remember?"

"You're right. I called you to let you know. I owed you that. And you owed me the truth about you and Baijan. So, thanks. Now I know."

"That's enough, Tom. Like I said, you don't know the whole story."

"Because you never told me the whole story, Jake. You should never have used those tapes after the auction. Now you have, and now there are consequences. And you can't control the consequences, can you? Secrets don't stay secret, do they?" I realized I was parroting Beth's warning, delivered on that long ago day when I brought the tapes home.

"What's done is done, Tom. We have to figure out where we go from here."

"As I said, Jake, there's no 'we' involved. It's you. You got the benefit of the tapes, now you have to account. Leave me out of this."

"Of course I will, Tom, if that's the way you want it."

"That's the way it needs to be, Jake. This is your problem. And if anyone asks me about it I'll make sure they know that."

He paused as if he wanted to say something more, but he stopped himself. Finally he looked back at me.

"All right, then. Thanks for letting me know. Goodbye, Tom."

An hour after I hung up I began to regret my angry dismissal. It had been the product of frustration rather than clear thinking. What I really wanted was to be part of the solution, to con-

·tinue our association no matter what Jake had done to cause the problem. He had no other use for me. His goodbye meant we were finished. How could I have been so hasty? But there was nothing I could do. I couldn't call him, offer to come crawling back. I would lose whatever respect I had earned from him. "Shit." I cursed quietly. My career was once again in crisis and I would have to find a way out of the problem by myself. I had lost Jake. Why was he so important to me? I had never been able to answer that question, but I knew how acutely I felt his loss, despite everything.

As it turned out, Harry didn't have time to pursue his investigation of Jake's "missing material." He was too busy coping with Baijan, who lost no time taking control of his new plaything. During the ensuing months he grew increasingly brutal, unforgiving and demanding with both the bank and Wainwright. The banking lawyers were terrified. Baijan required each banking partner, including Reedwell, to wear a beeper so he could page them at any time of the day or night. He bullied, intimidated, harangued them until they did what he wanted. Other lawyers, removed from the banking crisis, teased their colleagues, calling them "beeper butts," but I kept quiet. I didn't need more trouble from Harry. And I knew the banking business had to be protected at all costs.

Before long, though, everyone realized Baijan was not protecting his acquisition or Wainwright. He was supposed to build up First City's assets. Instead, he gave every indication that First City was his personal piggy bank. He decorated his office at the bank's expense with millions of dollars of fine art. We heard grumblings from our banking partners about being forced to document highly questionable loans to Baijan's friends. And bank employees were terrified of getting fired if they questioned anything Baijan said or did.

I didn't want to start any new war with Harry, so I held my tongue. Then, after I had been lulled into a false sense of security, I returned from lunch one afternoon to find a message at my desk: "Mr. Baijan will see you in his office at one o'clock." It was twelve-fifty. His office was five floors above mine. I ran like hell for the elevator and arrived at his receptionist desk out of breath and sweating.

"Mr. Baijan wanted to see me."

"And you are?"

"Mr. Nielsen."

"Just a minute."

She picked up the intercom and announced me. "Have a seat," she said. I had a weird sense of déjà vu—my first attempt to talk to Harry Reedwell. Except that time I was desperate to get into the meeting. This time I was desperate to avoid it. Unfortunately, this meeting would not be postponed. After a few minutes, the door opened and Baijan motioned for me to come in.

"Mr. Nielsen."

"What can I do for you, Mr. Baijan?"

"You can tell me where the tapes are."

"Tapes?"

"Let's not fool around. You know what I mean."

Had Jake talked to this man? Told him about me? About my role in the tapes' disappearance? I had to make a quick decision. Admit or deny.

"Sorry, Mr. Baijan, I have no idea what you're talking about."

"Do you understand that I could have you fired from your firm? With one phone call? On the other hand, I could make your life, your career, very enjoyable. It's your decision." He picked up the phone.

I was a poker player, an expert at reading bluffs. I decided he was bluffing. I sat quietly, waiting. He looked at me carefully, then put down the phone.

"Was there anything else I could do for you, Mr. Baijan?"

"You're a cool sonofabitch."

"I'm a lawyer. A Wainwright partner. And I'm afraid I'm not the person you need to talk to. I'm sorry." I got up to leave.

"I am not finished with you."

A stone dropped into the pit of my stomach. I struggled to keep my voice level. "I am always available. You know how to reach me."

"Yes, I do. I have your work number. And I believe your home phone number is 656-9899."

"It's publicly listed. Many clients call me there."

"Your house is in a lovely neighborhood. So many beautiful old homes on North Boulevard. And yours is so large for only two people. Of course, with two incomes you can afford it. And your wife, Beth, has tenure at the University. You are very comfortable."

"We both work very hard. As I said, you are welcome to call me if you need my legal advice. Is there anything else?"

"Not at this time, apparently."

I left his office and went to the men's room. I sat in a stall for a long time, trying to calm down. I had just been threatened. My wife had been threatened. Now I knew what it felt like. Had I given anything away? Had Jake already betrayed me? Why would he? And if Jake had already given Baijan what he needed, why would the man be after me? Surely Jake hadn't told him I had the tapes. So why had Baijan suddenly decided to meet me, try to learn what I knew? Something was going on, something big and dangerous that I knew nothing about. I replayed our meeting

over and over looking for a clue, trying to assure myself that I had thrown him off the scent.

I was tempted to call Jake. But I had driven him away. Anyway, I was too proud. If he had gotten me into this mess he wouldn't help. And if he hadn't there was likely nothing he could or would do. Calling him would just make me look weak. I took a deep breath and headed back to my office.

"I think we need to have our house protected against burglars," I announced to Beth over dinner that night."

"What do you mean, dear?"

"The security people come to your house, do a safety inspection, wire the doors and windows, install motion sensors. It's all connected to a security service like Brinks. If someone tries to break in, or if there's a fire, the system calls them automatically."

"Isn't that expensive?"

"Not that expensive. Lots of the partners are doing it, and I think it's a good idea. There are too many desperate unemployed people running around these days. Break-ins are happening all over the city. And we live in a wealthy neighborhood."

"If it will make you feel safer, go ahead."

So our house was fitted with the best alarm system, a pass code we needed to enter to shut the thing off and a big Brinks Security sign in the front yard. I still couldn't sleep well, though.

No one tried to break in, but Beth and I managed to set off the alarm several times. We would enter the house and forget to punch the security code to turn off the system.

I finally got a clue to Baijan's motivation, though not in a way I would ever have expected.

The call came a month after Baijan's attempt at intimidation. At 5:15 in the afternoon. I was preparing to leave the office. The caller whispered. "Nielsen, I need to see you. It's urgent.

Trip In The Dark by Kaaran Thomas

Meet me at James' Coney Island in fifteen minutes. Don't tell anyone."

I had no idea who it was, but James' Coney Island, a local hot dog place, was a short walk from the office. Curiosity overcame any trepidation. My secret caller turned out to be David Ward. He and I continued to work together on the bank's troubled loans. He had attended some of my bankers' education classes and we had become casual friends. He was one of the few bankers who appreciated my desire to work with the borrowers instead of foreclosing on them, and the two of us came to appreciate and admire each other as the bank's crisis deepened. He emerged from the restaurant to greet me. He had been casing the joint to be sure there would be no witnesses to our meeting. The coast was clear.

"We need to talk. You need to know some things. And nobody at the bank told you what I'm about to disclose. You found out from someone else. Not me. Agreed?"

"Of course, David." I realized I was whispering. He was obviously terrified. After my meeting with Baijan, I understood his feelings.

"I'm going to tell you some things, Tom. I hope they can help you save the bank, but at least you might be able to save yourself. "

"David, what's the matter. Jeezus, man. Sit down. Let's have a beer or something. You need to calm down."

"No, Tom. That's not what I need. And after I tell you what I know you won't be calm either. I was hoping this would work itself out somehow but now I know better. We're finished, I'm afraid. All of us. I should just shut up and let it happen, but I couldn't let this go on without telling someone."

"Have you told Reedwell?"

"Hell, Reedwell's up to his neck in this. The whole damn Wainwright banking section is. I'm not sure what's going on in your firm, but I'm pretty sure most of the partners don't have a clue about what the banking section is up to. Somebody over there needs to know. The only one I know well enough to trust is you."

"What's going on?"

We sat in a booth away from the windows, with a view of the front entrance so we could check out any newcomers.

"We've made lots of questionable loans in the past year, but it's getting outrageous. And there's going to be an audit of the bank. In two months. It's supposed to be routine, a requirement of the Office of the Comptroller, but it won't be. When they discover what's going on, the bank'll be closed."

"What?"

"You heard me, Tom. Unless you can work some sort of miracle we're finished."

"I'm sure you're exaggerating this, David. I mean, if that were about to happen the partners would know about it. And surely Baijan can't be so stupid that he'd deliberately destroy his most valuable possession. "

It was a chilly, rainy February evening. We huddled together like refugees. I ordered coffee, trying to gather my thoughts. I was half-listening to David and half-trying to figure out the tie between Baijan's meeting with me and the impending audit.

"Baijan doesn't seem to care. He's going through the bank's assets like there's nothing to worry about. I don't understand it."

I was afraid I did understand it. Baijan believed he could get enough information to protect himself from any prosecutor. How far would he go to get the tapes?

Trip In The Dark by Kaaran Thomas

"And as for Reedwell and the banking partners, Baijan's got them so intimidated they'll agree to anything. He laughs about them behind their back. When we threaten to call them, tell them about what's going on, Baijan just picks up the phone and says 'Go ahead. They already know.' And they do. They're as afraid of losing the business as we are of losing our jobs. So we just go along. We've all been hoping Baijan had some magic strategy he could pull out of his sleeve. As you said, he couldn't be dumb enough to destroy the bank. But I'm pretty sure he is. He must be involved in much bigger things with the people he's loaning all this money to. So they'll take care of him when we go under. At least, that's the best explanation I could come up with."

"So why did you call me, David? Why do you think I can or should get involved? I have no pull with Reedwell or the firm, unfortunately."

"But surely there are partners outside the banking section who would do something if they knew? I didn't know who else to talk to."

"So what do you think I could do?"

"I'll give you an example. A month ago Baijan brought a memo for me to sign. He doesn't ask me to read those things anymore; just lays them on my desk and says 'Sign here.' This particular time, for some reason, I insisted. The memo approved a fifteen-million dollar loan to Calumet Farms."

I was familiar with Calumet, America's most famous thoroughbred racing stable. I also knew it was in trouble. Racehorses, like any other luxury item, were hard to sell in a recession. Many of Calumet's clients had come from the Texas oil patch.

"What's the problem with the loan?"

"I've looked at their cash flow. There's no way they can repay the loan in accordance with its terms."

"What's the collateral"

"That's the problem. They've already pledged almost all of their assets to other lenders. The only collateral is the breeding rights to Alydar. I'm worried that's not enough to insure we get paid."

"What do you mean?"

"You heard me."

Alydar was a famous racehorse. His three Triple Crown races against Affirmed were legendary. He had retired and was standing at stud at Calumet.

"Stud services aren't much in demand. Bookings are way behind projections. They're making all sorts of special deals to raise money. Calumet used to demand full payment in cash up front. Now it's a deposit and the balance when the foal is born. Customers are requiring them to guarantee a live birth. They've run into problems. Alydar is going to have to be screwing those mares every damn day. And I'm afraid Calumet is on the rocks."

"What's the loan going to be used for?"

"That's another problem. The memo didn't identify how the proceeds must be used. That means it's likely the money will go into the owner's pockets. This smells like another personal favor from Baijan to his buddies. I've told Baijan his friend may not be the owner much longer at this rate but he'll not hear of that. And worse, he required Wainwright to give a bankruptcy opinion."

"A what?"

"A bankruptcy opinion regarding the value of the collateral if Calumet has to file for bankruptcy."

"You're kidding me. No one has discussed this with me. When do they expect me to have that ready?"

"Why do you think we're having this meeting, Tom? Reedwell already delivered the opinion."

"Reedwell knows nothing about bankruptcy."

"That really doesn't matter. Not to Baijan. Apparently not to your managing partner, either."

"But if Calumet fails, if the loan goes into default . . . I don't even want to think about what can happen."

"That's why I'm telling you. This is just one problem. Believe me, it's one of many. But we have to begin somewhere—try to fix things somehow. At least we have to do what we can to protect each other. I'm trying to help you. Will you do the same for me when this thing explodes?"

"I swear, David, I'll do everything I can to protect you. I'm just not sure what that might be. If you can think of something, let me know. I owe you, man."

"That's all I can ask. I'll try to let you know what comes up. Can you do that for me from your end?"

"Absolutely."

We shook hands and he left through the back door. I sat alone, fending off the waitress's attempts to get me to order an "original new improved Coney dog." How could I talk to Harry about the Calumet loan without giving away my source? If I did talk to Harry, what could I accomplish? I feared the bank was beyond help. But perhaps there was a way to protect the firm. And me. If the bankruptcy opinion turned out to be inaccurate, no one would excuse me just because my name wasn't on it. They would see Wainwright's name and blame Wainwright's bankruptcy specialist—me. I was Wainwright and they were me. Of course, if the opinion correctly stated the law Wainwright would be blameless, regardless of Calumet's and the bank's fate. I had to see the opinion letter without letting Harry know.

The next morning I called my deep throat. "Is there a way I can see the opinion? That way, I can let you know if it's correct."

"I'll make a copy and bring it to your house this evening."

I got home late. The letter had already been delivered.

"Someone dropped this off for you," Beth said, handing me an unmarked envelope. "He didn't leave a name."

I opened it immediately.

"It must be important, sweetheart, your hands are shaking. Don't you want to sit down?"

"In a minute."

The letter was a modification of an opinion letter I had prepared for another deal. The letter Reedwell plagiarized dealt with the effect of a security interest in inventory, and Reedwell had assumed that the same principles would apply to the bank's interest in Alydar. The letter had all the standard preliminary language. I raced through two pages of boilerplate. Reedwell had gotten that right, at least. The last page contained the fatal error. I sat down. Reedwell had copied my conclusion. He had overlooked the critical difference between a company's inventory and the offspring of a racehorse. A security interest in inventory usually continues after bankruptcy. A security interest in future breeding rights does not, unless it includes the racehorse itself. Since Alydar had already been pledged to another lender, First City had no security interest in Alydar and their lien on breeding rights and foals would end the day the bankruptcy was filed.

The letter had already been signed by Reedwell and delivered to First City's Board of Directors. There was no way it could be retracted.

The phone rang. Beth answered. I already knew who the caller was.

"Have you read it?

"Yes. It's not correct."

"What do you mean?"

"If Calumet files bankruptcy the bank's security interest will cover live foals or foals in utero, but none he sires after the bankruptcy is filed."

"Then we're dead."

"Why? We may be able to keep Calumet alive for another couple of years—enough time for Alydar to sire his way out of our problem."

"There is no way. We had a meeting with the Calumet board this morning. Things have cratered faster than they expected; faster than they let on when we loaned them the money, anyway. They've already decided to file a Chapter 11 bankruptcy."

"Any idea how many foals are in utero?"

"Not enough. Not nearly enough. And the Comptroller's office is already breathing down our necks. Calumet is just the tip of the iceberg. We'll undoubtedly fail the audit unless we can fool the examiners somehow."

"You don't want to do that. There are worse things than failure. Believe me. There's criminal liability."

"Jesus."

"You should resign from the bank, David. Now. You don't want to be there if this thing breaks."

"And what would I do, Tom? Where would I go? I've been at the bank for twenty years. It's been my life. And no banks are hiring. In fact, they're firing, as Baijan reminds me every day. I've got to ride this thing out, try to salvage something."

"I'll talk to Reedwell, see if there's anything that can be done."

"We could sue Wainwright. They've given us lousy legal advice and now an incorrect opinion letter. It looks like malpractice to me."

"Please don't jump to conclusions. Let me talk to Reedwell."

"I was joking, man."

"I wasn't. Let's talk later. Goodbye."

"What's going on, sweetheart?" Beth couldn't help but overhear my conversation.

I explained the situation

"You should leave that place, Tom. It's bad enough that they don't appreciate you or the work you do. Now they're ruining your reputation. Even worse, they may be dragging you into some criminal scheme."

"I realize that, Beth. I think about leaving at least once a day. But then something stops me. Maybe it's inertia, or fear, or curiosity. Or maybe it's just that old saying: 'Keep your friends close and your enemies closer.'"

"Come have some dinner."

I went into the dining room and sat down, but was too distracted to eat much.

"Want to talk about it?" Beth cleared my hardly-touched plate.

"I just don't know what to do. We've already given the opinion letter."

"Can you withdraw it? Do an amended one?"

"The loan's already been made."

"The loan was a foregone conclusion, wasn't it? The opinion was window dressing."

"Every opinion is window dressing until something goes wrong."

"What will you tell Reedwell?"

Her question summoned an old memory.

"Remember the morning after I came back from the trip to deliver the tapes, when you asked me what I was going to tell Jake?"

"I'll never forget it. I was so afraid for you."

"Are you afraid for me now?"

"No."

Trip In The Dark by Kaaran Thomas

"Why not? Our financial well-being is at stake. Wainwright may collapse."

I didn't have the guts to tell her the other risks we were exposed to.

"We'll manage."

"My reputation may be damaged beyond repair. I'll be blamed for the opinion letter. The bank is talking about suing Wainwright for malpractice. Even though I didn't write it, Reedwell will find a way to pin the opinion letter on me. I may not be able to get another job."

"You will. In this economy you can have your pick of jobs. You're the most famous bankruptcy lawyer in the state. Other firms will trip all over themselves to get you."

"You're just saying that to make me feel good."

"You're blind, Tom. You're absolutely blind to who you are, what you are. After all you've accomplished you still think you have something to prove. I blame it on Jake. He's given you a permanent inferiority complex."

"Jake? That's crazy. How did Jake get into this conversation?"

"You brought him here, remember? You said my question about what you were going to tell Reedwell reminded you of the morning you had to tell Jake you wouldn't deliver the tapes. You're right. Remember how afraid you were then? You didn't know how to solve the problem. But you did solve it, sweetheart. You did. Not Jake."

"This has nothing to do with Jake." As the words left my mouth I realized I had lied. This did have to do with Jake and, more specifically, with the very tapes I had in my possession that long-ago morning. Except Beth didn't know that. She didn't know about Baijan or BCCI or the Network or Baijan's ties to First American Bank or his deal with Jake or his accusation that some of the

contents of Jake's file cabinets were missing. I hadn't told her about Reedwell's accusation that I had something to do with Jake's missing property. Harry's suspicion made my task all the more difficult. I remembered the other part of my conversation with Beth that fateful night, "Secrets don't always stay secret." Now the secrets were leaking into my relationship with Wainwright; my ability to think clearly about the Calumet opinion. They made their appearance at the most inconvenient times, in the dark corners of places where critical decisions were being made.

And they were contaminating my marriage. The unspoken truths about Jake's unexplained wealth, the tapes, the danger, hung between us like an affair. Perhaps I should unburden myself, seek Beth's fully-informed advice, permit her to share our fate with eyes wide open. But if I did that, what would she think of me? I could face losing the bank business, even losing Wainwright and my reputation. Anything but the love of my wife. And her respect. I could not live without Beth.

"Do you want to come back to me now?"

Beth's question startled me.

"You were a million miles away."

"I'm sorry, sweetheart. I'm tired. I have a lot to think about."

My thoughts kept me awake most of the night.

Chapter 22: The Storm

A storm was brewing. The thunderheads hung like sledge-hammers over Houston. There was no wind. The world was holding its breath. I entered our building and headed directly for Reedwell's office.

"I need to see him. It's urgent."

"Let me buzz him."

After a few seconds she announced: "He'll see you."

Until I walked into his office I had no idea what I was going to say. I prayed that inspiration would strike me when we came face to face.

"Harry, we've got a great opportunity, but we need to move quickly."

"Really, tell me."

"I've been approached informally by attorneys for a group of investors in Calumet Farms. Apparently Calumet's about to file bankruptcy. The investors are looking for counsel. The bankruptcy will be filed in Lexington, not a lot of bankruptcy attorneys up there. The investors don't want to pay the New York rates so they're looking at our firm. They're willing to post a hundred thousand dollar retainer. It would mean I'd have to get local counsel in Kentucky but that wouldn't be much of a problem. They don't have to be bankruptcy specialists, just a place I can

work temporarily when I'm there. "I've been hoping for a chance to expand our name outside of Texas and this is perfect. I'm sure it will be a high profile case and the investors will play a significant role."

"We can't do it, Tom."

"What?"

"Can't do it. We have a conflict."

"What's the conflict?"

"First City is a secured creditor."

"Wow, when did they make that loan? Isn't it a bit outside their book of business?"

"Just happened."

"Really? Apparently Calumet's been on the brink of bankruptcy for a year. Isn't that a little risky?"

"We looked at the collateral carefully."

"I heard they'd pledged all their assets. Did the bank acquire another lender's debt?"

"No. It was new money."

"Secured by what?"

"It's a done deal, Tom. Nothing for you to get involved in. Tell your people you're sorry. We have a conflict."

"Obviously I can't represent them, Harry. That's disappointing. I guess the consolation prize is we get to represent the bank. How much did they lend?"

"Fifteen million."

"That's a significant amount. What was the collateral."

"We'll discuss it later, Tom. I've got another meeting. I hear they're not ready to file bankruptcy for a while, anyway. They're still trying to work out a deal with their major lender."

"Harry, I need to know what the collateral was. I'm the bankruptcy expert in this firm. I'm hearing Calumet pledged all its

assets more than two years ago. And contrary to what you're telling me, they're about to file. The bank could be at risk."

"I'm telling you not to worry about it." Harry's voice had changed pitch. I could see his neck turning red at the base of his collar.

"Harry, you need to level with me. Is there something I should know about the Calumet loan? Please don't let me be blindsided by something. It won't do the firm any good to make me look bad."

"That's ridiculous, Tom. There's nothing to hide. We took a security interest in the breeding rights to Alydar, probably the most valuable asset Calumet has at this point. The bank is very pleased. Our lawyers did a great job in finding a way to make this loan work. This loan was important to Mr. Baijan, personally."

"So no other lender took a security interest in Alydar? I find that hard to believe."

"Oh, their senior lenders, the bank syndicate, has a lien on Alydar. They released their lien on breeding rights only, so we could take it as security. Get it?"

"You mean just the breeding rights?"

"Correct. They sliced and diced their stallions every which way. They were desperate."

"I can see that. So how many breedings have taken place?"

"I'm not sure."

"How much per breeding?"

"Fifty thou for the act and another hundred thou for a live birth."

"So a hundred successful births and we're repaid our principal?"

"Yep."

"Hopefully Alydar's been a busy guy."

"It's a floating lien. We get all the money from his foals till the loan's repaid. It may take a few years but the bank'll make out so long as Alydar can perform. And they got a fifteen million dollar insurance policy to back up the loan in case something happens to him."

"Interesting. Only problem is the lien will be cut off by the bankruptcy filing."

"What?" Harry half-rose from his chair.

"Those types of liens that cover property created in the future, after the loan is made, are cut off when a bankruptcy is filed unless the lender has a lien on the originator of the property. From what you've told me the bank syndicate didn't give up their lien on Alydar himself. So what First City got will vanish if Calumet files."

"That can't be right."

"Harry, you hired me for my bankruptcy expertise. I assure you I'm right. Take a look at Section 552 of the Code. I'm surprised the bank didn't require an opinion letter. Everybody knows Calumet is in trouble."

There was a pause.

"They were in a hurry to get the deal done. The Calumet people are personal friends of Mr. Baijan. This was a favor to them."

"So they guaranteed the loan?"

"No. You always come in here with bad news, Tom. You're like a black cloud over all our deals. Can't you ever find something good to say about what we do?"

"My job is to warn our lawyers of problems. Your job is to commend the lawyers for good work. I don't want to tread on your toes, Harry."

Trip In The Dark by Kaaran Thomas

"I'll pass along your comments to the bank. Now, any other cold water you want to throw at me before I have to leave for my meeting?"

"I came in to give you good news, Harry, about a possible important new case. Sorry it didn't work out. I'll keep on the lookout for other opportunities."

"Thanks."

But his voice clearly indicated he was not grateful. And he was lying. Covering up. I had to make a public record of his statements, so if the opinion letter ever came to light it wouldn't be his word against mine.

My opportunity came the following week at our monthly partners' lunch. The firm circulated the usual memo in advance, asking partners to fill speaking slots, discussing interesting new cases. They never got enough responses. Few partners were willing to undertake the effort necessary to prepare an interesting topic. The firm usually had to call people and beg them to speak. The lunch committee was delighted when I suggested an update on hot topics relating to loans to troubled companies.

Reedwell didn't sit on the lunch committee and didn't set the agenda, so he was unaware of my presentation. I was given ten minutes. The lunch was held in a conference room at a local hotel. Reedwell and I were seated at a head table on opposite sides of the portable speaker podium.

I was the first speaker. I began by discussing the volatile environment and the importance of understanding the assets and business plan of a troubled company. I then gave an example— Calumet Farms. I heard a gasp and looked to my left to see Reedwell shooting me a wildebeest-stopper. I ignored him.

"Calumet is an interesting company because they've adopted a strategy that's increasingly used by many troubled companies—the slice and dice. A troubled company has two ways

190

to borrow money. They can look for high-priced subordinated debt, "junk bonds," but that's very expensive for the borrower who's already cash-strapped. The other way to borrow money is to slice up the company assets and borrow against each piece. Sometimes the company can slice a piece off a current lender's collateral. The current lender might not object if the new money will help the company survive and if the slice isn't too important to their security package. Calumet has sliced the value of its prize stallion, Alydar, several different ways and has financed each slice. They've separated him and the right to use his image in advertising and so forth from breeding rights, which they've pledged to our client, First City National Bank. The problem with the First City lien is that it is cut off if Calumet files bankruptcy. I wasn't brought in to consult on this deal, but I'm sure our banking section warned the client of the risk. The bank was apparently willing to overlook it. Sometimes that makes sense if there are other benefits to making the loan. But in order to give good advice to our lender clients we need to thoroughly understand the borrower's business, the market they operate in and all of their assets and liabilities."

I took my seat and snuck a peek at Harry. He had gone white. He was the next speaker, delivering the quarterly financial information. It wasn't good. The firm was owed two million dollars for legal services from First City National Bank and the bill was more than ninety days past due. Reedwell was peppered with questions from concerned partners. What action was being taken to collect the First City receivable? Was the bank in financial trouble? Was the firm at risk? Reedwell informed the partners of the upcoming federal comptroller's audit of First City. He treated it as good news—an opportunity for Wainwright to do significant work for the bank. He emphasized the firm's role in assisting the bank to prepare for the audit and the fees it would generate.

"Hopefully they'll pay us before the audit?" It was a sarcastic remark from Jim Holmes, head of the litigation section.

Before Harry had a chance to respond another partner asked a question: "Is there a chance the bank won't survive the audit? That they'll be closed?"

"Of course not," Harry blustered.

"Of course they won't pay us or of course they're not in danger?" Holmes' remark drew laughter from everybody but Harry and the banking partners.

"The bank won't close and I'll put pressure on them to bring our receivables current prior to the audit. The bank is the firm's largest client by far. We need to do everything we can to keep their business."

"Not if they don't pay us," Holmes commented loudly. More laughter.

Harry had grown increasingly flustered. He wasn't used to being challenged or confronted. He stalked out immediately after his presentation, leaving the room buzzing with talk of the bank and its problems.

When I got back to my office Reedwell's message was waiting. "See me immediately."

I walked into Harry's office unannounced. "You needed to see me?"

Harry was so upset he was shaking. "What the hell do you think you're doing?"

"I have no idea what you mean, Harry."

"Discussing the bank's problem loans, criticizing the banking section. You have no right. No right."

He was purple with rage. I experienced a second of déjà vue. This was a replay of my first confrontation with Jake. Harry was a man in crisis, facing financial ruin; a man who needed my

help. Except this time I had no sympathy, no respect for the man in front of me.

"Harry, I had no idea you would object. You didn't say anything about the Calumet loan being confidential. I was asked if I wanted to fill in a speaker slot at lunch and the Calumet situation was fresh in my mind. I'm sorry if you're upset."

The problem was, I wasn't really sorry. Apparently it showed.

"You knew, didn't you?"

"What are you talking about, Harry?"

"You knew about the opinion letter."

"What opinion letter?"

"The one I wrote on the Calumet loan."

"What? You wrote a bankruptcy opinion letter?"

"I copied one of yours."

"I don't recall writing an opinion letter on this type of loan."

"I used your form for opinions on inventory loans."

"Jesus Christ, Harry. How could you do such a thing? I need to see the letter. There's a chance there's a serious flaw in it. We need to amend it as soon as possible."

"Too late."

"Harry, it can't be too late. We need to discuss this with the bank, explain the error, help them mitigate the damages. We could get sued."

Harry half rose out of his chair. "Don't you tell me what to do, you little upstart. You come in here, we invite you to join our firm, and you make trouble from day one. You think you're better than all of us. You think you can tell us what to do. You don't know anything. You don't even belong here. You're an outsider, an outsider. You'll never be one of us. Do you hear? Do you . . ."

Trip In The Dark by Kaaran Thomas

Harry's tirade was cut short. He flopped backwards in his chair, his face bright red, his mouth open, his eyes rolled back. I ran for the door.

"Reedwell's having a heart attack. Call the ambulance. Get a medic. Get oxygen."

Within minutes, Reedwell's office was a sea of people, bringing oxygen, laying him on the floor, doing mouth to mouth, pounding on his chest, making suggestions. I backed slowly into the hall, out of the way.

"What the hell happened?" It was Sandy Farber, a senior partner and member of the management committee.

"Nielsen went into his office, then I heard Harry shouting." Harry's secretary looked at me accusingly. "Then he had a heart attack."

"I guess my lunch presentation upset him. God, I'm so sorry. He was so angry. I don't understand why."

"I do," Sandy said. I was relieved he didn't appear upset with me. "I was part of the team that put together the Calumet loan. Baijan wanted it done immediately. No due diligence, no delays, no excuses. Harry tried to insist on having you review the loan. He said there might be bankruptcy issues, since Calumet was in so much trouble. Baijan blew him off, told him to put something together to paper the file. He threatened to fire us if the loan didn't go through. Harry was worried, Tom. He didn't want you to know. Today you confirmed his worst fears. Hell, you confirmed mine. This whole bank business has gotten out of control. Something has to happen. Probably the audit will bring it all crashing down. I don't see any way the bank will be able to pass muster with the feds."

Sandy looked almost as bad as Harry. I couldn't resist laying a comforting hand on his shoulder.

194

"You guys have been carrying the weight of the world on your shoulders." The look on Sandy's face confirmed my observation.

"I don't mean to upset firm procedures or anything, but I really think you should have talked to me, to all the partners about all this. The bank is Wainwright's problem, not Harry's or yours. We understand how important bank business is, but we can't let ourselves be bullied like that."

"That's fine for you to say, Tom. You don't understand."

"The hell I don't understand, Sandy. I deal with troubled companies. The bank is one. Apparently Wainright is another. I could help. There are time-tested strategies you can use when customers slow-pay receivables, when business tapers off, when the country is experiencing a recession."

"Harry would never come to you for help. He's too proud. Don't you understand that? You're an outsider."

"That's bullshit! I'm a partner in this firm. I'm as much a part of Wainwright as you or Harry or anyone else."

"You didn't grow up here. You don't understand how things are done, how proud Harry is of being managing partner, how much the banking business means to him. He's spent his whole life in banking. Did you know his first job in high school was mail boy in the bank? He loves First City. It's like his child. Along with this firm. You weren't here when Harry was elected managing partner. His acceptance speech—he was so choked up he could hardly finish. He said it was the proudest moment of his life, and he would devote the rest of his life to making the firm proud of him. And now he feels responsible for destroying everything that ever mattered to him."

"This is not his fault. It's not your fault. It's Baijan. He's a criminal. He destroys everything he touches."

Trip In The Dark by Kaaran Thomas

At that moment the paramedics arrived. We watched as they loaded Harry's inert body onto a stretcher. As they rolled him away the beeper on his butt began buzzing. It buzzed and buzzed like an angry insect till the stretcher disappeared from sight.

"Point made," said Sandy, watching our managing partner disappear. "But what could Harry or you or anyone of us do about that man? Harry knew Baijan was trouble. He thought someone with Jake McCarty's political clout might be able to help us. He's tried to get Jake involved over the past few months, but Jake just brushed him off. Maybe that's payback for the way Harry treated Jake when he had to file his own bankruptcy."

I tried to hide my surprise at the news. I would never have thought Harry would have been desperate enough to call Jake. I almost lost track of what Sandy was saying, trying to imagine that conversation. I finally realized that Sandy was looking at me expectantly. "I didn't think Harry had a choice. Jake couldn't stay with the firm, simple as that."

"Oh it wasn't about Jake's leaving the firm." Sandy stopped and looked at me. "It was about you."

"Me?"

The crowd in Harry's office began to disburse. "Let's go to my office," Sandy suggested.

"How about my office? Your phone is going to be ringing off the hook, Sandy. And I'd like to hear what you meant by that remark."

"Tell you what. I doubt either of us is going to get a lot of work done today. I suggest we adjourn to the bar."

The bar was in the hotel across the street from the office. It was empty. We settled into a booth.

"I'm buying," I said.

196

"Based on the financial condition of the firm, we should probably go Dutch treat." Sandy reached for his wallet.

"Hell, I know what. We'll charge this on the firm credit card!" At least I could make my distraught partner laugh.

"So what was it about me that made Jake upset with Harry?"

"No. The other way around. It was Jake's relationship with you that got Harry upset with Jake."

"Now you've completely lost me."

"Remember when Jake joined the firm? That was right about the time you came on board. Jake was a huge catch for Wainwright. He had dozens of job offers. Harry led the negotiations to get Jake to join us. Harry had just become managing partner. It was a big assignment for him and he pulled it off. He expected he and Jake would become best buddies, I guess. He helped the McCarty's find a house here in Houston; he invited them over for dinner just about every week; introduced them to all his friends. McCarty never returned the invites. Word got out around town that McCarty had decided Harry was just another sycophantic blowhard. McCarty's words, allegedly, not mine. Harry heard about it. You know how sensitive he is. Then McCarty turned around and befriended you. Hell, he practically made you a partner. You were a nobody and he took you under his wing, anointed you his protégé. And even Harry had to acknowledge you. He had no choice. Jake was a powerful man and he wanted to put you in all his deals. You with your bankruptcy opinions. Harry was furious. And when McCarty began to have financial problems, Harry saw the chance to get his revenge."

Sandy held up his hand to stop my protest. "You and I both know Harry has a rather large ego. And, frankly, he can be petty, especially when he feels threatened. And Jake had threat-

ened his reputation in the community. He didn't just ask Jake to resign. He berated Jake in front of other partners; even firm clients—clients Jake had brought to us. He paid Jake back for every insult, real and imagined, he'd suffered at that man's hands. And he was going to do the same to you. Trust me. But you had become so powerful in your own right, it wasn't possible. And that had never happened before in Wainwright history, as far as I know. It had never happened that a partner had become so dominant, so important to the firm, that he was immune from political attacks from the managing partner. Not only that, you made him look like an idiot in front of all the partners."

"That wasn't my intent, believe me. And as far as my power in the firm, don't you think the economy had a little to do with that, Sandy?"

"Of course. Of course. Harry never figured on this goddamned recession getting so bad or lasting so long like it did. None of us did. Hell, nobody in Texas did except maybe you. But that got Harry even madder, because you had predicted this. It was like, like you just walked into the firm and changed everything and the firm had to play by your rules."

"Jesus, Sandy. I had no idea what was going on."

"You're kidding."

"No, really. I was so busy trying to handle all the business, all the financial crises for all the clients, I never had time to pay attention to firm squabbles."

"That's the other thing Reedwell hated . . . hates . . . about you. You didn't care about firm politics. People like that usually last about a year at Wainwright. But you managed to be above it all. To us, who grew up in Wainwright, firm politics is everything. To be made partner, to be on the management committee, to be head of a section, to be managing partner, that's what we live for. You never seemed to care about any of it."

"You sound like I pissed you off, too."

"Let's have another round."

Sandy ordered Glen Livet on the rocks and sipped it slowly. One drink was my limit so I ordered tonic water.

"And to top it all off, the man's a teetotaler," Sandy commented before downing his second drink in one gulp. We sat in silence for a while.

"Things have to change," Sandy finally said.

"I want to be a part of the change."

"You have to be. First of all, we need to get you on the management committee. I'm sure there will be an emergency meeting to decide what to do in Harry's absence. I'll bring it up, try to get them to appoint you an ex officio member. We can do that without a full vote of the partnership. I think you have to be the catalyst. Because you are the outsider, like it or not. We really don't have the ability to see ourselves, see what direction to take."

"We're not so different from other troubled companies. Frankly, I doubt I'm the right person to decide what direction the firm should take. I'm more of an implementer. But I can introduce you to great consultants who specialize in helping professional firms. Maybe you should consider getting one involved. Especially if First City craters."

"It may very well crater, Tom. And faster than you think."

"Then we need to act quickly."

"That's not possible for Wainwright. All I can do is work with the management committee, try to get you on board. There are ways of doing things . . ."

"The old ways, Sandy. We need the new ways to start. Now."

"See why you're an outsider?"

Trip In The Dark by Kaaran Thomas

The storm crashed over Houston like pent-up fury. High winds made foot traffic impossible. We took to the tunnels that ran under downtown streets. Rain came in sheets so thick they stopped traffic. The bayous filled, then flooded. Careless motorists were swept away. Employees were told to stay home if commuting would involve any risk. Partners didn't have that luxury.

I became an ex officio member of the management committee. Sandy served as my advance man, along with Jim Holmes, who had asked the tough questions of Reedwell at the lunch. The rest of the committee members agreed. They clutched at straws; I was shocked to learn they thought I had an answer to Wainwright's problems. After two days of meetings we all realized the problems were too big for us to handle by ourselves. And our problems were dwarfed by the crisis at First City. As the audit loomed, First City bankers and their allies, Wainwright's banking partners, huddled together in damp, miserable clumps, praying for salvation.

Harry had survived but his condition was critical. He was unable to communicate. In Harry's absence I came to realize his importance. It was funny because the same thing had happened when I parted company with Jake. Harry's self-assured, solid presence was an anchor. Harry was known and liked by the firm and by most of our important clients and the people in the community. He had been elected to manage the firm and the firm was accustomed to his leadership. Without him we were adrift. The rudderless management committee met, circulated memos, met again, circulated amended memos. They listened to my suggestions, debated, listened to other suggestions, debated again. No decisions were made. Everyone waited to see what would happen to Harry. It seemed as though he was as important to Wainwright as First City.

Trip In The Dark by Kaaran Thomas

"Waiting is the worst thing we can do," I urged for the umpteenth time when another of my suggestions was tabled. "It's just another name for drifting. We're headed for a waterfall. We need to start paddling."

Sandy appreciated the analogy but he was powerless. Paddling was not the Wainwright way.

"Maybe we should get a paddle for ourselves," Beth commented over breakfast as we watched the floodwaters rise above the curb in front of our house. We were in our fourth week of constant rain. The university was closed, the law school flooded. Wainwright lawyers were working from home as much as possible; avoiding the waterlogged roads and dangerous underpasses.

The rain had forced Beth and me to stay home together for longer periods. I was able to fill Beth in on all the remarkable developments of the past month. Her opinion remained unchanged: "Leave." She was also thinking of leaving the university.

"I guess I've gotten bored with it," she admitted. "And tired of dealing with the administrators, the bureaucrats. They were always a nuisance; but now, with the budget crunch, they're impossible. They block every suggestion. Their solution to everything is to cut back on staff and supplies. And the students have changed. They're all desperate to find jobs. I guess that was always important, but they were never violent about getting a good grade. I've been threatened by a student for giving him a "D". He deserved to fail. I thought I was doing him a favor. He had the nerve to tell me he would make trouble for me if I didn't give him a "B." I asked him why he deserved a "B." You know what he said? He said 'I need a "B" to graduate.' Can you believe that? What's this world coming to?

"What would you do?"

"I don't know yet. Perhaps work for some nonprofit? There are so many deserving charities out there that need counsel

but can't afford to hire them. But I want to see what happens with you and Wainwright first. I don't want to make a move that would put us in jeopardy."

I appreciated her concern. For the past few months her salary had been our only regular source of income. Wainwright partners weren't getting paid. The firm needed all its revenue for employees and overhead. Beth's paycheck wasn't big but it paid the mortgage. I wondered how all the other partners with their stay-at-home wives were managing to pay the bills.

"I promise, sweetheart, that as soon as things settle down I'll do whatever I can to support your job search. It's a shame to waste your talents on a place that doesn't appreciate you."

"Ditto, sweetheart."

She gave me a peck on the cheek. I took her face in my hands and kissed her on the mouth. She led me into the bedroom, where we took advantage of the rainy morning to indulge in some extended lovemaking.

"That was wonderful," she sighed, resting in my arms afterword. "Why don't we do it more often?"

"We've been so busy, so concerned with everything, and we both come home so tired. I can think of a few other reasons, all related to stress."

"It will end, sweetheart. It will. It has to. Nothing lasts forever. "

"Right, and every cloud has a silver lining and there's a rainbow after every storm and"

"And people live happily ever after."

"Amen."

"If only Jake were here."

Beth jumped out of the bed like it was on fire.

"Jake! It's always Jake. Even here, even when we're lying in bed together!"

202

"It's not always Jake, sweetheart. I haven't even mentioned him for a month or so."

"Very funny," she said over her shoulder as she headed to the bathroom. "You know what I mean. He's the first person you think of in any emergency."

"Not true. You're the first person. Then Jake."

"Cut it out, Tom. I'm serious."

"Me, too. I need Jake right now. If he were at Wainwright he'd be stepping in, taking control. He's that sort of person. And they'd follow him. They won't follow me. That's all there is to it."

"What you're saying is, Wainwright needs Jake. You don't. You need to listen to me. You don't need them. Just leave. You can't go back to the way things were. Jake can't come back to Wainwright. You can't undo Harry's heart attack. You can't make them do something they don't want to do."

"I have to go. The rain's slowed and I'm going to try to make it into the office."

I got up reluctantly and threw on casual clothes. There was no chance of a court hearing. The federal building was flooded. All hearings had been cancelled.

"I'll see you tonight," Beth called as I left.

"It may be sooner. I have no idea what's going to happen today."

"I'll try to get to the store. I'll get supplies and look for a paddle."

"Good girl. Be careful."

I arrived at work to find a message from Sandy: "See me asap. I'm in my office."

"What's up? Another amended management committee emergency meeting?"

"Alydar's dead."

"What?"

Trip In The Dark by Kaaran Thomas

"Broke his leg in his stall last night. Had to be destroyed this morning. We're saved. Thank God, the bank at least got insurance on the collateral. Fifteen Million Dollars. The proceeds should help their capital situation, they may have a chance to survive the audit."

"That's awfully convenient for the bank. Are they sure there's been no foul play?"

"I thought the same thing. But so far nothing's surfaced."

"If you thought it and I thought it others are thinking it. Insurance companies are suspicious by nature. Let's hold our breath."

We didn't have to hold our breath long. The nightly news featured the story and the suspicions. Alydar's screams had brought stable security running. His left hind leg had been shattered beyond repair. He had to be euthanized. The owner said the stallion had accidentally hurt himself, but circumstantial evidence indicated foul play. Alydar's groom had been told to take a week off the night before the accident. The vet who oversaw the euthanization speculated there was no way the big horse could have broken his own hind leg as the owner had described. He surmised that a truck had been driven into the barn, a rope tied to Alydar's leg and the leg pulled until it shattered. The insurance company was demanding an investigation and delaying any decision to honor their fifteen million dollar policy. Insurance executives told reporters they had received enraged demands for payment from Baijan himself.

During the following month the financial storm crashed over us. The Comptroller proceeded with the bank audit over Baijan's frenzied objections and discovered what we already knew: the bank was hopelessly insolvent. No other bank would even think of taking it over. Baijan's Chicago bank was in the same shape. Both banks closed, putting over a thousand employ-

204

ees out of work in Houston and devastating Wainwright. Over a million dollars of Wainwright's revenue—which Baijan required to be deposited in his bank—was lost. The FDIC guarantee covered only a hundred thousand dollars. Even worse, Wainwright was stuck with over two million dollars of unpaid legal bills. I remembered my "gentlemen's agreement" with Reedwell—I would never try to join the prestigious banking group. Now the mighty banking partners appeared before the management committee, one by one, to convince us to let them keep their jobs. Banking business was finished. Word got out about Wainwright's involvement with questionable loan documents. The publicity scared off several of Wainwright's largest remaining clients. The banking section was clearly to blame. Was it right to chastise them, point the finger of blame, fire all of them? The looks on the faces of the committee members, their guilty glances at each other told me to proceed with caution.

"We can't move too quickly on this," Sandy observed. "It will look like we're disintegrating."

"We are disintegrating," I replied sadly.

"We know, but to let so many senior partners go, to destroy their reputations, throw them out on the street, how can that help us?"

"How can we afford to keep them?"

No one answered my question. Two members of the committee, including my friend Sandy, were partners of the banking section. There was no easy answer. How could I kick my friends out of the firm? Such talented people? So many years of loyal service?

Of all the nightmares of that nightmarish time, the worst was David Ward's visit to my office.

"Got some time for me?" He poked his head through the open door. I had been so wrapped up in the crisis I had completely forgotten him. His appearance stabbed at my heart like a knife.

"Come in, come in. I've been meaning to call you when things got more settled. So we could sit down and work out a plan."

"I'm afraid it's too late for plans, Tom. At least for plans that involve you and me."

"David, I don't know what to say. I'm so sorry. I wish I could do something. I just haven't figured out what."

"Hey, it's OK, man. I'll figure something out. And I'm luckier than most of the staff. The FDIC kept me on to help wrap things up. I've gotten a few extra paychecks out of it. My retirement account is gone, though. It was all bank stock."

"The bank was your life, you said. Wainwright was mine. Looks like we both have to find a way to start over."

"I like your chances better than mine, Tom. "

"Don't say that, David. You have a great skill set and you're a great man. I'll keep my eyes open for you. Can I get your phone number?" I remembered all those university employees who had given Beth their numbers hoping she could help them somehow. David's hand shook as he wrote it down on the back of one of his First City business cards and handed it to me.

"Guess these aren't good for much of anything anymore."

"You'll find a way out of this, David. I promise. I'll do everything I can for you. I won't forget."

"Thanks, Tom." His voice didn't carry much enthusiasm. "You take care."

And he was gone. I did something I hadn't done since I was a child. I closed my office door, sat back down at my desk, put my head in my hands and cried.

Chapter 23: Making Up

The firm was in gridlock. We didn't have the will to make difficult decisions, but we couldn't afford not to. Some of our partners, including me, were still bringing in business, but my main client was the FDIC, successor to First City National Bank. Productive partners were getting tired of sharing their income with the banking partners. Talented lawyers were threatening to walk out. Many of them came to me asking if I would go with them.

"We can start our own firm, Tom. We don't have to put up with this. It's not fair to us, and, frankly, we don't see that the banking partners would have given us a break if the situation was reversed." Jim Holmes had invited me for a drink after work. We sat in the hotel bar where I had sat with Sandy a lifetime ago and learned the truth about my relationship with the firm.

"You don't have to tell me, Jim. I've been told to my face that I was dispensable; that my career would last only as long as the recession. And that was after I became a partner."

"Those bastards. They deserve everything they're gonna get."

"So you don't think the Wainwright name is worth preserving? You're ready to walk away from seventy years of history?"

Trip In The Dark by Kaaran Thomas

Jim looked down. "I can't believe you're asking me the question, Tom. You weren't brought up in the firm."

"I know, the Wainwright way."

Jim laughed sadly. "Right. Mighty Wainwright."

"You haven't answered my question, Jim."

"The answer is . . . I don't know what the answer is. I just know I can't support those guys. It's not in my budget. I have my own family to look out for. And the banking partners are high maintenance. You know what their draws are."

"I just wonder if there's some way to keep them on some reduced basis. Maybe not even pay them a draw. Let them stay as long as they can contribute something to our bottom line. Hell, it's not like we need their offices for anything. And frankly we need some revenue to help cover our overhead. Every penny helps. Meanwhile, we can see if they could be retrained. Make them go out and look for business. Help them learn to handle it when they bring it in."

"I'd support something like that. I'm sure most of us would. But I don't see the banking partners going for it. They're a bunch of vain s. o. b.'s. They'll never agree . . ."

"Unless Harry agreed." I finished his sentence for him.

'You need to go talk to Harry."

"Is he up to it? My last meeting with him didn't go so well."

"You need to try, at least if you want to save the firm. I'm not sure why you would even care, frankly."

"Maybe it's because I've seen Wainwright as an outsider. I remember how important I felt the day I was offered a job here. The day I learned I would be a partner. I think we forget what we mean to the community. We're a symbol for them. A symbol of pride and tradition. And frankly they need symbols just now. And besides, my life has been working with troubled companies and

208

this would be the biggest troubled company I ever worked with. If I can turn it around it'd be a tremendous feather in my cap."

Jim laughed. "So that's what we are for you, another troubled company."

"You can believe that if you want. If you have a hard time accepting that I could be more loyal to Wainwright than you."

Jim looked into his glass. After a minute he swirled the bourbon around a few times, swallowed it in one gulp and shook his head. "They say the converts are always the most religious. OK, Tom. Go talk to Harry. We can wait a few weeks."

I did something I would never have dreamed of a year earlier. I went to see Harry Reedwell.

I called his home and asked his wife if I could visit.

"Let me check with him, Mr. Nielsen. He's not seeing a lot of people right now. He's in a good bit of pain."

"I can imagine. I don't want to disturb him, but it's important. Please ask him and let me know."

I held for a few minutes. At least I would give Harry the pleasure of turning me down.

"Would you like to come after work? Around six?"

"That would suit perfectly, Mrs. Reedwell. Tell Mr. Reedwell thanks."

I stopped at a florist to get an expensive bouquet of flowers. I stopped at a liquor store to get a bottle of Harry's favorite scotch. I was beginning to learn the Wainright way.

"These are for you, Mrs. Reedwell." I held out the flowers. "How are you holding up under all this?"

"Why thank you, Mr. Nielsen." She took the bouquet and reached for the scotch.

"Please call me Tom. I meant the flowers are for you. The scotch is for Harry."

She laughed.

Trip In The Dark by Kaaran Thomas

"Now, y'all are just makin' a lot of work for me, trying to keep him away from this. He's gotten pretty feisty lately. He hates sittin' around when the firm is in so much trouble. Oh, dear. I'm not sure I'm supposed to know about all that."

"You're obviously an intelligent woman, Mrs. Reedwell. I'm sure Harry gets a great deal of comfort and satisfaction from consulting with you."

That produced a blush and a "Please, Tom, call me Louise."

First step, win over the wife. Mission accomplished. She led me into Harry's study, where he had set up a makeshift office.

"Harry, look who's come to see us. He brought lovely flowers for me and a bottle of Chivas for you, which I told him I'd keep for when you're better."

"She's become my jailer, Nielsen. What am I going to do?"

"I suggest you get back to the office as soon as possible. We need you."

He was unable to hide the pleasure that spread across his face like sunshine.

"Louise, why don't you leave us to chat?"

"Okay, dear. But I'm takin' the scotch with me."

Harry's laugh was cut short. The doctor had had to crack his chest and his stitches were still giving him trouble.

"So how are you, boss?"

"I've been better, Tom. But I'm managing. I think the partners are tired of all my phone calls, though."

"Nah, they look forward to them. Couldn't do without them, in fact."

"Are you suggesting I communicate more often?"

"Absolutely. That's one reason I came to see you. We need you to communicate a new direction for the firm."

"So you think they miss me?"

210

"Of course. Me, too, Harry. You're our flag bearer. We're adrift without you."

"I have to say I'm surprised to hear that coming from you."

"Perhaps it's a lesson I've just recently learned. But I wanted you to know how I feel. Especially after our last meeting. There were some hard words exchanged."

"Mostly from me, as I recall."

"It takes two to argue, Harry."

"Yes it does, but I've done a lot of thinking about that conversation. I have to admit, you were right. But I was also right. You are an outsider. You don't do things our way."

"Maybe that old way needs to change. We're facing a whole new world right now. The firm is split into two groups. The partners who are still bringing in money and who are tired of sharing it with the banking section, and the banking section who thinks they're entitled to stay at any cost. We're going to have to adjust."

"Are you saying you want me to help you fire the banking section?"

"No, though that's what a lot of the litigators want."

"Holmes. He's always been a troublemaker."

"That may be, but what if he leaves the firm and takes all the litigators with him?"

"He wouldn't do that."

"He will, unless we can do something. And fast."

"And you would go with him, I suppose?"

"I'd like to stay, to find a way to save the best of the old Wainwright. But we have to make some changes. We don't have the money to go on the way we were."

"So you're here because you see me as the old Wainwright?"

"I'm here because I owed you a visit. But to answer your question directly, no. I see you as the leader of our firm. Wainwright is like a big ocean liner. It doesn't change course by itself. It can't. If the ship is going to change direction it has to be on captain's orders. You're the captain and everyone knows and respects that. And you're the one who would best know what of the old Wainwright needs to be preserved, and what needs to change. I'm only a member of the crew."

"You're a bit more than that, Tom. I think you've been promoted to first mate."

"Reluctantly. I've never had my eyes on a management position. That's not what I'm cut out for."

"I've heard you feel that way. Problem is, you do it so well."

"Not really. I have good ideas, I certainly know my area of expertise, thanks mostly to the cases I've been able to work on here at Wainwright. But leading, managing, that's not something that comes easily to me."

"So what good ideas do you have to get us out of this mess?"

"First, I disagree that we should let the entire banking section go. I think that would demoralize the firm. Hell, it would probably be the end of us. On the other hand, it's clear that banking business is gone. The banking partners need time to regroup, retrain themselves, find new business and new clients. In the meantime I think they're going to have to take a pretty big cut in income. The ones who are willing to do that, to forego taking a distribution except from whatever they bring in after they pay their overhead, should be welcome to stay. The others—we can't afford to keep them.

"And how do you propose to convince us—convince them—of that?"

212

"I was thinking you would do it."

Harry burst into laughter, then bent over clutching his chest. "Goddamn, Nielsen. I never know what to expect from you. You are sure full of surprises. And what, exactly, would you propose I use to convince them?"

"If we put the plan to work, Holmes will stay. So will most of the litigators, I think. They'll follow Holmes. If we don't they'll leave. Wainwright will be finished."

"And you, Tom? What will you do?"

"I'd like to be part of the new Wainwright. I think we can beat this thing. We have so much talent, so much tradition. The community will get behind us if they see we've got our act together. I hate to see the firm die. Hell, I've just got here."

"I'll think about it."

"I don't mean to rush you, but we don't have a lot of time. Probably to the end of next month, at most."

"I understand."

"The firm needs you, Harry. You're the only one who can save us."

Once again the flush of pleasure brightened his face.

"If you come back, I promise to try to be more like you. To learn the Wainwright way."

"Maybe I could learn to be a bit like you," he said, half-jokingly.

"An outsider, you mean? An upstart?"

He tried to laugh again. "As you said, Tom. We need to combine the old and the new. Maybe each of us needs to become more like the other."

"I never thought of it that way. But I'm happy to try if you think that's the way to go."

"I do, Tom. And thanks for coming to see me. I appreciate it."

Trip In The Dark by Kaaran Thomas

Louise returned to cut short our conversation.

"Time for dinner, dear. Would you care to join us, Tom? I'm sure there's enough for three."

"Thanks, but Beth is expecting me home."

"Of course. Some other time, then. We need to get together, the four of us. At the club."

"Look forward to it."

I surprised Beth over dinner. "Guess who I dropped by to see on the way home?"

"No idea. Who?"

"I'll give you a hint. They proposed a tewst to the new Wainwright."

"Not Mr. and Mrs. R?"

"The very ones."

"Why?"

"To smoke the peace pipe, or drink the peace drink, or whatever. It needed to happen. Wainwright won't go anywhere until Harry feels comfortable about coming back and working with us on a new direction for the firm. If I can't convince him to help make some of these tough decisions about the banking section we're finished."

"You mean he needs to help you?"

"Unfortunately for my ego, that's correct. I might have the world's best ideas about where the firm should go, but the partners won't follow my lead. They're waiting for Harry."

"So were you successful?"

"He said we should get together at the club. Just the four of us."

"Wow. Have we come up in the world?"

We used to be guests at Jake McCarty's ranch. Now we'll be dining at the club with the Reedwells. I'm not sure if that's coming up or a comeuppance."

214

"I'll tell you what it is, dear. It's a chance to shop for a new dress."

"Why hadn't I thought of that?"

Chapter 24: Charlie

I welcomed nineteen ninety-one with a case of déjà vu. I sat at my desk wondering how the hell I could save my career, just like I used to do in my first months at Wainwright. Sure, my desk was a lot bigger and the office was actually Jake's old office, but the choice was the same: stay with a sinking ship or take my chances on my own. Harry and I had fashioned a fragile peace and he returned to work. Each of us promised the firm to try to incorporate the best parts of the other; forgive each other's trespasses and give our best efforts to saving Wainwright. But the amalgamation was not easy.

The firm's continuing crisis made everything difficult. The banking partners didn't warm to our idea and Harry had a hard time telling them it was our way or the highway. Many of them had been his friends since they joined the firm. It seemed the entire state was focused on Wainwright, waiting for our collapse. New clients were hard to get. We had to offer the lowest rates and the best service in order to compete with other established Houston firms.

We also had serious cash flow problems. Partners were still not guaranteed regular monthly draws; but finally we reached an uneasy truce with the banking section. For the time being,

each partner would take home what they brought in each month, after payment of bills, salaries and reserve for emergencies.

First City's failure had not only damaged our reputation, it had left a three-million-dollar hole in an already fragile balance sheet. The sense of camaraderie we had generated when Harry showed up at the office and the two of us conducted a management committee meeting together had faded when our joint efforts failed to produce immediate results. People began to doubt, several of the more prestigious banking partners left, along with several profitable young litigators. In some respects their departure was a blessing—we couldn't afford to keep them. In others it was a curse—the public and our clients saw rats leaving a sinking ship. But Holmes stayed, and so did I. Harry and Sandy convinced their reluctant partners to come to grips with a new reality. "The new Wainwright."

Every time someone knocked on my office door I felt a moment of hope—maybe Jake would walk in and say "Howdy!" and pull me out of the mess. I had an open door policy. I never got over my hatred for Harry's requirement that visits be by appointment only. People in crisis needed immediate access to the decision makers. Anyway, I liked the surprise, despite being constantly scolded by my secretary.

I didn't expect a visit from Jake, of course. No matter how much I wished for it. I hadn't seen him for more than a year. He had never called to give me a chance to explain why I was so upset, or to apologize. I had undoubtedly alienated him forever. Wainwright's situation had been the subject of several newspaper articles and a Texas Monthly cover: "End of an Era," detailing Reedwell's medical condition, the dissolution of the once-mighty banking section and the firm's loss of business and reputation. Jake knew what was going on. He probably knew more than I did.

In response to my "Come," the door opened.

Trip In The Dark by Kaaran Thomas

Jake walked in.

"Howdy!" He smiled, sat down, put his boots up on my desk and offered me a cigar. "How the hail areya?"

The urge to jump up and hug him was almost irresistible. I had forgotten the largeness of his presence, the way he could fill up a room all by himself, the power, confidence, humor that radiated from him like warmth from the sun. I also noticed little changes in him. They would probably have been imperceptible to people who saw him every day, but they were obvious to someone who had imagined his presence in their office for more than a year. His six foot-two inch frame was leaner, but he still moved with the grace and confidence of a much younger man. His face was almost gaunt; his hair had lightened from silver to pure white. It was no longer slicked down. It floated around his face like snowy egret feathers, framing his dark blue eyes. The effect was to make him appear more vulnerable but at the same time more intense.

"What're you doing here?" I wondered if I looked different to him, if my own face reflected the difficulties I had faced since we had last said goodbye.

"I came by to see how you're doing."

"Things are pretty troubled right now." I was so happy to have the flesh and blood Jake sitting in my office I forgot all the questions, all the accusations I had stored up to assault him with if we should ever meet again. His eyes told me he would not answer those questions. He was above reproach, above having to answer to me. He was as he had always been. He had come for a purpose. To see how I was doing.

"Clients and lawyers are leaving in bunches. My FDIC cases are keeping the firm afloat, but that can't last too much longer. The FDIC is a terrible employer. They make you fill out a thousand forms for every case, they pay bottom dollar, then they slow-pay.

They lose our forms and accuse us of never submitting them. And their employees change every month. This damn recession has to end sometime. "

"Baijan really took Wainwright for a ride."

"Looks like he's landed on his feet again, too. The head of Calumet Farms is going to jail and Baijan gets off with being banned from involvement with any national bank—a slap on the wrist. Meanwhile First City is gone. First Chicago, too. And Wainwright's not far behind, I fear." I kept to myself the suspicions about what role Jake might have played in Baijan's recent reprieve.

"The firm'll survive." Jake's cigar assumed the upright position. "Charlie Harrell's moving his and Odyssey International's business over here. If you approve, of course."

"Isn't Odyssey just as bad off as the other oilfield companies?"

"Nope. Charlie never borrowed like the others did; he financed his operations out of cash flow, then picked up all the business the others left when they failed. He's sitting pretty, and when this recession finally ends Odyssey will be the biggest oilfield equipment company in the world and he'll be a billionaire. Hell, he might be one already."

Charlie was a self-made man, like Jake. He was infamous, notorious. Folks either loved Charlie or hated him. In turn, he welcomed confrontation and delighted in taking people down a notch or two. In 1980 he had applied for membership in Houston's elite River Oaks Country Club. The club turned him down. Charlie bought the mansion next to the country club, demolished it and built an extravaganza. Naked marble goddesses lined the front entrance, flashing their large busts at sedate River Oaks patrons. It was war.

Charlie won. The club tried to make a deal with him: membership in exchange for taking down the naked ladies. He declined. The naked ladies still lined River Oaks Boulevard. Charlie became a Houston legend.

Charlie disliked the party circuit and the jet setters who hung around wealthy people, though his wife loved to use his money to throw magnificent galas for the international set. Charlie loved to piss on her parties. He farted, loudly and odiferously, at the dinner for the Prince of Wales. At an intimate dinner for internationally famous composer Leonard Bernstein, Charlie remarked that he didn't usually let queers in his house. He complemented Nelson Mandela for being "pretty good for a negra".

On the other hand, Charlie was unwaveringly loyal to his friends. Lots of folks deserted Jake after he filed bankruptcy. Not Charlie. He put Jake on the Odyssey Board of Directors and recommended him for several other boards. "Nobody knows how to deal with trouble better than somebody who's been there," Charlie said. With his friend's help Jake made his way back to respectability. Charlie was also rumored to have covered Jake's share of several good investments. Jake repaid Charlie with political influence, the trip to Iraq being the most obvious evidence of Jake's continuing political pull. Or perhaps, Jake had let Charlie in on the secret of the tapes.

Now Charlie was willing to move millions of dollars of business to Wainwright. I wondered if this was a favor to Jake, and, if so, what Jake expected of me in return.

"What brought this about?"

"Me."

"Why?"

"Charlie's not that happy with the law firms he's got. He uses several. He thinks they all take him for granted. Wainwright

needs clients. They won't take Charlie for granted. And you're here."

"Me? What would Harrell want with me?"

He didn't answer. Instead he continued: "I want you to meet Charlie."

"Oh, that's okay; I wouldn't want to take up his time."

"No, I want you two to meet. I have something in mind. We need you."

"Have you talked to Harry?"

"No. Charlie is sending his business to you to manage. Personally. Unless you're not up to it, of course."

I would not let Jake put the rush on me, or verify his hunch about how much a client like Harrell would do for my position at Wainwright.

"I'll need to run a conflicts check, to be sure we don't have anything that would prevent us from representing him." I noticed the cigar moving downward as I spoke.

"But I can get that done this afternoon. Thanks for thinking of us, Jake. This is a wonderful opportunity for the firm. We'll do our best for Harrell, I promise you."

"Come to the house after work today and I'll introduce you. The three of us need to talk."

Tiny alarm bells went off.

"Is there some urgent business he needs handled? Should I bring someone from our corporate section along?"

"No. Just come to the house. You'll find out."

"What house?" Jake no longer had a Houston residence.

"Charlie's, of course. You know where it is?"

I just laughed.

"Thought so. See you at six?"

"Okay. Okay."

Trip In The Dark by Kaaran Thomas

Jake left and I sat at my desk speechless. After months of silence he had blown through my office and dropped millions of dollars of business in my lap. Harrell and Odyssey would be my clients. As the partner in charge I would control one of the largest books of business in the firm—possibly as significant as First City had been in the past. And First City business had made several lawyers managing partners. My future, Wainwright's future, had just been assured. I wondered how the firm would react. There was no time to waste. I had to let the management committee know, check the possible conflicts and be prepared for an all clear by that evening.

I scribbled a memo for my secretary to type in multiple copies and hand-deliver to the management committee to let them know what was up. I reserved a conference room for an emergency committee meeting and had a minute to sit back and luxuriate in feelings that hadn't visited me for months: excitement, anticipation, joy. Within fifteen minutes I had gotten a response from each member of the management committee confirming a meeting at four. One result of the First City fiasco was our greatly diminished client list. We had no trouble clearing conflicts to take advantage of the opportunity.

"Jake McCarty came to see me today." I had the pleasure of seeing disbelief, hope, envy, flash around my fellow committee members' faces like strobe lights.

"Charlie Harrell is not happy with his current law firms. Feels he's being underappreciated. Jake and Harrell are good friends, as you probably know. Jake has convinced him he'll get better service over here—him and his company, Odyssey. I haven't talked to Harrell yet. I'm meeting Jake and him at his house tonight. Does anyone have any objections?"

Each of them shook their heads no, their mouths still frozen with shock.

222

"I don't know the exact nature of the matters we'll be getting. Jake said it involved millions of dollars in billings. He may have been exaggerating, but I assume we'll need a team of at least five lawyers and some paralegals to handle the transition. It may be intense work if there are any deadlines coming up, any court cases we would need to step into. We don't want to risk losing the business before we get it. Can we commit the manpower?"

Seven heads nodded wordlessly.

"Great. Any questions? Anything I should ask Harrell? Any ideas about the size of retainer we should get?"

"You say McCarty is behind this?" It was Harry. I recalled Sandy's discussion of Harry's opinion of Jake, his request that Jake help the firm out of the First City problem and Jake's response. Harry was lousy at hiding his emotions. The look on his face bespoke jealousy and promised trouble. Jake had brought the business to me. Jake had ignored Harry.

"That's right. Apparently you had contacted him some time ago, he said."

"I can't understand why he didn't come to me about Harrell."

"He seemed to think there might be some social issues between you and Harrell. Involving the country club, he said. He wanted to keep you out of the loop." It was a wild guess but a good one. Harry was exactly the kind of stuffed shirt that Harrell would get cross with. Harry's harrumph and reluctant nod confirmed I was right.

"Why don't you find out exactly what we're being hired to do and then we can discuss retainers," he suggested.

That was the first full sentence anyone had spoken.

"Great suggestion, Harry. Shall we set up a follow-up meeting later this week after my meeting, to discuss exactly what we need to do?"

Harry reverted to his take charge mode. "If you're meeting tonight let's meet tomorrow morning. Sooner the better."

"Sounds like a plan. Thanks for the quick response, gentlemen. Wish me luck."

"Good luck, Nielsen. And thanks." Sandy patted me on the shoulder as I rose. "You'd better be on your way. We have some things to discuss among ourselves." They remained seated. I had never wanted so badly to eavesdrop on a conversation, but I had better things to do. I called Beth to let her know I'd be home late.

"Don't hold dinner for me, sweetheart. I have a meeting at six."

"Okay. Anything good?"

"Just wait till you hear. I'll fill you in when I get home."

"Sounds promising. Good luck."

I announced my arrival at Charlie's wrought iron gates at six sharp. They swung open and I entered under the watchful eyes and erect nipples of Venus and Aphrodite.

All the stories I had heard of Charlie's wretched excess failed to capture the reality of his house—a fountain the size of Trevi, exotic granite floors, solid gold railings and knobs, hand painted murals on the ceilings, old masters on the walls. Amidst it all stood Charlie, looking like Jabba the Hut, a noticeable stain on his wrinkled white shirt. Next to him lounged the ever-elegant Jake. Smiling.

"Tommy maboy. How tha hail areya?"

"I'm fine, Jake. How are you?"

"This is Charlie Harrell. Charlie, this is Tom Nielsen, the best damn poker player I know, except for Amarillo Slim, who's Tom's uncle, by the way."

I nodded modestly and shook Charlie's hand. It was sticky. "I'm not used to being introduced as a poker player. In real life I'm a lawyer."

"And Tom is the best damn bankruptcy lawyer in the country." Jake put his arm across my shoulder. Nothing was said about taking over Charlie's work. I began to get nervous. Extravagant praise usually accompanied an extraordinary request. I waited.

"Let's have a drink," Charlie said. We followed him through the granite and gold foyer into the bar; an ebony and zebrawood-paneled extravaganza overlooking a pool that could have been from a movie set. Outdoor lights were coming on as the sun set.

Charlie and Jake ordered Wild Turkey; I ordered tonic water.

"You a damn teetotaler?" Charlie looked at me suspiciously.

"I drink in moderation."

"That's what we need, Charlie," Jake interrupted. "Tom keeps his wits about him."

Charlie nodded suspiciously, downed his Wild Turkey in one gulp and slammed the glass on the bar for a refill. "It's the rare breed – 108 proof," he commented. I assumed he was referring to the bourbon.

"So what did you have in mind?" I looked Charlie square in the eyes.

"I like you." Charlie belched contentedly. "I like you." Apparently it bore repeating.

"So what's up?"

Trip In The Dark by Kaaran Thomas

"We gonna screw us an A-Rab," Charlie mused, watching me over his glass.

"Pardon? I thought Arabs were your friends. You're always talking about the good times you had with this sheikh or that Saudi prince"

"Not this particular one."

"What Charlie means," Jake interrupted, "is that we want to get even with Baijan."

"For what?"

"Are you shittin' me?" Charlie appeared upset that I didn't perceive the need to personally avenge Wainwright's injury.

"Baijan is a dishonest man and probably a criminal." I replied. "But why not leave him to our system of justice?"

"Do I have to answer that?" Charlie was speaking to Jake, ignoring me.

"Tom was asking a rhetorical question, Charlie. He knows Baijan and his family can get away with anything. Isn't that so, Tom?"

I nodded, reluctantly. I was not going to discuss what I believed to be the reason.

"He killed a magnificent racehorse—tortured him—for damned insurance to save his fuckin' ass. He's a fuckin' slimeball."

Charlie was still talking to Jake.

"Tom knows about that, Charlie." Jake cast a confirmatory glance at me. "Remember? Hell, Baijan almost took down Tom's firm."

"So he's in?" Charlie was addressing Jake again—unwilling to recognize me for the time being.

"I need to know what you have in mind." I interrupted their dialogue. "And I thought this meeting was about bringing your work, Odyssey's work, to Wainwright."

226

"That, too," said Charlie as though millions of dollars of business was a gratuity for helping him to get even.

Bourbon number three hit the back of Charlie's throat as he nodded to Jake to do the honors.

"Baijan is going to lose a lot of money. A helluva lot."

"How?"

"In my annual poker game." Charlie leaned back with a satisfied look.

Jake put down his glass and looked at me intently.

"I think I'll have that bourbon," I replied.

"There's maboy!" Jake slapped me on the back.

"And what will happen to all that money you take off him?" I asked.

"It'll be put to good use. It'll fund the two-million dollar donation he promised UT, put something back in Wainwright's coffers to make up what he done to 'em. And there'll still be lots left over for us."

I was adding as Jake was talking. So far Baijan would have to lose five million. With lots left over for us.

"What do you mean, 'lots'."

"How much do you think of as lots, boy?" Charlie had decided to address me now.

"It's not my game, sir. How much do you think of?"

Charlie laughed. "I like you, boy. Lots is lots, millions. I'm thinkin' seven to ten million. That should teach the little shit a lesson."

"Who's going to stake this game? I'm not good for that amount of money, or any amount for that matter. And what if we lose?"

"Jake said you were the best. Are you or not?"

"Even the best get beat, sir. Poker is about skill but also about luck. How good a player is Baijan?"

"I've only played him once, several years ago. In Monte Carlo. He wasn't that good."

"So you're staking this game?"

"So are you the best or not?"

"Why don't we play a few hands and find out?" Jake suggested.

"Not tonight," I said. "I was told this visit was about transferring business to my firm. They're expecting a report from this meeting. They're ready to commit a lot of manpower to taking on your and Odyssey's business but they need to know what's expected of them. We have a management committee meeting tomorrow morning to discuss allocating resources."

"No problem. Call Odyssey's office tomorrow. It opens at eight. Our general counsel is Matt Gray. Have your people arrange a meeting with him. He'll oversee the transition of the Odyssey work. We've been doling it out to several firms. None of 'em has done a good job and it's hard to keep track of all of 'em. We want to consolidate everything with one firm. Gray can give you the names of all the firms and what they're handling. He's already made up a list of court cases and deadlines. We have fifteen state court cases, mostly small stuff, employment disputes, personal injury claims, collection actions, things like that. We have four cases in federal court. They're big. You have a good litigation section, I'm told."

"The best."

"I like the confidence. Maybe you should send one of your trial lawyers to Gray's office tomorrow to get the lowdown on the federal cases."

"Any pending business deals?"

"Many. But most of them are handled in-house. We're working on an interstate pipeline, though; we've hired law firms in three states; it's hell to coordinate the damn thing. It's a mess.

We need a firm to take charge, a firm with federal energy regulatory expertise."

"We have just the man for the job. Shall I send him along tomorrow?"

"Why not. Let's get this thing started. Now, as to the poker match?"

I had to stop the cash register in my head from totaling. This could put the firm far down the road to recovery.

"What sort of time frame are you thinking for the game?"

"Baijan is in Europe right now with a new girlfriend. He'll be back in time for the Houston Livestock Show. He told me he's going to bid at the auction—on the prize bull. It's a big ego trip for him. I've invited him to my annual livestock show poker tournament, that night after the auction. He's been fishing for an invitation and I was happy to oblige. The creep didn't even have the smarts to wonder why he'd get invited after all the damage he's caused in this town."

"That's only two weeks from now" I cautioned. "Not much time to get everything ready. I suggest we have a practice game this Saturday."

"Suits me," Charlie belched.

"Everything's set up, Tom." Jake pitched in. This is an annual game. And yes, Charlie will stake you." Jake looked purposefully at Charlie, who nodded. "Of course we understand that luck is involved, but we think you're our best chance. If you lose, then so be it."

"You sure as hell better not lose," Charlie interrupted.

"He's just kidding," said Jake.

I poured myself another bourbon.

"You've been drinking," Beth announced as I walked in the door. She was at least five feet away so I must have either smelled or looked pretty soused.

"I've been with Jake. And Charlie Harrell. At Charlie's house."

"What on earth would bring the three of you together?"

"Two things. And they're related. Charlie wants to transfer his and his company's business to Wainwright. It could very well save the firm. And of course my control of the business will likely give me a shot at becoming managing partner one day. If I want to play that game, of course."

"Wow! That's fantastic. Congratulations, honey. You were due for a lucky break. The firm must be ecstatic." Beth hugged me.

"There's something else. They want to get even with Baijan."

The hug came to an abrupt end. "Meaning what?" Beth had learned a lot about Baijan and BCCI from the First City scandal. Newspaper reports had linked them to the First American Bank collapse. There had been several articles in the Houston Chronicle as well as the New York Times describing the organization and the man and their involvement with international money laundering operations, criminals and various kinds of fraud.

"Meaning a poker tournament where I take him for five or ten million."

"What! I assume you said no."

"I said I would see; first we needed to have a strategy and Charlie has to agree to stake me." I tried to make it sound pretty indefinite.

"What did they say?"

"They said we needed to play some practice games. At Charlie's place. This Saturday."

"And you're going to do it?"

"No harm in playing some poker. They probably won't go through with it. It's a wild scheme and Charlie has no stake in this—he's just going along with Jake for some reason."

But Beth beat me to the conclusion.

"Oh, they'll go through with it. There has to be more to this than what they're telling you. What I can't believe is that you got roped in."

"It's the cost of getting the business. They didn't say that but they made it pretty clear. When you think about it, there's no logical reason to go through the hassle of changing law firms. And if I win, it could save Wainwright; my winnings will go in part to repay them for the losses Baijan caused. And two million will pay UT the donation he promised at the auction. And that could mean a lot more jobs saved." I tried to make it sound noble.

"And if you lose?"

"Then Charlie Harrell will be out a few million, which he probably loses at poker every month."

"I can already see you've made up your mind. I just hope you know what you're doing. I've heard you complain about Baijan since you came back from Washington on that First American deal. He is a dangerous man from a bad family. And this organization, BCCI, is even worse. Harrell can protect himself. You know he'll protect Jake. When all this is over, who'll protect you? Us? Baijan is not going to forget your face. Or where you live."

"Baijan loses a lot of money on a lot of things. I don't see him holding a grudge against me because I beat him at cards.'

"At a rigged card game?"

"It won't be rigged."

"Then you better pray for luck."

The next day was the happiest Wainwright had experienced in years. The news raced through the firm. Work would be coming in, great work for litigators, regulatory experts, business lawyers. I would have loved to delegate the staffing of Odyssey business to someone else but I had to keep control. This was my client and I would oversee every detail of the representation. That way no one else could claim credit.

The task of transitioning Odyssey business made the week pass quickly. Saturday morning, Venus and Aphrodite admitted me to Charlie's house. I had considered several strategies and finally decided it was worth a consultation with Uncle Slim. I hadn't talked to him in years. I had to get his number from my dad.

"Tommy maboy! How the hail areya?"

"I'm great, Uncle Slim."

"Your dad tells me you're happy as a pig in shit down there in Houston."

"Yes, sir, that's pretty much the story. But I wanted to talk to you about something else—a poker tournament with some high rollers."

"Anybody I know?"

"Charlie Harrell, Jake McCarty and Armand Baijan."

"Holy shit!"

"Have you played any of those guys?"

"Nope. I'd sure as hell remember if I had. They all have reputations as nasty sons-o'-bitches. They don't like to lose. Period. And anyhow, we run in different circles. They play on padded tables with upholstered chairs and pretty girls to bring 'em drinks and all."

"So you think they'll be easy marks?"

"Aw, hell, no. A rich man can play just as good as a poor one, I suspect. I play those types once in a while, in celebrity tournaments. Some of 'em are very good."

"Any advice?"

"Don't let the glitz get to you. Keep your mind on the game. Remember they put their pants on same as you, one leg at a time. And wait for the big kill. Take your time. Draw 'em in. Hell, I taught you all that already."

"Yessir. But it's good to get reminded every so often."

"And call me when it's over."

"Definitely."

I went to Charlie's prepared for a serious poker discussion. The butler led me through the house to the back where I could see Jake and Charlie sitting in a hot tub, smoking cigars.

"Tommy, come on in. Water's fine!"

I walked over and looked down at the two of them. Why would someone smoke a cigar in a hot tub? Ashes mixed with the bubbles.

"I'm here on business. We need to discuss strategy and you need to be convinced I can do the job. We can hot tub once the job is done."

"That's what I like, a man who's all bidnuss. Guess we better get to work, Jake." Charlie snuffed his cigar in the water.

Jake and Charlie exited the tub, sloshing speckled water around my shoes. I looked down at my damp shoes, then up at Jake. I was about to make a nasty remark when I saw the scar. It was on the left side of his chest—a large ragged circular mark instead of a nipple. Almost thirty years later it still looked lethal. I marveled again at the power of the people who had put it there.

Jake noticed my stare.

"Let's get started, then," he said, hastily throwing a towel over his shoulder.

As he walked away, I noticed something else about Jake. In his half-naked state he looked old, fragile.

"Are you two going to play dressed like that?" I asked.

Jake laughed nervously. "We'll throw on some clothes. Meet you in the card room. Butler'll show you where it is."

The card room held two large tables, each with nine luxurious chairs. Another magnificent bar decorated one end and crystal chandeliers hung over each table. The room had its own set of bathrooms, Persian carpets on the floor and oil paintings on the paneled walls. A huge portrait of Mrs. Harrell in a gilt frame hung over the bar. It was the only evidence of Charlie's wedded state that I ever saw in the house. She was never there.

The night of the tournament there would be eight players, a professional dealer from Las Vegas and four "hostesses" on loan from the high stakes room at Caesar's Palace to serve drinks and food. I learned the other invitees were UT grads who knew of Baijan's failure to meet his pledge and were happy to be part of his comeuppance even at the risk of losing a cool million, the customary buy-in for the big game. Charlie wanted me for insurance. Jake had convinced him I was the best chance to beat Baijan if everyone else lost.

We played a few test games. I told Jake about his "tells"— the cigar motion. Charlie had his own tells—facial gestures. I figured if Baijan were a good player he would pick up on them.

"Jake is giving up cigars, as of this week," Charlie said, patting Jake on the back. Jake and Charlie exchanged a look that I didn't quite understand.

"Doctor's orders," Jake said. "I'm replacing cigars with booze."

"That night you need to cut down on the liquor. Mix it with something so Baijan doesn't know. We all need to be sharp.

I recommend an afternoon nap. It does wonders for the concentration."

"Jake'll nap." Charlie said. He and Jake exchanged another of those looks. I tried to ignore the feeling that something was going on either behind my back or over my head.

"This is a professional sport, just like any other," I continued, finally. "Treat it that way; you need to be in top shape, physically and mentally." I showed them what I meant by beating both of them soundly.

"Alcohol, lack of sleep, can make all the difference."

Charlie looked at me, then at Jake. "You were right about Tom, Jake. He's our man." Then, to me, "We'll pay attention to what you say, Tom. And Jake'll be spending the week with me. I'll see he gets plenty of rest and clean living."

After I left a funny thought hit me. Why was Jake spending so much time at Charlie's place? Did they have some undisclosed business dealings together or was something else going on?

Chapter 25: The Game

The day of the big game I got a call from Kathleen, Jake's secretary, reminding me to wear my Armani sports coat and expensive shoes and belt. "You can wear jeans if you like," she added. "That's Texas chic."

I napped all afternoon, then Beth and I went to the livestock auction. I needed to be able to talk about the event if I got into a conversation with Baijan. We had never been, though it was one of the highlights of the Houston social season. We mingled with the wealthy crowd of gentlemen ranchers and their wives, all wearing custom jeans and designer jackets along with giant Stetson hats covered with pins—a pin for each animal they had bought at the auction over the years. The pins, and the auction itself, were a throwback. People greeted each other warmly, discussed past auctions, the "good ole days." Jake and Charlie were both in attendance. They spoke knowledgeably about the weight, muscle, and structure of each of the animals coming up for bid. The animals had been raised by 4H students, who proudly led pigs, goats, sheep and cattle to the block. Bidding was raucous, competitive, laced with insults: "Hey, Joe, what you want with that sheep? Your wife's better lookin'."

The main event was the auction for the prize bull—the best in show. Even I could see he was magnificent as his young owner

led him to the block. His coat gleamed; his hooves and horns had been polished. His muscles rippled under the inky black hide. Bidding started at fifty thousand dollars. I spotted Baijan among the bidders. Baijan was decked out as impressively as the bull. He wore a large white Stetson, which seemed too big for his head. His Hugo Boss designer jacket cost a fortune, which was probably doubled by his jewel-studded belt and the rings on each finger. His boots were obviously expensive and appeared to have elevators in them, adding at least three inches to his height. The crowd around him was not friendly but they gave him grudging respect; in a town short on cash Baijan's money meant college educations for the young animal owners. He was happy to be the center of attention, raising each preceding bid by more than ten thousand dollars, causing cheers among the audience. Charlie bid against him, finally quitting when Baijan's bid was three hundred fifty thousand dollars.

"This fella's gonna be the daddy of my prize herd." Baijan smirked into the TV cameras. "He's got a lot of work to do. I already have the cows at the ranch, waiting."

So Baijan had kept the ranch; and apparently had acquired a taste for the life of a wealthy cattleman. He was oblivious to the attitude of the other attendees, most of whom knew of his affiliation with First City and Alydar. He either didn't see me or chose to ignore me.

The sun was setting as Beth and I got home. I showered and shaved and Beth helped me with my jacket and the golf shirt we had bought at Nieman Marcus for the occasion. Fortunately I had the jeans and the elaborate silver buckle and I had upgraded to Luchese boots the preceding Christmas.

"You look Texas rich, sweetheart," she said, trying to sound carefree. I kissed her soundly.

"Don't wait up."

237

Trip In The Dark by Kaaran Thomas

Charlie's limo was waiting at the curb. I felt a little like Cinderfella.

It was nine o'clock when my coach carried me through the gates to Charlie's palace. Baijan's limo pulled in just ahead of mine. He instructed his driver to wait in the car. "How long will you be, sir?" the driver asked, hopefully. I lingered, afraid our target was planning an early evening.

"Most of the night," he replied. The driver looked unhappy.

"Is there some problem with that?" Baijan asked, irritated.

"No, sir!" The driver, chastened, returned to his vehicle's seat.

Baijan and I walked into the house together. As we joined the guests mingling at the pool bar, he finally recognized me.

"Mr. Nelson, is it not?"

"Nielsen."

"You still work for Wainwright."

"Yep, despite all your best efforts."

He looked at me like he intended to say something. Whatever it was, it was interrupted by two gorgeous bikini-clad hostesses working the crowd, each of whom took one of his arms and escorted him to the patio, their stiletto heels clacking on the patio tiles. Other hostesses passed out drinks, hors d'oeuvres, flashing smiles and cleavage.

At ten sharp Charlie announced the start of the game. The hostesses escorted us into the card room where the tuxedoed dealer was already seated.

238

Trip In The Dark by Kaaran Thomas

"Texas Hold 'Em," he announced in a prizefight voice. "One Million Dollar buy-in. Post your buy-in, gentlemen." Stacks of chips were placed in front of eight chairs. Each of us gave a million-dollar marker to the dealer. I cringed thinking what would happen if it ever hit my bank account.

I closed my eyes to focus, ignoring the thought of the most gigantic overdraft in history, the gorgeous hostesses, the James Bond aura that hung about the room. When I opened them I was staring across the table at Baijan. He had put on sunglasses. It was something professional poker players do to reduce the chance their eyes might be "tells." The man was not an amateur. I took out my sunglasses and put them on.

The first couple hours of play went as expected. Jake, Charlie, Baijan and I continued to win while the other players cashed out, said their goodbyes and left. The room got quieter. The stacks of chips in front of us grew larger. I had managed to double my stack. Jake and Charlie were also doing well, but Baijan had the largest pile of chips by far.

After an hour of observing the enemy I was worried. He played a tight game—giving nothing away. His only interaction was with a hostess when he needed a drink or food. His head rarely moved. His only "tell," so far as I could see, was his hands. When he was nervous he held his drink, sandwich or cards tightly, moving jerkily. When he was confident the hands were loose, the movements smooth. He rarely gave signs of nervousness—unusual for any player. He played confidently. He had obviously picked up on the other players' tells. Even mine. I couldn't figure out how I was giving myself away; but it was obvious I was doing something to give him a clue. I got up to use the john, to loosen up and think. How could I gain the advantage? Baijan was much better than I expected—as good as me. He had a fantastic card sense—again and again making the right calls, the right bets.

239

Trip In The Dark by Kaaran Thomas

The four of us played in earnest, conversing mostly with the dealer and hostesses, saying little to each other. Jake was the first of our group to bust out, losing to Baijan in his final hand. I had taken three-hundred-thousand from Jake, Baijan had taken the rest. He now had over four million in chips and was getting close to being able to dominate the rest of us by sheer chip power. I tried to run a few bluffs on him. Nothing doing. I still hadn't figured out how I was giving myself away.

When Charlie lost the last of his chips I knew we were in trouble. Baijan had twice as many chips as I did. Jake and Charlie excused themselves, promising to return in a few minutes. Baijan and I played on alone in the silent room, except for one remaining hostess and dealer. It was almost one a.m. Charlie had suggested the hostesses could leave, but Baijan said he would like one girl to remain and Trudy volunteered. She circulated around our table asking if we wanted anything.

A few hands later, Jake and Charlie returned. Jake was carrying the famous elephant hide briefcase. I had only a minute to wonder why, then I saw my chance to win back some of the money. The famous briefcase had brought me luck. I had the two and three of hearts in my hand and the flop came three hearts: king queen and ten. I had an excellent chance to win with my heart flush. My first bet was tentative—a hundred thousand dollars to draw him in. Baijan called. The turn card was the nine of hearts. The board was nothing but hearts. I bet and he raised.

I wondered whether to call his raise, glancing at my hole cards. Was he bluffing? If he had any heart in his hand he would win. I was calculating the odds when the hostesses came up behind me and asked me if I wanted to freshen my drink.

"No, no." I was startled. And a bit rattled. It was unusual for a professional hostess to interrupt a player at such a time. I

decided to re-raise; pushing another hundred thousand of chips into the bet.

What the hell did he have? I went through all the possibilities. He could have two pair. If so, I would win. I looked at Baijan's hands. He was clutching his cards nervously. Why?

"I call."

Then something unusual happened. Baijan's head moved. He looked up from his cards at me. But something wasn't right. I can tell when someone is looking at me, even if they have sunglasses on. He wasn't looking at me, after all, he was looking past me. I realized the hostess was still behind me and he was looking at her. He saw my stare and quickly looked down.

Then it hit me. The hostess—the untimely question about my drink just as I looked at my hole cards. Could she have tipped him off?

The dealer dealt the river card. It was the jack of hearts. The common cards on the board made a straight flush. I checked. Baijan thought for almost thirty seconds before also checking.

"Split pot"? The dealer asked. A split pot means there is no winner.

We laid down our hands. Baijan had the four of hearts and four of clubs. The board beat both of our hands so neither of us could win.

I could feel Baijan watching me behind his glasses as we each scooped half the chips. I wasn't sure what to say or do. It would be highly unusual to accuse someone of cheating in any poker game, much less this one. And I wasn't absolutely certain. It was late, after all, and I was tired. Perhaps I had overreacted. On the other hand, I had seen his hand—the four of hearts and four of clubs. He was nervous before the river card, before the hostess could see my cards. He relaxed after he glanced at the

hostess, then irritated when the jack of hearts saved my hand—a sign he knew too much about my hole cards.

Baijan interrupted my chain of thought. He got up, preparing to leave. "Thank you, gentlemen," he said quickly. "That was very entertaining. What time tomorrow can I call to collect my winnings?" Jake and Charlie were conferring.

"Just a minute, Armand." Charlie intercepted Baijan on his way out the door. I wonder if you'd be interested in playing for bigger stakes. A lot bigger."

"It's late, perhaps another time, my friend."

"This is a once in a lifetime opportunity."

Baijan stopped. Turned. "What does that mean?"

Jake put the briefcase on the poker table. Opened it. Took out a pile of twelve of the familiar white boxes. I gasped.

Baijan took in the boxes and my expression and removed his sunglasses. His eyes were bright with greed.

"What are these?"

"What you were looking for at my auction?" Jake smiled.

"Ah—so they do exist. I had begun to doubt, although your information was so accurate, so . . . persuasive . . . I assumed your source was good."

"They exist. And they're all you ever dreamed they would be. One tape for each month from December 1963 to November 1964. One million dollars each."

"And how do I know I am not being cheated yet again?"

"I never cheated you. I never told you what was in those file cabinets. You made an assumption. And I've been fair with you in all our dealings so far, haven't I?"

"And now you are telling me these are authentic?"

"I give you my word."

"And these are the only copies?"

"So far as I know."

"Jake, you can't—not for this." My voice was shaking with frustration.

"That's my decision, Tom."

"And mine," Charlie added.

"I need to take a break," I said, leaving the room. I walked outside to the pool area and sat in a lounge chair, feet up. I closed my eyes and tried to focus.

As Beth suspected, I had not been told what was really happening, the real motive behind the night's game. I was both a player and a pawn in something undisclosed. I was not to know the stakes—they were obviously much larger than I had been led to believe. They involved things I did not know—did not want to know. But I knew for certain that Jake had been selling pieces of information, gleaned from the tapes, to Baijan. My suspicions were correct; my accusations well-founded. I could leave. I didn't have to play their games.

On the other hand, I knew about the tapes and the games. I was already involved. I had been involved since 1987. This was just another inning. What would I gain by leaving? I had regretted my last angry parting from Jake. If I left, what would the consequences be? On the other hand, what would I gain by staying? I knew about games, and about winning and in the end this was a game like any other. I needed to assess the strategies and the odds; the dangers of losing or refusing to play and the rewards for winning. I needed to determine my leverage—my hole cards.

If I left we would probably lose Charlie's and Odyssey's business—in retrospect it was clear the offer of business was bait to lure me into their plot. And if I left, Jake would lose the tapes. Charlie and Jake couldn't match Baijan's card-playing skills.

And what of the hostess? If I let them know my suspicions I could end up looking foolish. Besides, their goal was to get Baijan to play, not to stop the game. They might even take his

side. I could make up some excuse to get Trudy to leave, but that might discourage Baijan.

What if I won? How could I turn a win to my own advantage?

The night was fairly warm for April—an azalea-scented breeze blew softly and the fountains were splashing gently. I closed my eyes and concentrated.

"There you are! We've been looking all over for you." Jake came up behind me, sounding worried.

"I was just resting—considering my options."

"What options do you think you have, Tom?"

"Just tell me why, Jake. Why did you sell him the information? Why did you give him what he needed to avoid paying for all the damage he's done—all his crimes."

"I would think the answer would be obvious, Tommy."

"For the money? Did you need the money that badly, Jake? Did you need the helicopters, the zebra?"

He looked at me carefully. Then looked away. "I did it to protect you."

"What?"

"He knew you had the tapes. He saw you at the auction with the briefcase, then he talked to Schumer. He's a smart man, Tom. He can put two and two together, just like we feared. But of course, hurting you wouldn't get him the tapes, so he called me. He threatened to kidnap Beth unless I gave him the tapes. I made a deal with him. I gave him information instead. I could have given him a copy of the tapes, I guess, but I wanted to dole out the info, not just let him have everything. That would have been too catastrophic. I made him call me when he needed something so I could keep track of what he was up to. That's why he threatened you in his office that day. He thought you could put more pressure on me."

244

I would have given anything to have seen his face, but it was dark and he was looking away from me.

"I don't know what to say, Gov."

"Don't say anything. Are you ready? Let's do this, Tom."

"Roger, Gov."

My mind was clear, my thoughts focused, and I had a plan. And I had answers. Jake did care about me. He cared about Beth. For some reason just knowing that made a difference in my life. I couldn't explain it—didn't even try to. I didn't have time. I tucked the information in my heart for future reference.

I was ready to play. I felt empowered. I remembered Uncle Slim's advice when, as a youngster I had first asked about cheating at cards.

"Cheaters might win in the short term, Tom, but in the long run, if their opponents are smart, they lose."

"You mean the opponents will find out?"

"Not just that. But, yes, they will find out, and if they're good, the cheater will never know his opponents have learned what he's up to. Cheating is just another 'tell'. Once you know it's happening it's a dead giveaway. You can use it against the cheat."

I returned to the room, apologetic, obsequious, naïve. "I guess I fell asleep, Mr. Baijan." Everybody laughed. "I'm sure sorry."

"Nothing to worry about. Let's get started."

"Why are we just playing for twelve of the tapes?" I asked, looking innocently at Jake.

"What—you mean there are more?" Baijan looked from me to Jake. Jake gave me one of his wildebeest-stoppers.

"Oh, gosh. I've seen at least twenty." I charged on. "Don't they start in November, 1963 and go all the way to July, 1965 when President Johnson tells Herbert Hoover to"

"To what?" Baijan was leaning over the table he was so anxious.

"Well—if Jake doesn't want you to know then I guess I'd better not say anything." I looked at Jake.

"We will play for all the tapes," Baijan insisted.

"I'm sure they decided you couldn't afford all of them," I mused, half to myself.

"Twenty million for twenty tapes," Jake said.

"The price is high. Perhaps I'll just play for the first twelve, then if I find them interesting I'll make you an offer for the last eight."

"Since I'm the one playing, I think it should be all or nothing." I said.

"Twenty million is a lot of money."

"Oh well . . ." I started to walk away, then stopped as if an idea had just occurred to me. "Why don't we do this? You buy the first fifteen months of the tapes and I'll buy the last five. Each tape will be a one-million-dollar chip. Minimum bet is one million. No antes. That should make the game go quickly."

Jake gave me another one of those looks, but I ignored him. This was fun.

"Your friend makes it hard to say no—an offer I can't refuse, as they say." Baijan had no idea how appropriate his words would prove to be.

He made out a fifteen-million dollar IOU to Jake. I wrote out my five million dollar IOU with a flourish, smiling at Jake, ignoring his scowl. Jake stacked the tapes in front of us. Charlie called the dealer, who had left the room while we talked. He and Trudy were lounging by the pool.

Everyone returned and we sat down to play.

The first few hands were the most tense. I minimized my risks, bet only on fairly sure hands, which made it hard to get

Baijan to bet against me. He played with his chips first, hoarding the tapes until he had to spend them. But after thirty minutes I had all of his chips and two of his tapes. I kept close watch on my hole cards, letting Trudy sneak a peek when I intended to fold or had a sure thing.

I arranged my hole cards so Trudy could see only one card—the bottom one, which I always arranged as the highest. When I won I showed my cards, confirming that the high card was always the one Trudy could see.

Twenty minutes later I had ten precious tapes on my side. It had nothing to do with my strategy or Baijan's cheating. I was riding a lucky streak. Time after time I won on the final turn of the cards—the river card. I was able to show my hand each time, confirming to Trudy that she was always seeing my high card. Three hands later Baijan bet against me on the flop and I got a lucky break on the turn card. He lost two more tapes to me. He had bet on Trudy's accurate information but the next turn card went my way. Baijan was down to five tapes. My streak seemed to end with the next hand. Baijan won three tapes with a lucky river card.

But fortune was still smiling on me—the next set of cards presented the chance to spring my trap. The flop was jack, ten of spades and seven of clubs. My hole cards were the eight, nine of spades. I had a straight with a possible flush. I arranged the eight on the bottom, so Trudy would think it was my high card. Baijan bet a million and I called. The turn card was ace of diamonds. Baijan threw in two tapes. I raised two more tapes. Baijan hesitated as I checked my cards again, then called.

The river card came the queen of spades. "All in." Baijan announced, pushing his remaining tapes into the center. Queen, jack, ten of spades on the board gave me a straight flush with my eight, nine of spades. If Baijan had the ace and king of spades, he

would have a royal flush, beating my hand. But if that were the case, Trudy wouldn't have had to check my hand. I read her "tell" perfectly.

I called.

Baijan laid down his cards: ace and seven of spades. He was already scooping up the pot when I laid out my eight nine of spades: a straight flush. "I'll take that," I said. Trudy had signaled my high card as eight of spades. If that were true, he would have beaten me. When he saw the nine of spades he almost jumped out of his seat. Trudy's face gave her away. She was terrified. She immediately turned and left the room. "I'll have the bartender call a cab," she said over her shoulder.

Baijan's reaction and Trudy's sudden departure should have tipped off Jake and Charlie. It did not. They were back-slapping jubilant. I tipped the dealer a hundred thousand dollars; Charlie made out the check to him in exchange for part of my stack of chips.

"You played a hell of a game," the dealer said. "And you're a real gentleman. Thank you. I'll get a ride with Trudy back to our hotel."

"I will return tomorrow to make good my IOU," Baijan said.

"That would be good enough for most folks, Armand, but not for you." Charlie's voice had turned cold as ice. "You don't deserve our trust, you scumbag."

"What?"

"You need to pay up. Now."

"It's three am, the banks are closed. I will have to move some money." Baijan continued to move towards the door.

"The banks in Geneva are open. My banker there is waiting for a wire transfer from your banker, a Mr. Hoffman, I believe."

The color drained from Baijan's face. He turned and almost ran from the room without saying another word. The three of us followed him through the house to the front door as he ran out towards his limo.

"Aren't you going to stop him?" I asked.

"Watch," said Charlie.

Baijan approached his limo, expecting the driver to start the car. We followed. There was no driver. Baijan yanked open the driver side door in frustration, then backed away, screaming.

We looked into the limo. The driver appeared to be fast asleep in the back seat but he had apparently had some assistance into dreamland. He moved not a muscle. On the front seat were two bloody balls—apparently removed quite recently from a bull. I had a good idea which one.

"I wanted to use the head, but that's been done before," Charlie said with a chuckle.

"Where did you get those?" I asked.

"Where the hell you think, boy? Offa Baijan's bull." Charlie laughed at the alliteration.

"You can take the balls like that?"

"Hell yes, but it'll probably be fatal," Charlie continued laughing. "To the bull, I mean. We didn't have a lot of time for bull repairs." Charlie thought it was hilarious.

"What'll we do with Baijan?" Jake asked. The man was walking in circles talking to himself.

We herded him back inside, Charlie handed him a phone and he called his banker in Geneva. Mr. Hoffman had received a call from Charlie's Geneva bank and was awaiting Baijan's instructions. A long discussion ensued about Baijan's line of credit and available funds, then Hoffman spoke to Charlie to confirm that the money necessary to pay Baijan's losses had been wired to Charlie's Swiss account.

Trip In The Dark by Kaaran Thomas

Charlie called Baijan a cab and escorted him to the door.

"We'll send your car to the dump tomorrow," he called cheerfully after the retreating loser.

I stayed in the game room anticipating my next move.

When Jake and Charlie returned I was seated at the card table with the stack of chips and tapes in front of me.

"Have a seat," I said. The look they exchanged confirmed they had forgotten they would have to deal with me. Charlie had Baijan's money but I had all the chips and the tapes. I pushed five million of my chips across the table to Charlie, to repay my IOU's. I had won everything else fair and square and was not about to give anything up.

"Jake, I'll need to borrow your briefcase."

"Now hold on, Tom."

"That's exactly what I'm doing." I wrapped my arms around my winnings.

"Why don't we all call it a night? Discuss this in the morning?"

"What's to discuss? Can I get a ride home? On second thought, maybe I'd better call Beth to come pick me up. I'm sure she's worried about me. Can I use the phone?" I started stacking the tapes in the briefcase."

"Damn it, Tom. Sit down. Calm down."

"No. I will not calm down. You told me we were playing a card game to take a few million off Baijan. You promised I would not be at risk. Next thing I know we're playing for Jake's tapes, which I am a little familiar with, by the way, so I know what they're worth. Now Baijan thinks I have the tapes. So I damn well better have the tapes. Hopefully he still has enough money to buy them from me because I sure am ready to get rid of them. Once and for all."

"We're sorry." Jake's voice was cracking with nerves. "We didn't know how this would turn out. But we were ready to let Baijan have the tapes. Not all of them. Just the ones that we offered 'til you upped the ante. I made a copy of those by the way. So I wasn't losing anything 'till you threw everything into the pot. We needed Baijan to part with a lot of money so he would have to call on his friends at BCCI to advance him some more. You have no idea what you've done for us."

"Us who? 'Cause I sure as hell haven't done much for me. I have a wife at home and the last thing I promised her was that I would not allow our family to be put at risk. Now I've broken that promise. And for what? For who?"

"For your country, for one thing. The money was going to buy arms to smuggle into Iraq in violation of the UN sanctions. Now there'll be less money and less weapons—hopefully a lot less than Saddam expected."

"So you're working for the CIA now? For the UN? Who do you think you're kidding?"

"We're not. But we're in the international oil business. It's our job to know what's going on. We probably know more than US intelligence."

"So I indirectly helped my country but they're not going to protect me since they don't know about this. So how did I help you?"

More looks between the two of them. Then Charlie spoke up.

"The money Baijan just paid to me was supposed to pay weapons dealers. Now they won't get paid. So they won't be able to pay their own creditors. All them folks live from deal to deal. When one end of the deal fails the whole chain collapses like a house of cards."

"So one of the cards is beholden to you?"

"They will be when I supply them with the money they were supposed to get from Baijan. I won't be loaning to arms dealers," Charlie added quickly. "The money'll go to the people who supplied the oil to the people who were supposed to exchange it for guns. So they can meet their own obligations. Then they'll owe me. In spades." He stopped, realizing too late the card analogy might be too sensitive at the moment.

"Jesus." I sat back down, my head spinning. I was suddenly exhausted, soul sick. These people played on a far bigger stage than I could imagine. I was truly their pawn in a game of their invention. I wanted to go home, but leaving now would put me at a disadvantage. I had to finish this game tonight while I had them off guard.

"Did you know that this game was rigged?" I asked.

"What do you mean?"

"I mean the hostess—Trudy—did you hire her?"

"She's a regular at Caesar's—yes I hired her." Charlie said.

"She was working with Baijan. I thought you would figure it out after that last hand. Didn't you see their reaction when I laid down my cards?" She had signaled to him that my high card was the eight of spades. I had caught onto their signals and arranged my cards to mislead her."

"Jesus Christ." Now it was their turn to sit down.

"You think you controlled the game," I said. "You didn't."

"Tom—you don't have to worry about Baijan. He'll never be a threat to you or anyone again."

"And why is that, Jake? Do you plan to sell him some more information to protect me?"

Jake looked at Charlie nervously. Charlie looked at Jake in surprise. Whatever was going on between them was still not going to be discussed in front of me.

Before Jake could say anything, Charlie went to the bar and pressed a button. The giant portrait over the bar unhinged from the wall like a door. Charlie opened it, revealing a hidden camera.

"I've got the whole thing on tape."

Jake burst out laughing.

"You tape your poker games, you old bastard," Jake guffawed.

"Just for security. Usually I just erase the tapes and reuse them. Never even look at 'em. But sometimes people lose big and they don't like it. They make accusations, things can get heated. The tape usually settles any arguments."

Now it was my turn to laugh. Another secret tape, this time hidden behind a portrait, would be my salvation.

"What do you plan to do?" I asked.

"I need to think about it. But people in Baijan's world don't like cheats."

"You've got to be kidding, Charlie. Arabs are famous for cheating."

"You oughta know better than that, Tom," Jake interrupted. "Not all Arabs are alike. Certainly they're not all cheaters. Not even the majority, as far as I know. I've dealt with them for years as friends and businessmen and with their leaders when I was Secretary of the Treasury. On the whole they are as trustworthy as Americans, I'd say. And even Baijan's group of friends, as disreputable as they are, would consider cheating at cards to be unethical. And they have their own ways of dealing with cheaters. You might not approve of their methods, but you can't fault their judgment. I'll package up a copy of the tape and send it to a certain man in Saudi Arabia. Baijan will already be in hot water because of the money. When his bosses learn he lost it in a

card game where he tried to cheat, well, he'll never bother us again."

Despite the fact that I was probably safe, I felt a chill. I imagined Baijan like Willie Wildebeest, going about his daily business, unaware that unseen forces were about to seal his fate. Suddenly I was tired, more tired than I had ever been. I needed to go home. I picked up the briefcase, stood up.

"We need to talk, but I guess this can wait until tomorrow—or later today, I guess. Can I get a ride?"

Jake and Charlie exchanged another look.

"You bet. How about we meet tomorrow night at six? That'll give us all a chance to rest up."

"See you at six, then."

Chapter 26: Beth

It was still dark when Charlie's limo driver dropped me at my front door. As I watched the limo pull away, the hairs on the back of my neck prickled. I was sure someone was watching me. I looked around, but I couldn't see anyone. Still, there were plenty of trees and hedges to hide behind.

I walked quickly to the door, clutching the briefcase, trying not to appear nervous. I held my breath 'till I was safe inside with the burglar alarm reset. I was just beginning to relax when I heard a noise coming from the back of the house. I slipped quietly through the house, holding the briefcase in front of me to use as a weapon. I figured I could surprise Baijan and knock him off balance before he could strike. I pictured the struggle, like a crime scene from the movies.

I almost clobbered Beth as she came around the corner with a hot cup of tea. The briefcase and the beverage collided in midair and crashed to the floor as we both screamed.

"What are you doing walking around in the dark?"

"I don't need a light to get a cup of tea. What are you doing sneaking through the house?"

"I just got home. I heard a noise back here and thought we were being robbed."

"So much for the burglar alarm."

"You scared the hell out of me," we both said simultaneously, then started laughing.

"Didn't you hear me open the front door?"

"I was half asleep. I was concentrating on the tea. Are you okay?"

"I am now. Are you?"

"I'm tired. I couldn't sleep I was worried about you. You must be exhausted."

"Completely."

"How'd it go?"

"You're not going to believe it. But I can't discuss it now. Let's make some more tea and go to bed."

We started up the stairs.

"Isn't that Jake's briefcase? Are you going to go to bed with it?"

"No. I'm going to put it under the bed. Let's pretend we're sleeping in the White House. In the Lincoln Bedroom."

"What?"

"Never mind."

We helped each other into bed.

"So what happened?"

"Drink your tea. Can I have a sip? We made millions of dollars."

"You're kidding."

"Nope. Pass the sugar."

"I think we need to howl," she said.

We probably howled for ten minutes, because at the end we were hoarse.

"That was good," she said, finally. "Now tell me what really happened."

"It's true. Before you go off on a shopping spree you need to know that I probably won't get to keep it. At least not all of it.

I need to come to an agreement with Jake and Charlie. They staked me."

"What kind of agreement?"

"An agreement that'll give us enough money for our hope chest. But the rest of what I won was not money. It was the tapes."

"You mean THE tapes? The ones you were supposed to deliver to the University? The ones we saved for Jake at the auction? Are they under our bed?"

"Yep." In my exhausted state, I had forgotten that Beth knew very little about the tapes or how valuable they might be to someone like Charlie or Baijan.

"So how much are we talking about?"

"Millions."

"As in two or three?"

"No. As in twenty."

Beth choked on her tea. "How could the tapes be worth that much? I can't believe they're in our bedroom. What's in them?"

"One question at a time. I already told you, the tapes are from when Jake was Secretary of the Treasury. They involve Baijan's bank, some pretty scandalous stuff, I guess. Baijan really wanted them. As to why they're in our bedroom, I figured they'll be safe there for the night."

"So he didn't get them."

"Obviously not. I won them. But Charlie staked me and Jake provided the tapes to keep the game alive after Baijan got way ahead. By cheating, I might add. But I figured him out right before Jake threw in the tapes, thank God. I ended up taking him to the cleaners. We need to come to some deal with Jake and Charlie about how to split the money. We're meeting this afternoon at six. I need to get some sleep."

Trip In The Dark by Kaaran Thomas

" 'We' means you and me."

"What? You don't want to get involved in this, Beth."

"On the contrary. I do want to get involved. We need to be a team to beat their team. That's what a marriage is."

"How will I explain to Jake and Charlie?"

"Tell them I insisted. And besides, I'm entitled to get involved. If you have won millions of dollars, or tapes or whatever, that's our community property. We own it jointly. I'm entitled to sign off on any settlement. I have to, in fact."

I had briefly forgotten that Beth was the Dragon Lady.

"You've been a professor since you graduated from law school. You have no experience in negotiating deals, Beth. Why don't you let me handle this?"

"What do you think I do at the university? I have to negotiate my contract, my grants, my schedules. And trust me, law professors are every bit as tough as your clients. Besides, we need more than negotiating experience. We need a good deal. We have to make them want to part with the money. We need to put our heads together to come up with something."

"And how, exactly, would we do that, my dear?"

"I don't know right now. Get some sleep. We'll discuss it in the morning."

"It is morning, Beth."

"I mean when you wake up, Darling."

I don't remember taking off my clothes. When Beth woke me, it was past noon.

"Maybe we can get them to invest the money in something that would make money for all of us."

"Good idea, but what would that be?"

"Maybe some sort of business. I've wanted to change jobs for months. I've looked into working for law firms, but I can't compete with you. As for other companies, most are worse than

258

the university. They're short on money and not interested in hiring a woman for a responsible position. All the interviews start with "Honey." Like, 'What can we do for you, Honey?' They go downhill from there."

"What if we could convince them to help you start a business? What would it be?"

I wish it could be something that would help our friends who've lost their jobs."

I thought of David Ward who was still out of work and running out of money.

"What if we could start a business helping troubled companies, Beth asked."

"You mean lend them money? You know how risky that is, Beth. They'd never go for something like that."

"What if there was a way to use a little money to help the companies help themselves? The way you try to do with the banking partners."

"You mean like a jobs training company? I don't think anyone would pay for that right now. Nobody's hiring."

"What if it was some other kind of help? Not job training but something else. You work with these companies, Tom. You have to know what they need? What they could do with a little money?"

We thought about it all afternoon. By the time of the meeting we had come up with a plan. And we had the element of surprise. Charlie and Jake would never expect to have to deal with the Dragon Lady.

When Beth and I pulled through the gates to Charlie's house, even Venus and Aphrodite looked surprised. Beth ignored them.

Trip In The Dark by Kaaran Thomas

Beth opted for her full lawyer regalia—her best black suit, nylons and black heels and a black briefcase. I decided to stick with Texas chic.

A butler answered the door. "They're in the hot tub," he said, escorting us through the house.

Jake and Charlie were back in the hot tub, smoking cigars. Jake had clearly been ignoring Charlie's instructions. They obviously expected a male bonding experience. The look on their faces when they saw Beth standing over them like the angel of doom was priceless.

"Is this how you dress for a business meeting, gentlemen?" she said in her strictest professor voice. They got out of the tub looking like naughty schoolboys, growing even more embarrassed as their water-laden bathing suits slipped down, almost exposing their private parts.

"I assume you have an office in this place?" She ignored their discomfort, gesturing disparagingly towards the house.

"Yes, ma'am."

"Why don't we meet you there, then? After you get dressed." We were escorted into the office. While we waited, we laid out the tapes, the briefcase, a notepad and a calculator on the conference table.

Charlie was the first to arrive. Beth stood up and extended her hand. "I'm Beth Nielsen, Tom's wife. And you are?"

"Charles Harrell, ma'am. Pleased to meet you."

"Thank you. Are you in charge of the negotiations over these tapes?"

"I think Jake will be here in a few minutes."

"Fine, we'll wait." Beth's nails beat an impatient tattoo for two or three minutes until Jake arrived. By that time Charlie was already nervous. He had poured himself a drink—Wild Turkey in

260

an iced tea glass. It was half gone, including the half ounce he had spilled on his shirt. Beth looked at the stain in open disgust.

When Jake arrived, Beth stood again to shake his hand.

"Beth, what a pleasant surprise," Jake said, smoothly.

"I don't see why you're surprised. I have a community property interest in these tapes. You would need my consent to make any disposition of them, of course.

"Of course," Jake mumbled, already conceding defeat.

"So, Tom and I have discussed several possible arrangements, all based upon their agreed value of twenty million dollars."

"Now wait just a minute," Charlie interrupted.

"Did I misunderstand something," Beth asked, looking Charlie in the eyes.

"Well, I'm not sure . . ."

"Not sure of what? That the tapes are worth twenty million?"

"Correct," said Jake, swallowing hard.

"Correct me if I'm wrong, but didn't my husband write an IOU for five million last night for five of the tapes? Didn't he put our community estate at risk for that amount, at your request?"

"Well, I guess you could think of it that way . . ."

"How did you think of it when you took his IOU? And didn't Mr. Baijan transfer fifteen million dollars US into Mr. Harrell's account for his purchase of fifteen of the tapes?"

"Yes, but . . ."

"So let's cut the bullshit, gentlemen. We are dealing with twenty million dollars. I can add."

"Tom agreed that three-million of the money would go to Wainwright and two million to the University of Texas." Jake said, defensively.

"That's fine," Beth replied, smiling. "We can use part of the money to make a donation to the University in Tom's and my name."

I chimed in: "As for Wainwright, you can't just give them money. You need to give them work to do—work they'll get paid for."

"I already gave them work they get paid for. "

"Were you thinking of using three-million of our money to pay Wainwright for your work," Beth asked skeptically.

"No, hell no. I mean, we haven't figured that out yet."

"We've come up with an idea. We do think we should get to keep at least some of the money."

"Of course, Tom. There's no question about that."

"But we also think there's a way to put part of the money to good use, in a way that can reward all of us."

"First, let's talk about how much you think you should keep for yourselves."

"How much were you thinking," Beth asked, smiling sweetly.

"It was never the deal that Tom would get paid for those tapes." Charlie decided to take over the negotiations. "The deal was that Tom would help us cause Baijan to lose a lot of money. Which he did, and we appreciated it. Greatly. And Tom gets to keep his winnings. I mean, the chips he won during the regular game. That's seven million dollars. Eight, really. We'll let him keep the money I staked him, his buy-in. He deserves a reward. No question about it. On the other hand, if Tom had lost to Baijan, we would never have asked him to pay on his IOU or to compensate us for the tapes. It was agreed that this deal was no risk to him. That was the deal."

"So Tom gets nothing for winning the tapes? For helping you get fifteen million dollars?"

Charlie and Jake exchanged the "What now" look. Beth pressed her advantage.

"Jake, Charlie," I picked up the argument. "Does anyone dispute that my contribution to this venture was significant? I think we have a good argument to all the money Baijan paid Charlie, but on the other hand, I don't want to be piggish. And, as I said, Beth and I have an idea that we'd like you to consider. It's something I've thought about a lot during the past few years when I visited Jake's ranch. So many people, people like your friend Joe Spracklin, could make money if they could get the assets they need. Joe has all the expertise a person needs to drill wells. And there are lots of landowners with wells to drill. Problem is, the landowners don't have the money to hire Joe and a crew and Joe doesn't have the money to buy the rigs and pipe. The rigs and pipe are sitting on a lot somewhere, owned by some liquidator, rusting away.

"We all know that, Tom. Hell, Spracklin calls me all the time complaining how the oil business is stuck. Everybody wants to drill but nobody has the money."

"Right. Well, what if we start a company to unstick it?"

"Hold on, Tom. Are you suggesting a business to compete with my company Odyssey?"

"No, Charlie. But your company needs businesses to sell to, doesn't it? Wouldn't it grow if there were more buyers out there?"

"So are you proposing a finance company? That'd take a hell of a lot more than twenty million to make a difference."

"That's not exactly what we were thinking."

"What, then?"

"Beth slid two copies of our proposal across the table. She and I had worked on it all afternoon. So many weekends at Jake's ranch we had sat around the campfire listening to owners of oil-

field equipment companies complaining there was nobody to buy their equipment, pipe manufacturers complaining about the lack of market for their pipe, owners of oilfields complaining about being unable to drill, lessees concerned about losing their leases because they didn't have the money to fulfill their drilling commitments. So many of Beth's friends had called asking if we knew of any job openings. So many unemployed First City bankers, including Dave Ward. All of them had college degrees; all were qualified to be employees for our new business. And Beth wanted to leave the university.

"What they need is something to bring them together—a joint venture. If the lessor and lessee, the equipment company and the pipe company can get together, we can invest in their venture, enough to pay for insurance and labor. And we can hire our out-of-work friends to staff the company. And we could take a royalty interest in the production in exchange for our investment. And when the wells come in everybody gets repaid out of production."

Charlie had put down his glass and Jake had taken out his cigar. They were both looking at the proposal.

"That might be doable, provided nobody's competing with Odyssey." Charlie said finally.

"Yep," Jake chimed in.

"Do you really think these little start-up companies will compete with you," I asked. We think what they'll do is soak up all the excess inventory and equipment that's driving down the price of what Odyssey has to sell. And when they get healthy and use up all that excess stuff, they'll be looking to buy your stuff at a fair price."

By nine in the evening we had put together the bones of our plan, estimated the number of ventures we could invest in and calculated the amount of time before we began to see pro-

ceeds from the sale of oil. I had committed Wainwright to prepare all the documentation for the ventures in exchange for the three million dollar retainer and additional royalty interests payable out of the new ventures' sales of the oil and gas.

We agreed to invest five million of our winnings. Charlie agreed to kick in ten million, as needed. The company would be staffed with Beth and David Ward and some of Beth's former co-workers. We were sure we could rent an entire suite of offices in the former First City building, fully equipped with furniture and equipment for next to nothing from the FDIC.

"What do I get out of this?" Jake said with mock concern.

"Forgiveness for all your misdeeds," Beth said without cracking a smile. "And our undying gratitude. And a chance to help restart our economy. And membership on the Board of Directors—and, if Mr. Harrell consents, a percentage of the royalty—a very small percentage. And you get your tapes back, of course. Assuming you want them."

"How about Joe Spracklin? Can you hire him?"

"Jake, that's a great idea, I said. "He'll be our deal finder."

"What do we do with the profits after the loan's repaid?" Charlie piped up.

"We split the profits three ways. Tom and I get one third. You get the other two-thirds, unless you want to cut Jake into the deal. And I get a small salary plus a royalty interest in the deals. "

Charlie muttered something unintelligible, but he had already bought into the idea. I could see it in his eyes.

The biggest argument was over the name of our venture. I suggested Straight Flush, Inc., but Beth decided the word "flush" might have an unpleasant connotation given the nature of our business. Charlie suggested our initials, "HMN, Inc."

"Alphabetical order," he said, innocently.

I suggested reverse alphabetical order. Jake wasn't taking sides. Finally, Beth resolved the argument.

Chapter 27: Texas Hope

Texas Hope, Inc. opened for business in the old First City offices with the happiest staff in history—Beth, several university alums, David Ward and Joe Spracklin. Spracklin's experience in the industry, and his knowledge of all the deals he had lost when his company failed due to lack of funds, made him the perfect CEO.

At nine sharp the new employees filed in. They all had assigned offices, but instead of going to their desks they just stood there, looking stunned.

"I never thought I'd see the inside of this place again," David choked. He had reclaimed his old office. He would have hugged Charlie if he had looked at all huggable. Jake beamed.

Spracklin had already identified two wells that had been closed up before drilling was completed due to lack of funds. He was able to reassemble the lessor and lessee and the pipe company and to find a troubled oilfield equipment company to supply the rig and other equipment in exchange for a royalty interest that would pay once the oil was sold. Within four months, oil was flowing to the refineries in Bayport. Money flowed from the oil companies to the oilfields and the workers; then on into the Texas economy. We got our royalties. And hope flowed—through the

pipeline and through the rumor mill as the story of Texas Hope sped across Texas faster than oil through the terminals.

Wainwright put together the model agreements for willing participants. We gave them a "retainer" of three million dollars to do the work; an indirect way to repay them the three million in unpaid fees and deposits they had lost. Even better, the Wainwright name was restored—the stigma of First City's failure, mitigated by its work for Harrell and Odyssey, was fully erased by the association with Texas Hope. Wainwright's publicity machine worked overtime, broadcasting the benefits of the "Hope Venture Model" and our role in its creation.

A week after we decided to form the company, the front page of the Houston Chronicle headlined the unsolved murder of a Vegas showgirl, a hostess last seen at Charlie Harrell's rodeo poker tournament. It was Trudy.

Beth and I were untouched, however. I will never know whether Jake or Charlie protected us or Baijan just didn't have time to get to us. I couldn't help comparing the effect of the tapes on the lives of those two women. Beth survived and triumphed. Trudy was killed. And neither suspected what was behind their fate.

Beth's transition from professor to president was effortless. She quickly learned the business issues from Joe and the financing issues from David and became the liaison between the two. She was the problem-solver, the dispute mediator, the bridge between the company and Charlie, who watched the company's finances like a hawk.

I went back to work but kept looking over my shoulder. Jake had warned long ago about someone coming up behind me, and what had happened to Trudy was a gruesome reminder, but Baijan never showed. I looked for news of him, hoping to learn

whether he was still alive. But he just disappeared. As if he had never existed.

It would be another decade before the price of oil started going up again. But by December, 1992, Texas was on the road to recovery. Texas Hope wasn't the only reason—not by a long shot. But Texas Hope was the most widely-recognized symbol of the new spirit sweeping the state. Texans had adjusted their businesses and lifestyles to the lower oil prices. And they began looking forward to Texas' role in the new millennium that was rushing towards us.

And Jake? Did he become the symbol of Texas' recovery? Did his involvement in our company result in a better, closer relationship between us?

It was Charlie, not Jake, who spent hours on company business; who went over the books with Beth and a fine tooth comb; who kept an eye out for new opportunities; who looked for ways to expand our business. Charlie had cut Jake in for a third of the profits, and Jake hung around for the first few weeks, but then he began missing Board meetings. All during that summer and fall we looked for an invitation to visit the ranch. It never came. Occasionally Charlie would mention something about the McCartys. From his comments I learned Jake and Belle were spending less and less time there and more time in Houston.

The only McCarty-Nielsen relationship that grew during those days was between Beth and Belle. They talked on the phone occasionally and got together for lunch when Belle was in Houston.

"Why not have Belle replace Jake on the Board, Tom? Jake's not contributing anything anyhow."

"Is Belle interested? I had no idea she had a head for business."

"How much does she need to know? She can be a figure-head, like Jake was supposed to be. Maybe she can help get some women-owned companies involved. I'm going to call her and ask."

Beth went off to make the call and came back looking worried.

"What happened? Did she turn you down?"

"Yes, but that's not the problem."

"What, then?"

"She didn't know Jake was missing Board meetings. He's been going off, telling her he was coming to the meetings. Now she's concerned."

"For God's sake, she won't tell Jake we told on him?"

"Damn it, Tom, why is it always Jake? How about Belle? He's been lying to her. What's he doing? Having an affair? Why don't you try to imagine how she feels instead of worrying about Jake?"

"In case you forgot, our company exists because of Jake. So yes, I'm worried about him."

"Our company exists because of you and me."

"And Jake and Charlie"

"OK. All of us. The world does not revolve around Jake McCarty."

"I need to figure out what's going on."

"That's their business, Tom. Stay out of it."

The next Board meeting Jake showed up. And he attended all the following meetings. He ignored Beth's pointed references to his absences and participated in our business as though nothing had happened.

And Belle never again called or lunched with Beth.

Chapter 28: Waltz Across Texas

Wainwright's 1992 Christmas party was lavish. Once again they rented the Houston Fine Art Museum, a dance band, the best caterer. How different from Beth's and my first Christmas at the firm when we walked among the crowd unnoticed. This time, we were the ones for whom the Red Sea parted; the people everyone wanted to greet. We were escorted to a prominent table by the dance floor. Jake and Reedwell were among our table mates—all former Wainwright partners had been invited. Belle was missing—Jake said she was off visiting her daughter. Our table was surrounded by well-wishers and partners hoping to get a piece of Texas Hope or Odyssey work. Jake was at his best—regaling his tablemates and the surrounding tables with stories of his career.

The event was black tie. I still hadn't sprung for a tuxedo, but seeing Jake in his custom outfit made me realize my shortsightedness. My rented tux hung limply from the shoulders; Jake's fit comfortably, showing off his slim figure. My pants were just a tad too short; his hung perfectly over the tops of his boots. I hadn't thought to wear boots with my outfit.

Beth made up for my lack of fashion sense, considering it her job to take all attention away from me. She had indulged her passion for vintage designer clothes, appearing like a vision in a blue dress that was all sparkly. It fell from her shoulders,

271

skimmed her hips and splashed around her feet like a sunlit waterfall. Her diamond earrings sparkled as brightly as her eyes. Beth hated makeup—she had never polished her nails or worn mascara. On that evening her cheeks were lightly blushed and she dabbed on a bit of eye shadow and a natural shade of lipstick, but otherwise she was completely, beautifully herself—managing to make Reedwell's wife and the other women at the table look overly made-up.

"You are a vision," Jake said, openly admiring her. Reedwell nodded in agreement. "You're a lucky man, Tom."

Beth blushed and smiled thank you. After dinner, the band played, starting with "Deep in the Heart of Texas." Jake led the audience clapping and stomping in time to the music. The band followed with several favorite Texas dance tunes. Beth was watching me. I knew she wanted to dance. I looked away, recalling my last disastrous adventure on the museum dance floor. Finally she turned to Jake, "Can't you teach Tom to dance, Jake? I know he'd learn if you made him. He just ignores me."

"What makes you think Jake's a good dancer?" I asked.

"I'll have you know I'm a fabulous dancer, Tom," Jake said. "Jackie Kennedy told me so. And I do believe that at the time she was wearing a dress a lot like the one Beth is wearing this evening."

Then he turned to Beth, rose and bowed with exaggerated ceremony. "May I have the honor of this dance, ma'am?"

The band struck up "Waltz Across Texas." Beth looked up at him, stunned. Then, with every woman in the room watching in obvious envy, she accepted his arm and his offer. My wife in a spectacular evening gown in the embrace of a handsome, famous Texan. I had never seen her that way. I had not realized how graceful she was; how effortlessly she glided across the floor in Jake's arms, smiling into his eyes.

True to his claim, Jake was a fabulous dancer. The two of them waltzed in ever-widening circles and the rest of the crowd paid them the ultimate compliment—they cleared the floor. It was magical. I was unspeakably jealous.

When the music stopped, the audience applauded. Jake tucked Beth's arm through his to escort her back to our table as the band struck up another tune. Halfway across the floor Jake stumbled. His face turned white. Beth supported him on her arm, helping him back to his seat.

"Are you alright?"

"I'm okay, just a little winded. It's been a while since I had that much exercise. Thank you, Beth. You are a marvelous dancer. I guess you took my breath away. Shame on Tom if he doesn't learn to dance. Tom, you don't know what you're missing."

I wasn't fooled.

"I think I'll be getting home," Jake said when his breathing had slowed down.

"You're not going back to the ranch tonight?" I asked, worried.

"No, no. I'm still staying with Charlie. He'll be waiting for me to join him in a nightcap. I'll be on my way. Beth, thank you again for a perfect evening." He coughed. He was still pale, still unsteady. I didn't want to embarrass him by offering assistance, but I watched him until he made it safely to the entrance.

After Jake left, the party turned dull. We took the first opportunity to excuse ourselves.

Back at home, I shrugged out of my tux and put it on its rented hanger. As I brushed my teeth I lectured myself in the mirror. "You will buy a custom-made Armani tuxedo. You will take dancing lessons. You will become more like Jake . . ." The lecture stopped. I could never be like Jake. He was better than me in every way. He always won, even after he had to file bankruptcy,

he still came out ahead. He kept his ranch and everything that was important to him. He improved his status as a Texas legend. He was still the Big Tall Texan and now he was a hero for surviving. Hell, he had kept me in his thrall for so many years. And now he was a hero with Beth, too. Jesus, she had hated him and now she was probably half in love with him. She was probably laying in bed this minute dreaming of their waltz together. He had made her the center of attention, the envy of every woman in the room. I would never have the power to do that. I was a failure. Even with my own wife.

I tiptoed into the bedroom. There, by the crystalline light of a winter's moon, stood one of Charlie's naked goddesses come to life, rising from a sparkling blue pool.

"Want to dance?" she whispered.

I held her in my arms and laid her gently on the bed. I kissed her with a hunger borne of revelation. She kissed back as only a goddess could kiss. We set out upon our own, horizontal, waltz across Texas. She explored my grassy prairie, my mighty live oak. My fingers traced her rolling hills; my tongue explored the depths of her steamy bayou. When I entered her, it took a second for us to find our rhythm. But our hearts caught the beat, and we swept in each other's arms through the timeless dance of creation, faster and faster; and when the music stopped all the stars in the Texas sky exploded.

Chapter 29: The Scale

What had come before was the naïve giddiness of youth. The months leading up to that December had been like branches on our Christmas tree. The morning after the party, when I awoke in Beth's arms, we put the star on top. Together we hung the ornaments and decorated our new life with hopes and plans. Now we had the means. We had the ideas. We had each other. We sprinkled the tinsel, wrapped our world in twinkling lights. Beth made hot chocolate. We built a fire. It was eighty degrees outside but we set the thermostat at sixty and snuggled together in a blanket by our hearth, unwrapping our shining dreams. What the hell.

The holiday season was a blur. We went to parties, hosted parties, visited relatives, exchanged gifts in a daze. New Year's Eve, after the stroke of midnight, we watched an old Fred Astaire, Ginger Rogers musical and fell asleep on the sofa.

That was first night I had the dream. I saw the old-fashioned scale of justice. Beth and I and all our treasures filled one side to overflowing. The Gods had noticed—too much joy, they decided. Something must be placed on the other side to bring the scale in balance. At first I couldn't recognize the small, squirming figure in the hand of the unknown god. But when he

put it on the scale where it lay naked, defenseless, struggling for breath, I saw it was Jake.

I woke frightened, worried, guilty. I hadn't spoken to Jake since the night of the Wainwright party. I called the ranch, hoping Jake and Belle might have returned there for the holidays. A maid answered. They had been gone since the first of December. Of course, that meant Jake was fine. He was visiting family. He would be back, as he always came back. We had a Texas Hope board meeting February first. I would see him then.

Board meetings were always fun. I was looking forward to a lively exchange between Beth and the ever-cautious Charlie. Beth and Charlie's relationship was another source of amusement in our lives. Charlie didn't know how to behave around Beth. He was afraid to use his usual obscenities but he was tongue-tied without them. Beth took full advantage of his discomfort. The February meeting was going to be important – Beth was pushing for an expansion of the business. She wanted Texas Hope to become a venture capital firm. Jake had assumed the role of mediator, which he performed with much amusement. As secretary I had to record the antics for posterity.

In January, however, I learned I had to be at the opening of our new London office on February first. Beth said not to cancel the Board meeting; she could manage without me. I returned the Friday after the meeting, tired and jet-lagged. Beth was also feeling unwell. I didn't think about the board meeting until Sunday.

"How did the meeting go?" I asked over breakfast.

"Better than expected," Beth said. "Charlie was in favor of the idea. Can you believe it? He's asked if we're interested in merging Texas Hope with a new company he's forming—taking the business national. Anyway, we'll discuss it over the next few weeks, see what we want to do."

"How was Jake?" I asked, trying to sound casual. I hoped for an answer that would calm the nervous tremors that came on me when I least expected, the recurring dream I tried to forget.

"He couldn't make it," Beth replied absent-mindedly.

"Why?" My question sounded more urgent than I had intended.

"Charlie didn't say, and I didn't ask."

"Why didn't you ask? Has he started dodging meetings again? Or maybe he's still sick. Don't you even care about Jake?"

"Sweetheart, calm down." Beth gave me a quick hug. "I had other things on my mind. Besides, I assume Charlie would have said something if Jake was sick."

"You assume, you just assume? You don't even care enough to find out?. You couldn't even ask a simple question: 'Is Jake okay'. What's the matter, afraid it would spoil your little meeting?"

Beth backed away, looking at me like I was some demented stranger.

"Tom, I'm sorry. Let's call Jake right now. You're right. I should have asked. I just wasn't thinking about that."

"Forget it. I'll call. You obviously don't give a damn."

I stalked into the bedroom, slammed the door and dialed Jake's number at the ranch. No answer. I dialed Charlie's number. For some reason my hands were trembling. A small worm was eating at my guts. The butler answered the phone.

"Can I speak to Charlie, please? This is Tom Nielsen."

"Mr. Nielsen, how are you, sir?"

"Fine, fine, but I need to speak to Charlie."

"He's not here right now. Can I take a message?"

The wriggly worm grew into a monster.

Trip In The Dark by Kaaran Thomas

"I need to find him, I'm actually looking for Jake McCarty. He's not at the ranch. I thought maybe they'd be somewhere together, or that Charlie would know where Jake was."

There was a pause on the other end of the line. The monster's jaws closed around my heart.

"Mr. Harrell is actually with Mr. McCarty and Mrs. McCarty at Methodist Hospital."

"Is Charlie sick?"

"No, sir. It's Mr. McCarty."

I put down the phone and ran out of the bedroom, stumbling down the stairs, heading out the door.

"Tom, what is it? Where are you going?"

"Jake's in Methodist Hospital. I'm going there."

"Wait, Tom, it's pouring rain. You'll need your raincoat."

"Leave me alone. Just leave me alone."

I was still an outsider, looking in on Jake's life. I was not his friend; not a person he confided with about his illness; not worthy of being informed that he needed to go to the hospital. Why should I care? But I couldn't help myself. They probably wouldn't even let me see him, but I would try. I needed to see him, for reasons I could not explain. Methodist was twenty minutes from the house. My stomach was doing flip flops the whole way. I thought of all the things I had meant to say to Jake—all the things I had wanted to hear from him—all the wasted occasions I had had the chance to have a serious talk. I had never followed up on our brief exchange by Charlie's pool the night of the poker match. I had never thanked Jake. At the time I had been too emotionally drained to have a real discussion with him; and there was too much going on. After that night there never seemed to be a good time. We had never visited the ranch again. I only saw him at Board meetings. Then there was the Christmas party where we were too busy with others. Then we never saw

each other again. I might never see Jake again. I might never have the chance to say goodbye.

I hated hospitals. The smell of sickness, death and fear hit me when I walked in the door. The receptionist looked askance at my dripping body as I told her I wanted to see Jake McCarty.

"He's not receiving visitors right now."

"I'm a close friend."

"Of course you are. But he's not receiving visitors."

"Mr. Harrell is with him, he's a visitor."

"Look, Mr. McCarty is on the fifth floor. Go to the receptionist there. She will talk to the family and doctors and see if you can visit."

The fifth floor receptionist was no better.

"He is not to be disturbed. That's what it says here on his chart."

I was about to start a screaming match when Charlie walked up.

"Tom. What are you doing here?"

"What do you mean? Why didn't you call—tell me? I want to see him." I realized I was yelling.

People were staring at us. Charlie strong-armed me into the elevator. "Get a hold of yourself, Tom." When the door opened he forcefully escorted me outside. "Let's find a place to sit." He dragged me across the street; oblivious to the rain. There was a little park with a patch of grass, a bench, a sculpture and sign. It was for relatives of cancer patients. I noticed the sign: "Survivor's Garden." For some reason I found it hysterically funny. I crumpled, laughing, onto the wet bench, looking up at the wind-blown drops stinging my face.

"He doesn't want you to see him, Tommy."

I looked up, angry, ready to argue. "Did he say that?"

Trip In The Dark by Kaaran Thomas

"Listen to me. Jake McCarty is a proud man. Right now he's layin' there mostly naked, in a white gown with oxygen masks and tubes and what not."

My nightmare scales rose in front of me.

"You think he wants you to see him like that? Hell, no. He'd be mad as a hornet. And he wouldn't want you to worry. When he gets out, he'll want everything like it was."

I snatched at the promise in Charlie's words. Jake would get out. Everything would be like it was.

"What's wrong with him? Is it the pulmonary fibrosis?"

"It's catchin' up with him. He won't take care of himself. He has to keep up with those cigars, with pushin' himself. Goin' to Vegas, stayin' up all night gambling and who knows what. Now he needs a lung transplant."

"Vegas? When did he go to Vegas?"

"He started a while back, when he began missing the Board meetings. I had to cover for him. I guess Belle found out. They had one hell of a row about it. But then he got sicker and had to stop goin' anyhow. He's had to stay at the hospital. They're still deciding if they can do the transplant."

"When will they know?"

"No tellin'. Come on. You're soakin' wet." Charlie put his arm around me and walked me to my car. "Let's go to my place. I've been meaning to talk to you about something anyway; a new deal Jake and I are doing. It's right up your alley. It's in Indonesia. That's the next great oil frontier, you know. We need to understand their economy; what the risks are to gettin' in on the deals early. They don't have much real law over there. It may be hard to enforce our agreements. We want you to do some advance work, interview some of the key players—help us plan."

I followed Charlie to his house and sat numbly at his bar for over an hour. He talked about Jake and him and their adventures together.

"Jake's a tough old bird. Don't you worry. He wants me to sneak some cigars and liquor into his room. He'll be fine."

Finally I was calm and Charlie sent me home, still jet-lagged and more than a little drunk. Charlie believed that liquor was the best tranquilizer.

"What happened? You were gone so long, I got worried." Beth's questions were tentative; her voice cautious. She was treating me with kid gloves, which only made me feel worse about the way I had left her.

"Jake's in the hospital. But he'll be okay. He's waiting for a lung transplant. Charlie didn't want me to see him; thought it might embarrass him. When Jake gets out they have a new deal for me to work on. Beth, I acted like a jerk. I was so worried. I'm so sorry, sweetheart. It's just that . . . that I've been so afraid lately."

"Afraid of what, Tom?" Her hand rested lightly, tentatively on my shoulder. She looked up at me, looked me straight in the eyes. I hated myself for comparing that look to Jake's look.

"We've been so happy; it just seems like we have too much happiness, it's like a happiness boom. And the scales have to tip. Every bankruptcy lawyer knows, a boom is followed by a bust. I've been worried that the bust is something bad happening to Jake."

"So are you still worried?"

Her eyes were still locked on mine. Now they demanded an answer—an answer to some question that she had not asked.

"Yes, but not as worried."

"So are you ready for a little more happiness? Or would that be too much?"

Trip In The Dark by Kaaran Thomas

She was looking at me expectantly.

"What sort of happiness did you have in mind?"

"We're going to, um, you're going to be a father."

I have no recollection of what I said next. All I remember is the worries, the nightmares being swept away by a tidal wave of joy. The feeling of joy flooding over me was physical, like standing under a warm shower on a cold day. Her hand that had rested on my shoulder had to grip me to keep me from falling over. That was Beth. My support. My joy. And now the mother of my child. Only one thing could make my life happier: Jake's recovery.

Charlie's reaction to the news was a purple blush that made him look like a balloon. "So I guess you'll have to resign from the board now, Professor."

"Why, Charlie, are you afraid I'll give birth in your poker room?"

"No, ma'am, I mean, no, Professor. I mean—well—don't you ladies take time off to have babies?"

"Hell no, Charlie. I'll be working right through my pregnancy. Then after the baby comes I'll bring it with me to Board meetings. You don't mind if I nurse it during the meetings, do you?"

Charlie's face turned maroon and Beth burst out laughing.

"I'm kidding, Charlie. Don't worry. I'll spare you the breast feeding."

"How's Jake?" I interrupted to save Charlie from further embarrassment.

"He's hanging in there." Charlie replied.

And that was Charlie's answer whenever I asked about Jake, as winter turned to spring and thoughts of the baby pushed thoughts of Jake from our minds. I didn't ask again about visiting him in the hospital. I didn't question the length of Jake's hospital

stay, or its relation to the seriousness of his illness. I didn't notice when Charlie stopped saying "Me and Jake" and started saying "Me" or "You and me."

Looking back, I realize I didn't want to question, or to know the answers. A new life was coming into being, along with a new Texas, emerging from a financial crisis that forever changed how Texans thought about themselves. They looked to the future—the past was best forgotten—and I was one of them. I didn't want to dwell on the old days, the old memories or one old life in particular that would pass from the scene as surely as the president's car turned towards the book depository; as surely as a boom will follow a bust; as surely as scales tip back in balance.

Chapter 30: From Night 'Till Early in the Morn

By mid-1993 Wainwright's Houston office had expanded to five hundred lawyers on seventeen floors. It was amazing that important news could still shoot through the firm like an electric current. On June 13, I was in the men's room, at the urinal next to Reedwell. He was boasting about the firm's new client.

"I want you to meet Kenny Lay, Tom. He's a helluva guy. He took that little Houston Natural Gas and expanded it into Enron. Trust me, we're going to make Enron an international player in the energy market. It'll rival Odyssey. We'll be getting some stock options, too—should really fatten those retirement accounts back up after all the damage from the past few years. And we're opening offices in Singapore and Beijing. Enron's footing the bill. I'm joining their Board."

An associate poked his head in. "Jake McCarty died. About an hour ago." Whatever they said next I didn't hear. I went home.

Beth was in the den when I got there.

"I heard the news. Are you okay?"

"I don't know, Honey. I need to go sit out on the patio for a while."

The patio was hot with the June sun. I took a seat on one of the lawn chairs out of sight from the kitchen. I sensed Beth

looking out the back window every few minutes. I couldn't talk to her. I had to be alone. I had to think.

How does a man—trained to deal with other people's losses—cope when the losses are his and his alone? I counted them up like precious coins disappearing beneath the water. The chance to say goodbye. The chance to say thank you. The chance to say . . . so many many things . . . The way he filled an entire room by his presence. His laugh. His style. His friendship. The chance to discover if he was really ever my friend.

How does a man—reputed master of the compelling presentation, the eloquent turn of phrase—express feelings that, once they rise to consciousness, suck the air from his lungs?

How does a man—fully grown, respected, a professional— stop the silly, helpless tears from running down his face?

I stayed on the patio till dark.

The funeral was enormous, of course. The Reverend Billy Graham presided, and talked about his close relationship with Jake. I didn't know they knew each other. Former president George Bush and his wife Barbara attended. He recalled Jake's conversion to the Republican Party and its dramatic affect on national politics. Ronald and Nancy Reagan attended. Reagan reminisced about his visits to Jake's ranch and their shared love of cattle and horses. Charlie attended and spoke about all their adventures, finishing with a spine-tingling description of the Iraq hostage negotiations. He didn't mention Texas Hope. Harry Reedwell spoke glowingly of Jake's time at Wainwright and his importance to the firm. I listened in amazement to Harry's references to the "close working relationship" he had with Jake. Harry had come to

Trip In The Dark by Kaaran Thomas

my office before the funeral to let me know he would be speaking. He couldn't resist a bit of gloating.

"Sorry they didn't invite you to speak, Tom. I'm sure it's because you would have reminded them of McCarty's bankruptcy. Rather a dark side of his life. Best forgotten, I would say. I want to put the positive spin on his time at Wainwright. Good for the firm's image, you know."

"I understand, Harry. I'm sure I wouldn't be a good speaker, anyway. I know you'll do the firm proud."

Jackie Onassis attended but didn't speak; she sat right behind Belle. The two held hands and talked for several minutes before the service. I sat with Beth towards the back of the church; resisting the temptation to tell our pew-mates the stories of my own relationship with Jake, stories no one considered appropriate for the memorials.

At the end of the service, the crowd rose as one and sang the University of Texas fight song at the top of our voices:

"The Eyes of Texas are upon you,
All the livelong day.
The Eyes of Texas are upon you,
You cannot get away.
Do not think you can escape them
At night or early in the morn-
The Eyes of Texas are upon you
Till Gabriel blows his horn."

The coffin, banked with Texas wildflowers, was borne past my row and a single bluebonnet slid from its face, falling like a tear at my feet. I picked it up quickly, hoping no one would notice. I cradled it to my face.

286

It was one tiny flower; but when I held it in my hand, the water from my tears released its special smell and I breathed in the memory of that night when I raced across the hills towards morning and Jake and my destiny. In the dark, windows down, the smells of Texas dancing through the car the way Jake was to waltz through my life.

The past few days my mind had been foggy with grief and selfish regret. I would remain an unpublished addendum to Jake's life. I would never publicly recount the memories of our time together. It wasn't that I needed the public acknowledgement—I needed the chance to deliver my parting tribute; to complete the farewell his disease had cut short. I needed closure. But it was not to be.

What had it all meant? We were so different—the worldly Texas legend and the bankruptcy lawyer. What was the meaning of our successes and failures, sins and schemes and redemptions, our nights of dark despair and hill country mornings? Warp and weft in some complex fabric that was Texas? Nothing personal? Nothing left at all? But I put the flower in my pocket.

"The eyes of Texas were upon you, Tom, during that night and early that morn," Beth whispered as her thumb flicked a tear from my cheek. "Texas would be proud of you."

"How did you know what I was thinking?"

"It's a funeral, sweetheart. It's the sort of grandiose kind of stuff people think about during funerals. The meaning of your journey through life and what you did with Jake and all that."

Then she took my arm in her wifely way and led me from the church.

Trip In The Dark by Kaaran Thomas

A glamorous crowd attended the reception at River Oaks Country Club. Beth and I stood alone in a corner. Jake had once said I was not a member of his club and the funeral and reception demonstrated how right he was. Even after ascending to Wainwright's management committee, I was not part of Houston's social scene. My bankruptcy expertise was a reminder of the horrors of the past decade. People kept a respectful distance. Beth wanted to say a few words to Belle but the family was surrounded by prominent well-wishers. Beth and I couldn't get through the crowd.

"I don't think we're going to have a chance to talk to her, sweetheart. And I can't stand much longer. It's too uncomfortable," Beth finally conceded.

"Let's go home, then. Maybe we'll have a chance to call Belle later and talk privately."

We were almost to the door when Belle caught up with us.

"Tom, Beth, hold up. Thank y'all for coming! Tom, I have something for you. Can you come with me?"

We followed Belle to the entrance.

"You know," she said, as she turned and bent down to rummage behind the receptionist desk, "Jake was so very proud of you, Tom. He wasn't good at praising or thanking people to their faces. In the end, he was sorry for that. Charlie Harrell told us you had tried to see Jake at the hospital." She smiled. "Charlie said you were bawling like some snot-nosed kid, trying to get the nurse to let you see him. Charlie was laughing about it, but Jake got a little upset. 'You should have let him come in for a visit,' he said. 'There were things I wanted to say to him.' He asked me to call you, to have you come back. But things took a turn for the worse right after that. The doctors wouldn't allow any more visitors. Anyhow, he wanted you to have this."

She stood up and turned to face us, holding out Jake's elephant hide briefcase. I was speechless. What could I say to this woman? My loss was so insignificant compared to hers. Yet in the midst of her own grief she had taken the time to console me. I took the briefcase reverently; noticing the smooth cradles Jake's fingers had worn in the handles over the years. I nestled my own fingers in their places.

"Jake said you would know what to do with it," she continued. Then, noticing the tears forming in my eyes, her face crinkled into a half-smile. "He said something about leaving you holding the bag."

I could hear Jake saying that; I thought how Jake's cigar would have stood at attention as he and Belle shared the joke, and for a minute Jake lived with us again.

Belle finally noticed Beth's baby bump. "And we're going to have a little baby! Oh, how wonderful! A new life! Jake would have been delighted!"

Belle's smile suddenly crumpled. Her eyes grew heavy with tears and could no longer look into mine and we were both back in the world without stars and she walked away without another word.

Charlie had been watching. He separated himself from a group of people and came over, pulling me aside so Beth couldn't hear.

"What did she give you?"

"Just Jake's briefcase. He wanted me to have it."

"Maybe there's something inside?" His pupils had grown small and black.

"Maybe."

"Aren't you going to look?"

"Not right now, Charlie."

"If it's what I think it is, I'd like to buy it from you."

Trip In The Dark by Kaaran Thomas

"What makes you think that's what's in there?"

"Just a guess."

"If Jake gave them to me that would mean he wanted me to keep them, not sell them."

"Jake promised those tapes to me, you know. After all I did for him that was only fair."

"I don't know, Charlie. I was never able to speak with Jake after he entered the hospital. I thought he had made copies for you."

"Not all. I need 'em, all of 'em, hear me? If you change your mind and decide to be reasonable, you know where to find me." Charlie turned and stomped away.

"Aren't you going to look inside?" Beth asked, when I rejoined her.

"I'm going to take you home," I replied. "I don't want you to get tired, after all. We need to be sure little Jakarinda comes out healthy and strong." I patted Beth's baby bump.

"Jacqueline, please!" she laughed. Then she took my hand and we left.

Chapter 31: Wildflowers

"What was he like?" I've finally become the authority on Jake. It's through a process of elimination. All Jake's contemporaries, all his buddies, are gone. Belle died two years ago. Larry King called her "the last survivor from the fatal Kennedy limousine." He interviewed her after Jackie Kennedy died. Belle recalled the beautiful sunny day when she and Jake travelled to Dallas to be a part of the presidential motorcade. She was riding in the front seat and had started to turn around to talk to the President when she heard the shots and saw blue matter spatter on her dress. It was his brains. Jake had fallen over into her lap, critically wounded, screaming "They'll kill us!" Jackie Kennedy was trying to climb out the back of the car. But Belle couldn't get out or even duck down. Jake was lying in her lap and she had to keep her hand over the hole in his chest. The doctors said that was what kept him alive, Belle sitting upright in that death car, applying pressure to the sucking wound.

"You were a very brave woman, Mrs. McCarty," King said. "Weren't you afraid of getting shot?"

"I just did what I had to do. I had to stay with my husband, tell him he would be all right."

That was Belle. She stayed with her husband through everything.

Neal Wallace and the rest of the tycoons are dead and buried along with their secrets. Charlie is gone, too. He died in prison. Turned out his Indonesian deal was part of a scheme to sneak weapons to Saddam Hussein. Apparently that was why he needed the tapes. He began withdrawing his business from Wainwright when I wouldn't sell them to him. They were in the briefcase, of course. So in a way the tapes acted as a shield for me and the firm. By the time Charlie started pulling his business, Wainwright had lots of new clients. Texas Hope's work was bringing in millions of dollars in fees each year. When rumors reached Wainwright about Charlie, it wasn't hard to let him and his company go.

Unfortunately, Charlie was replaced by Enron. Big Oil morphed into Big Energy, and the scheming, the conspiracies, the ugly secrets were so similar. Some things never change. Fifteen years after First City 's failure, we had another major crisis as Enron—the firm's most significant client—was forced into bankruptcy, leaving Wainwright with millions in unpaid bills and a shattered reputation. I could not represent Enron. Once again, the firm was a creditor, so we had a conflict. But there was another reason. The firm was a target of the federal criminal investigation, accused of helping Enron dream up its crooked deals.

Harry suffered his second heart attack, a fatal one, a result, I'm sure, of the Enron scandal. He died on the same day as Ken Lay, Enron's President. The firm looked to me, the new managing partner, to save them.

And I did what was expected of me. Wainwright survived. Texas Hope business helped pull them through. By 2001, the year Enron failed, Texas Hope had become the largest venture capital firm in the South. Beth, David and I had bought out Charlie. She

and I were rich. I had no need to work; but by that time I had grown to love Wainwright like a second child, almost as much as Harry had loved the old place. I hadn't realized how much 'till I stood to thank my partners for electing me their new managing partner. I had to fight back the tears, the memories.

But I was a minority partner in Texas Hope. Beth, David and I had long discussions about the Enron scandal. I pleaded with them not to pull the company's business; to give Wainwright a chance. Beth and David considered the issue for several weeks. In the end they decided to stick with us. A critical fact in their decision-making was that no criminal charges were filed against the firm.

Enron's accounting firm, Arthur Andersen, was not so lucky. They were indicted for criminal involvement in Enron's fraud. Andersen closed its doors almost as soon as the charges were filed. They could not continue to do business under the cloud of the federal prosecution. Thousands of Andersen employees were left hanging in thin air, unemployed; their stock bonus plans and incentives rendered worthless overnight; their paychecks bouncing, unable to find another job. Their offices were close to ours. I saw the employees on my way home on the day Andersen failed—sitting on the steps of their building in shock, like the Enron employees, crying, the news cameras capturing every moment of agony.

By some miracle, the investigation into Wainwright got stalled and finally died. All the bright young partners and associates, men and women I had helped recruit and train, lawyers who looked up to and respected and trusted me, were spared the fate of the Andersen accountants.

Trip In The Dark by Kaaran Thomas

Perhaps, though, the government's failure to file charges against Wainwright was not such a miracle? Perhaps the tapes were dug up from their hiding place and used as a sword one final time, disincentivising the justice department attorneys from bringing charges against my firm? Perhaps the temptation to use them was too great?

I made the trip to Washington with Jake's briefcase, the tape recorder and one tape. I had found my target after a lengthy search through the tapes. Back in 1963 he was a gopher at the FBI—bright, ambitious and fanatically dedicated to Hoover. By 2001 he had become a distinguished senior official at the Justice Department, an elder statesman frequently interviewed on CNN. His secretary said he couldn't see me, but a day after I told her he might want to discuss some interesting details about the Kennedy assassination, he changed his mind.

We sat in his office overlooking the Capitol. I turned on the old machine. His voice came through, younger, more eager, but unmistakable. He listened without looking at me. Then he bent over and fell off his chair to the floor, like a dead body falling off a cliff. He stayed there on his hands and knees like a dog, heaving up a smelly pool of vomit, mixed with tears and snot on his oriental rug. The tape hissed softly in the background as he mumbled things. It was hard to understand him through the sobs. I did hear him say, "Don't worry." And I think he said "forgive". I left without another word.

I also tried to ask forgiveness of whatever deity might exist that would hold me accountable. I focused on how I had protected so many innocent Wainwright lawyers and staff from the hor-

rors that faced Andersen and Enron employees. That was justification enough, wasn't it?

Apparently it wasn't—not for the deity that haunted my dreams for months after I returned from Washington. It exacted its revenge in nightmares followed by sleepless nights. It brought tears to my eyes at the most inconvenient times: when I listened to people reminisce about Jake, when people praised me for my leadership of Wainwright, when I collected my partner bonuses, and even now when I hold my daughter in my arms.

And perhaps, when Beth asked about Jake before I started this trip, it was because she suspected something, some unknown fact about the tapes that would explain my behavior, my refusal to discuss them with her over the years, my shouting matches on the phone with Charlie, the unexplained trips, sense of guilt and fear I carry like a mantle? Perhaps she worries that I keep some terrible secret that might cause us to grow apart like Jake and Belle.

Morning is breaking over the hills. It's time to wash up, make some coffee and deliver my package to the University. The dean is waiting. Not Schumer, who left to become dean of the Ohio State University Law School, but his replacement. An oil portrait of Jake hangs outside his office. We'll talk about Jake, but this dean never knew him. He only knows of the gift from Jake's estate, establishing the McCarty room at the law school library. And he knows about my package, but not what it contains. It comes with instructions to be delivered to the LBJ Presidential Library, to be opened upon my death.

"What was he like?" the dean will ask.

Trip In The Dark by Kaaran Thomas

I'll still search for the right words, words that add to the public image of the Gov but stop short of touching on the old questions that still plague me. Was his parting gift, the briefcase and its contents, a way for Jake to show me how much I resembled him; to explain something about himself; to show how susceptible we both were to the temptations of great power? Was it evidence of a bond between us, a sinister kinship I had subconsciously longed for? Or was the gift just a joke? Or were we both actors in a play that Fate devised for her own ends?

I'll come back to our hill country house to rest before my trip back to Houston. I'll lie on my stomach in the field of wildflowers; the field that was born from seeds randomly thrown from a Texas Highway Maintenance truck years ago. Ladybird Johnson started the program—"Highway Beautification" she called it. It became one of the most beloved legacies of the Johnson administration. Something complex and beautiful, some ever-renewing miracle, was born out of President Kennedy's assassination. For some reason, I take comfort in that thought.

After my rest, I'll drive east, towards the sunrise and home. And I'll decide what to tell Beth.

When my daughter Jackie was little and full of innocent wonder, we would lie on our tummies in this field and she would poke her nose close into the blue carpet and select individual flowers.

"Let's pick these ones, Daddy."

"Wildflowers are protected, Jakey. They're not supposed to be picked."

296

"I'm Jackie, not Jakey," she would exclaim, laughing. "Don't call me that." It was an old familiar tease, a name I called her when she wanted something I was reluctant to give her.

"OK, Daddy, but just let me pick these two? Just these won't hurt. And these are special."

"But if everyone picks just a few, Jackie, then how many will be left?"

"But there's only you and me and I'll just pick these special little ones."

So my determined daughter picked two flowers that had been born separately and had grown to maturity on their own. She took her prizes into the house and put them in water in a juice glass, where they remained together on our table for a brief space in time before they wilted and drooped over the edges of their container. And one day she noticed they were no longer beautiful. We took the glass outside together so she could toss them away.

"Why are you crying, Daddy?" she asked as the little blue specks flew through the air in random arcs, separating from each other forever as they fell towards the blue mass.

"Because I'm getting old, Jakey," I said. "Because I'm getting old."

THOMA

Thomas, Kaaran.
Trip in the dark :it began
with the Kennedy
Freed-Montrose FICTION
01/14

CPSIA information can be obtained at www.ICGtesting.com
Printed in the USA
LVOW06s1443221213

366444LV00002B/256/P